IVY

R.R.

World Ceramics

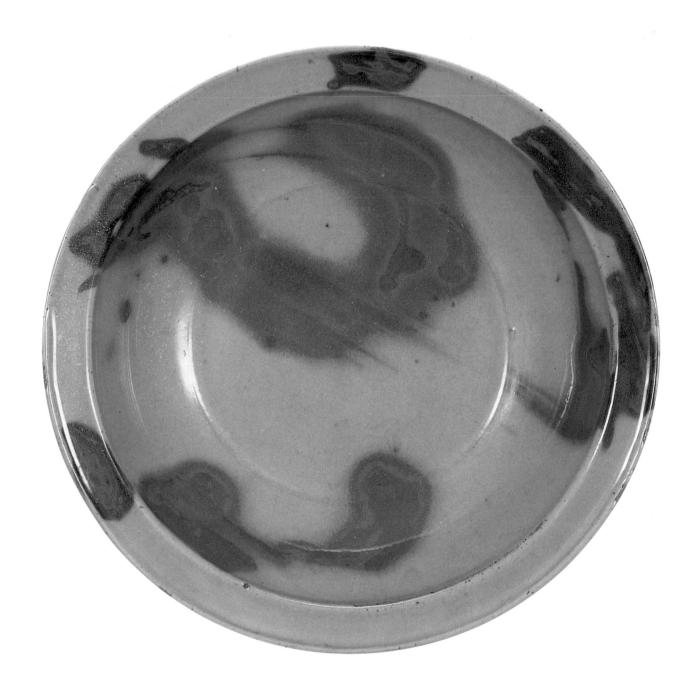

Basin, Chun stoneware. W. 12¾". China, Sung Dynasty, Honan province, 13th century. Courtesy Sotheby's Hong Kong Ltd. and Eskenazi Ltd.

World Ceramics

From Prehistoric to Modern Times

Hugo and Marjorie Munsterberg

PENGUIN STUDIO BOOKS

PENGUIN STUDIO
Published by the Penguin Group
Penguin Putnam Inc., 375 Hudson Street,
New York, New York, 10014, U.S.A.

Penguin Books Ltd, 27 Wrights Lane,
London W8 5TZ, England

Penguin Books Canada Ltd, 10 Alcorn Avenue, Suite 300,
Toronto, Ontario, Canada M4 V3 B2

Penguin Books (N.Z.) Ltd, 182-90 Wairau Road,
Auckland 10, New Zealand

Penguin India, 210 Chiranjiv Tower,
43 Nehru Place, New Delhi, 11009 India

Penguin Books Ltd, Registered Offices:
Harmondsworth, Middlesex, England

First published by Penguin Studio, a member of Penguin Putnam Inc.

First printing, November 1998
10 9 8 7 6 5 4 3 2 1

Figure 134. 19th-century majolica table centerpiece is reproduced from *Majolica* by
Nicholas M. Dawes. Copyright © 1990 by Nicholas M. Dawes and reprinted by
permission of the author and Crown Publishing, Inc.

Library of Congress Catalog Card Number: 95-71877

Book designed by Marilyn Rey
Printed and bound by Dai Nippon Printing Co., Hong Kong, Ltd.

ISBN: 0-670-86741-1

Dedicated to Kaete Brittin Shaw,
master potter and dear friend

Contents

Foreword

My father did not live to complete this book. With the enthusiastic support and constant assistance of Cyril I. Nelson of Penguin Putnam Inc., I have assumed that responsibility. Nancy Bowen, Assistant Professor of Visual Arts, Columbia University; Garth Clark, Garth Clark Gallery, New York; Jerome Eisenberg, Royal-Athena Galleries, New York; and Michael Weisbrod, Weisbrod Chinese Art Ltd., New York, gave freely of their time and knowledge. They, along with the always splendid resources of the Avery Architectural Library, Columbia University, helped educate me in a field that was not my own.

I am happy to say that this book has converted me into a full-fledged lover of ceramics. The sensuality and plasticity of clay, the extraordinary antiquity and variety in the history of its human use, seem to me deeply moving. I have often recalled the lines from the Prophet Isaiah, "As clay in the hands of its maker, so people in the hands of God." This elemental relationship seems to me evoked as much by Peter Voulkos's stack sculptures as by a seven-thousand-year-old clay female figure that nestles comfortably in the palm. The finest Sung ceramics also call Isaiah to mind in their daring pursuit of perfection. Of them, my father often paraphrased T.S. Eliot, "I tremble with tenderness."

In revising this manuscript, I have tried to incorporate the latest archaeological and historical information. In some cases, the changes of the last years have been dramatic. This is perhaps most true in the field of African art, where new interest and excavations have produced great riches. Those sections are entirely my doing, as is the epilogue about contemporary American ceramics. The judgments are my own and so too are any mistakes of fact or omission.

MARJORIE MUNSTERBERG
New York, New York, 1998

READER'S NOTE

My father was one of an older generation of scholars who used the Wade-Giles system of transliteration for Chinese names and B.C. and A.D. for dates. Had this book been started today, I would have chosen the newer style of transliterations and, perhaps, B.C.E. and C.E., although the latter is not yet common among art historians. Instead, I have retained the traditional designations with which he wrote this manuscript and which are in many cases still more familiar for most of us.

Preface

There is a vast and excellent literature dealing with the techniques of pottery, from simple how-to-do-it books to detailed treatises about glazes and other aspects of ceramics production. There also are many scholarly books addressed to collectors, dealers, and museum curators, describing the ceramics traditions of various countries, kilns, and types of pottery. This book does not approach pottery from either of these points of view. Rather it deals with ceramics as one of the major forms of artistic expression, fully equal to the so-called "major media" of the West—painting, sculpture, and architecture. It portrays creative work in clay from its very beginnings some thirty thousand years ago to our period, when this medium has become newly vital.

I am deeply indebted to hundreds of scholars, to the archaeologists who have brought to light so much fascinating material, and to the museum curators who have put their collections at my disposal. My thanks also go to the collectors and dealers who supplied me with photographs of the works in their collections, especially Garth Clark, Jerome Eisenberg, Frederick Schultz, and Michael Weisbrod, as well as the many museums that provided illustrations. I am indebted to my editor at Penguin Putnam Inc., Cyril I. Nelson, who committed himself fully to the best possible realization of this book. Finally, as on so many previous occasions, I owe thanks to my wife Peggy.

HUGO MUNSTERBERG
New Paltz, New York, 1995

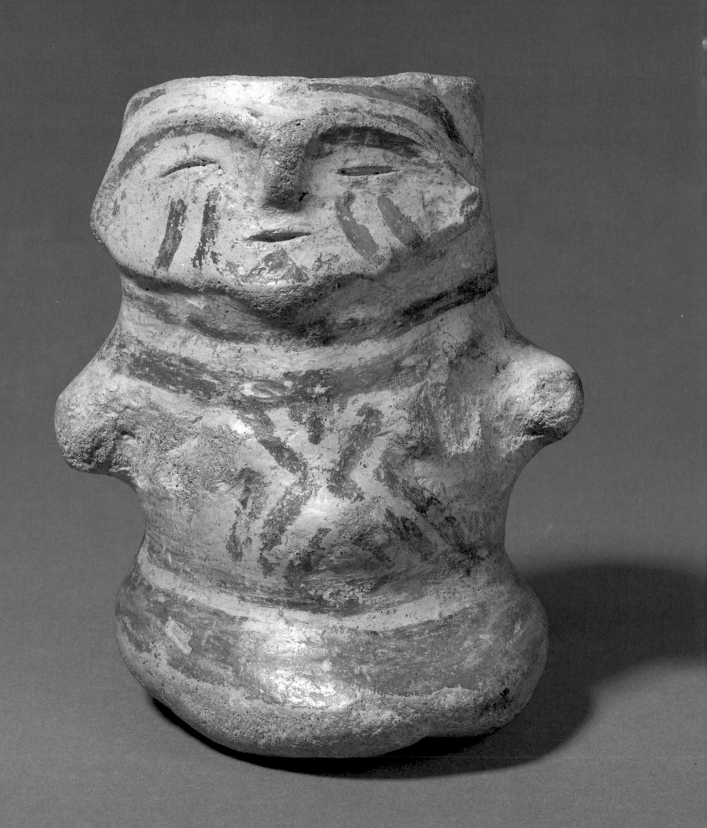

Chapter 1

Prehistoric Ceramics
from the Beginning
to 2500 B.C.

It is not known when or where people began to shape clay into purposeful forms and transform it by the red heat of fire into pottery. Interestingly, the oldest clay objects to have been discovered are not containers for food and drink, but small figures of all types. The most famous of them represent voluptuous women, similar to the limestone Venus of Willendorf from about 22,000 B.C. and its many bone and ivory counterparts. In fact, however, these female images account for only about one third of all the sculptures that have been found. Others depict male figures, sexless figures, and animals. One common interpretation links the sexually explicit images to fertility cults. Perhaps, through sympathetic magic, they ensured human fecundity and an abundance of food. Whatever their purpose, and surely there was more than one, these small clay figures had importance. To their makers and their possessors they mattered.

Despite this widespread knowledge of the technology of ceramics, no one seems to have applied it to the making of pots until the very end of the Mesolithic period or the beginning of the Neolithic age about 12,000 years ago. In other words, some 20,000 years elapsed before the methods used for sculpture were turned to the practical end of making vessels. Gourds, baskets, wood, and skin may well have seemed easier to manage than heavy, breakable ceramics. On the other hand, the availability of watertight, fire-resistant pots brought enormous advantages in the storage and preparation of food.

1. Vessel in human shape with painted linear designs. H. 3⅞".
Turkey, Hacilar, mid–6th millennium B.C. (1971.929)
Ashmolean Museum, Oxford, England.

Modern archaeologists have discovered ceramic vessels at sites all over the world. Current research suggests dates as early as the tenth millennium, or 10,000–9,000 B.C., but works that precede these may yet be unearthed. All evidence points to a variety of ways in which the technology of working clay was turned to the making of vessels and containers. Pots could be shaped by pinching the wet clay with fingers, by placing coils of clay on top of one another and then smoothing the sides, by building with slabs, or by using preformed molds either inside or outside. The archaeological record makes it clear that there was no single place of invention nor was the change linked to a single societal development, such as the transition from foraging to a sedentary agricultural life. Each culture presents a special case.

The oldest pottery known is from the Jōmon period in Japan. Through dating the disappearance of the carbon in the organic material, small cooking pots have been placed in the tenth millennium. Amazingly, a tradition visually identifiable as Jōmon lasted for 10,000 years, moving slowly across the island of Japan. In the Ancient Near East, usually regarded as the cradle of civilization, the oldest clay vessels that can be dated with any certainty come from the Iranian village of Ganjdareh. Carbon dating places them at the end of the eighth millennium. Beldibi near Antalyia in Anatolia is another location where early pottery was found, dating to the seventh millennium. The Egyptians do not seem to have used pottery during this time, but there is no doubt of its existence at many African sites across a 3,000-mile band along the southern Sahara by the eighth millennium and possibly earlier. Analysis of the clay shows that most of this pottery was made locally, and almost all of it seems to have been decorated.

Ceramics had greater aesthetic significance during the Neolithic period than painting or sculpture, which had

13

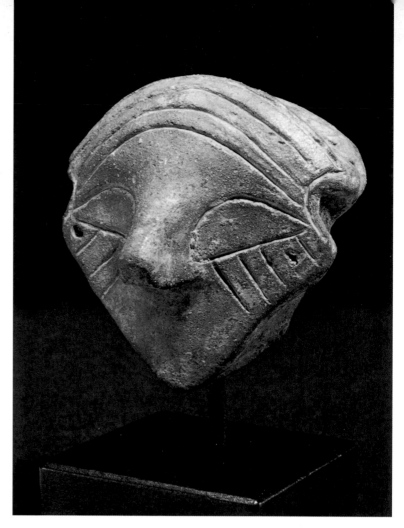

2. Head with incised features. H. 2½". Balkan area, Vinca culture, c. 5th millennium B.C. Courtesy Royal-Athena Galleries, New York.

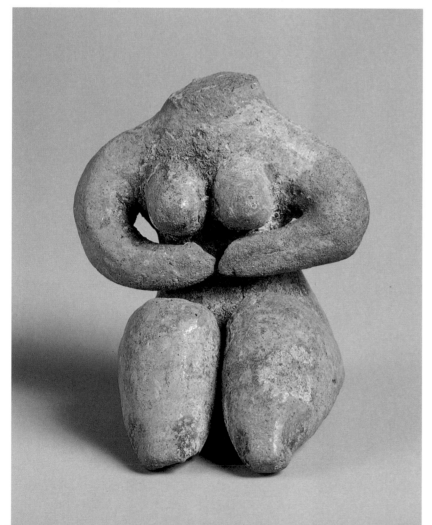

3. Seated figure of a woman, unglazed ceramic. H. 2". Iranian or Mesopotamian, Neolithic period, 6th–5th millennium B.C. (1985.84) The Metropolitan Museum of Art, New York; Purchase, Mr. and Mrs. Leon Levy Gift, 1985. Photograph © 1997 The Metropolitan Museum of Art.

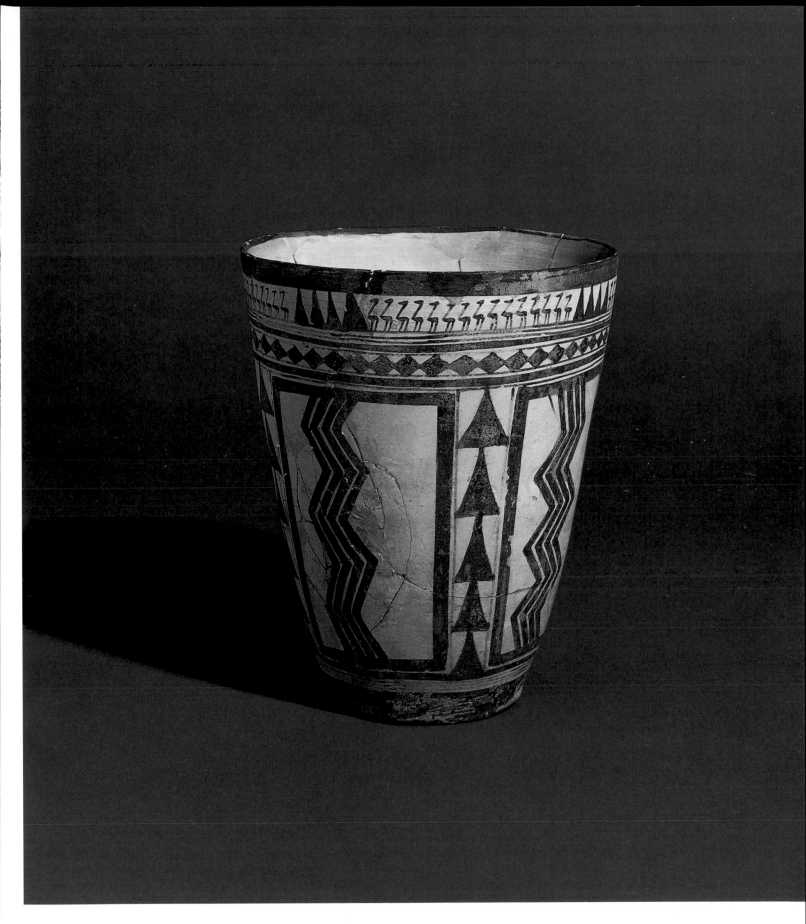

4. Beaker with painted birds and geometric designs. H. 8⅛". Susa, Elam, 4th millennium B.C. (1924-9-2,2) © The British Museum, London, England.

been the major arts of the Paleolithic age. Interestingly, a number of factors suggest that the pots were made largely by women. Some reasons are archaeological; others linguistic and mythological; still others based on the study of contemporary societies. Much of the pottery was found at domestic sites and it is utilitarian in design. According to the Neolithic division of labor, these facts put pottery in the female sphere. Furthermore, the availability of clay utensils for food had the most immediate impact on the lives of women, who benefited dramatically from all kinds of new possibilities. Not only did gathering, storing, and preparing food and water become easier, but weaning babies could be hastened by being able to cook plants into a kind of mash.

By the sixth millennium, ceramics had become a major art form. Dramatic evidence of this change comes from Anatolia, an area that seemed a backwater of civilization until excavations at Çatalhöyük yielded spectacular finds. The largest Neolithic farming village yet unearthed, it had a rich material culture spread over more than thirty acres. The oldest pieces of pottery, from about 6500 B.C., are plain red, black, brown, and gray. The earliest examples are burnished, while later ones are polished. By 5500 B.C., these simple works had become painted pots. Especially memorable are the vessels shaped like heavy-breasted females, that sometimes have inlaid obsidian eyes. They often hold a child, and one woman is even shown in the act of giving birth.

The most important Anatolian site for painted Neolithic ceramics is Hacilar in southern Turkey, but pieces have been found in many other places as well. Whether jars, cups, or bowls, the shapes are interesting and painted geometric decorations enhance the effect. Lines accent forms and repeated abstract motifs emphasize areas that may have had symbolic importance. The more complicated pieces are apparently later in date. Earlier ones are relatively simple in form and decoration. A small vessel in the shape of a human being still retains a sense of the hands working the clay, pinching and shaping it into a pot. Although rudimentary in its description of a person, the vessel shows a face with a definite character. The pointed chin, the small straight mouth, and the great arching eyebrows are features we could recognize in a crowd (fig. 1).

This remarkable culture disappeared around 5000 B.C. and its sites were abandoned, but its heritage lived on in prehistoric Greece. From Greece it spread to Macedonia and then northward to Bulgaria and Serbia. The pottery in all of these early cultures consisted of burnished or cream slip-covered vessels, simply shaped and painted with geometric designs. Beautiful examples from the middle of the third millennium come from Dimini in Thessaly. Decorations consist of spirals, very like those found on ceramics of the Balkans and Tripolje in Ukraine, as well as prehistoric China. In addition, female figures like those

from Anatolia have been excavated in this region. Other figural types include a hauntingly enigmatic head with large eyes and a prominent nose from the Vinca culture in the Balkan area (fig. 2).

The finest pottery of the fifth millennium comes from Mesopotamia and Iran. These same places made the most important contribution to the development of ceramics during the Neolithic period and then again when Baghdad and Persia became centers of Islamic pottery production thousands of years later. Whether this apparent continuity is a meaningful one is not clear, but sometimes certain peoples have shown a remarkable gift for a particular artistic medium. Most dramatic is the example of the Far East, where from the beginning of history to modern times, China and Japan have produced superb ceramics. Not surprisingly, these cultures also have valued the art of the potter very highly. In the Near East, on the other hand, the importance of clay declined sharply after the introduction of metals.

Unlike the geometric designs of Anatolian and Balkan pottery, the decorations on Mesopotamian and Iranian wares exhibit a wide range of motifs, including animals and human beings as well as flowers, leaves, stars, and other ornamental patterns. Outstanding among the Mesopotamian works are those excavated at Tell Halaf and Arpachiyah in the north. Both sites produced well-designed polychrome pots in high-quality kilns that kept the pots separate from the fire. This meant that smoke no longer blackened the painted decorations. In addition to jars, bowls, cups, and plates, numerous clay figures of voluptuous females have been found. These images, surely related to those from Anatolia and the Balkans, seem to represent the same kind of Great Mother goddess type. Their sensuality, the sheer physicality of the female forms as modeled in clay, makes them seem fresh and immediate (fig. 3).

Although the Iranian ceramic tradition is very old, it did not achieve its most aesthetically rewarding forms until the fourth millennium. Best known among the many sites that have yielded fine Neolithic work is Sialk, located south of Teheran. These wares display the strong, regular shapes that result from using a potter's wheel, a device probably introduced into the Near East during the fourth millennium. The earliest examples place black decorations against a red ground, creating a beautifully subdued color combination.

The finest of these ceramics come from Susa in Elam, southeast of the Mesopotamian plain. Archaeologists have discovered nearly 8,000 pieces there, fine wares with lovely painted designs and eggshell thin walls reserved for special occasions as well as coarser pots for ordinary use. Severe, elegant cylindrical cups and bowls dating from the early fourth millennium display a sophistication unique among early ceramics. Decorations include waterbirds and

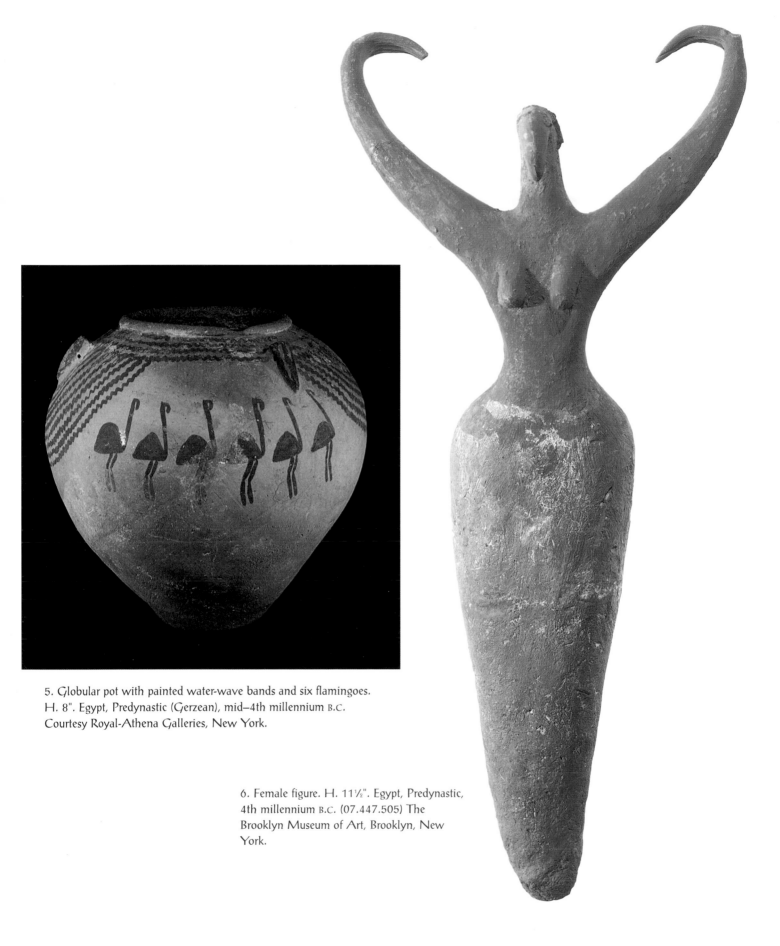

5. Globular pot with painted water-wave bands and six flamingoes. H. 8". Egypt, Predynastic (Gerzean), mid–4th millennium B.C. Courtesy Royal-Athena Galleries, New York.

6. Female figure. H. 11½". Egypt, Predynastic, 4th millennium B.C. (07.447.505) The Brooklyn Museum of Art, Brooklyn, New York.

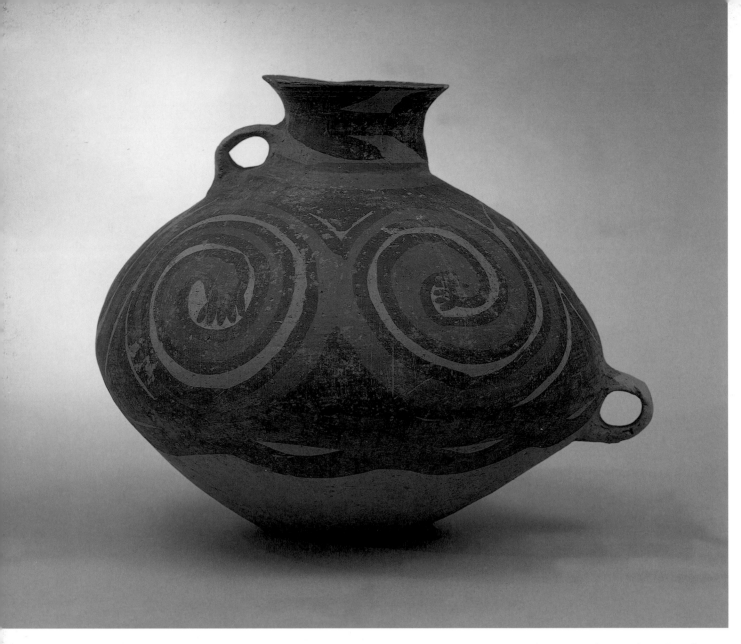

7. Globular jar with painted spirals and hands. H. 8⅜". China, Gansu Yang-shao, 3rd millennium B.C. Courtesy Weisbrod Chinese Art Ltd., New York.

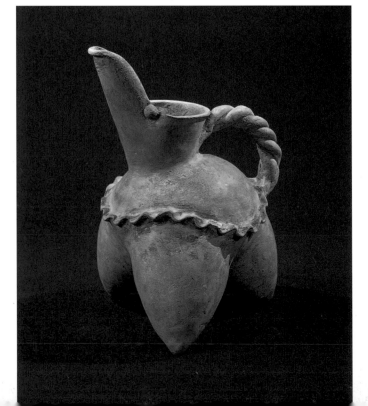

8. Tripod pitcher with legs in the shape of breasts, a twisted handle, and beak-like spout. H. 9⅛". China, Lung-shan, 3rd millennium B.C. Courtesy Weisbrod Chinese Art Ltd., New York.

9. Storage vessel, earthenware. H. 24". Japan, Middle Jōmon period, c. 2000 B.C. (1984.68) © The Cleveland Museum of Art, Cleveland, Ohio, 1996, John L. Severance Fund.

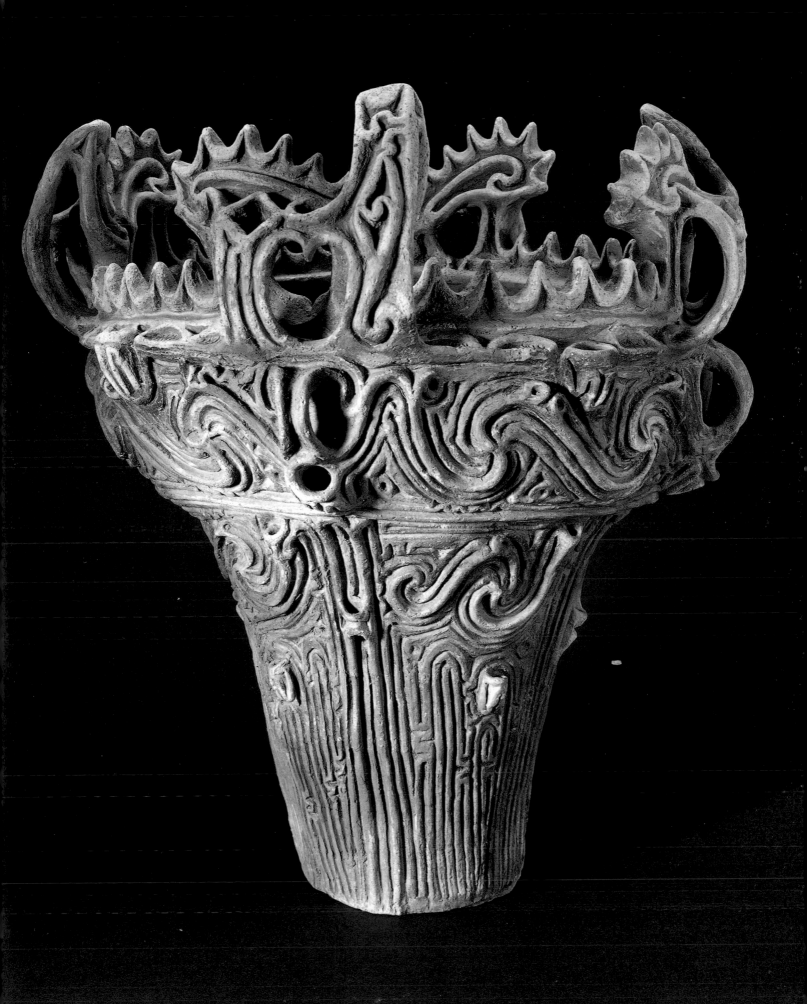

ibexes as well as floral and geometric designs that may symbolize fertility. Whatever the meaning of the motifs, they are always brilliantly arranged within painted panels and bands that mark off the smooth surfaces of the cream-colored vessels (fig. 4).

Egypt, the third great civilization of the Near East, did not produce ceramics that can be compared to those of Iran and Mesopotamia or to its own superb achievements in architecture, sculpture, and painting. Prior to the historic period, however, pottery did play an important role. Beginning in about 5000 B.C., thin-walled, plainly shaped pots were made of carefully prepared red Nile clay. A common shape from later centuries is a tall, narrow jar with a highly polished red body, pointed bottom, and blackened rim. Other ceramics are decorated with linear designs or pictorial compositions showing boats, men, birds, and animals in vivid descriptions of the Neolithic Egyptian world. The subjects are often charming, such as six flamingoes lined up between wavy bands indicating water (fig. 5).

From an artistic point of view, the most remarkable Egyptian productions of this time are clay figures of women. They already show signs of the sculptural genius that later appeared in the Dynastic periods. While not as sensuous as the figures from Anatolia and Mesopotamia, these women display a highly developed sense of plastic form. A particularly fine example depicts a woman with arms lifted as if in the graceful movements of a dance. The anonymity of the beak-like face and the breasted upper torso contrast pleasingly with the extraordinary elegance of her body's outline (fig. 6). The purpose of these sculptures is not known.

Nothing that has been found in Asia can compare with the earliest works known from the Near East. An important early Chinese site that contains pottery is Banp'o in Shansi province, where an entire Neolithic village has been excavated. The forms of the wares are not exceptional, but the painted decorations show what seem to be human faces as well as a variety of animals and designs. Contemporary Japanese pots are tall, hand-built jars and bowls of the early Jōmon age.

The greatest period for both Chinese and Japanese Neolithic pottery was the third millennium, when the Far East eclipsed the Near East in ceramics production. In China, these wares are known as Yang-shao pottery, after the village in Honan province in which they were discovered. We now know, however, that works in this style were made all over northern China, and that the most aesthetically pleasing examples come from Kansu province. Common wares are bulbous jars made of a fine clay and built by the coil method, perhaps with the help of a very primitive potter's wheel. Fired at a fairly low temperature in an oxidizing fire, these earthenware pots were burnished and decorations were usually applied before firing.

Apparently created as utilitarian vessels for the storage of food and drink, the pots also must have been used in funerary ceremonies, since most were found at burial sites. The most common decorations consist of spirals, but human figures, animals, and floral designs also appear, usually restricted to the upper half of the pot. To some scholars, these motifs have suggested a symbolic content. Certainly they give the pots a kind of visual vitality and, in the case of the hands, an almost uncanny reminder of the tactility of the clay. The hands, like the handles and the asymmetries of the design, invite our touch (fig. 7).

Ever since the discovery of Yang-shao vessels in 1922, there has been a lively debate about the relationship of this pottery to the Neolithic ceramics of western Asia. Europeans and Americans have tended to relate the painted ceramics of Neolithic China to comparable work from central Asia, Ukraine, notably Anau and Tripolje, and the Near East. Chinese archaeologists, on the other hand, have maintained that they represent an indigenous development and the similarities merely reflect similar social and economic circumstances. Whatever the relationship, and the history of ceramics is filled with tangled lines of influence, there is no doubt that the invention of pottery occurred independently in China. It also is interesting that the voluptuous female figures so prominent in the Balkans and the Near East do not appear here.

Another major ceramics tradition that appears over large areas of prehistoric China is known as Lung-shan after the site in Shantung province of eastern China where the first remains were discovered. Most remarkable are the lustrous black wares, which come from the latter part of the Neolithic period, chiefly the third millennium. Called "Classical" Lung-shan, they were thinly potted on a fast-turning wheel, a device that appeared in China around the year 3000 B.C. The shapes are elegant, with stem cups, beakers, and tripods being the most striking. Unlike the Yang-shao pots they were never painted, but depend upon shape and surface for aesthetic effect. Although black wares seem to have been the most prized type, perhaps reserved for special occasions, red, gray, and white Lung-shan ceramics also have been found. One example demonstrates the most surprising of the typical shapes, a pitcher resting on three breasts with a beak-like spout raised high (fig. 8).

The prehistoric pottery of Japan is very different from that of China. It was first discovered by Edward S. Morse, who was excavating shell mounds at Omori, near Tokyo, in 1879. Since that time, thousands of sites have been found and a huge literature has grown up, largely in Japanese, about Neolithic ceramics. The name given to this style is Jōmon, or rope-impressed ware, a name that refers to the pattern pressed into the hand-built clay forms with ropes, matting, wooden sticks, or shells. Unlike so much other

prehistoric work, these pots do not appear in burial sites. This suggests that they were used for food storage and preparation as well as, perhaps, ceremonial occasions.

The greatest time for Jōmon pottery was the third millennium, the so-called middle Jōmon period. Potters, believed to have been women, produced some of the most expressive ceramics ever made. Using highly imaginative, even bizarre shapes, sometimes filled with sexual suggestion, the most striking examples display relief decoration and rims sculpted to resemble all kinds of birds and animals in abstract form. The visual effect is extraordinary. The heavily scored lines on the tapered body of the pots seem to grow upward and outward until they are transformed into a tangle of improbable shapes in ceaseless motion (fig. 9).

These middle Jōmon wares may have had some magical meaning connected to fertility. Spirals are prominent among the decorative designs, along with snakes, frogs, slugs, lizards, rodents, and birds with huge eyes, beaks, and feather crests. Once regarded as purely archaeological finds illustrating the early cultures of Japan, they are seen today, especially by modern potters, as the most original clay creations of the Neolithic period.

It is also in this period that ceramics first appeared in Ancient America. The oldest pots known come from the Amazon river basin in Brazil and date from the sixth millennium. Incised geometric designs on the rims and shoulders of bowls are the most common decorations, and the pottery has been found in all contexts. Soot on the surface of some sherds indicates that some of the pots were used for cooking. Two sites in Colombia contain richly ornamented fragments dating from the mid-fifth and the mid-fourth millennia. Later work has been found in Ecuador, Peru, and the southeastern United States. These dates cannot be regarded as conclusive, but they do invalidate previous theories about pottery being brought from Jōmon Japan or Africa to the west and east coasts of South America respectively, or about its spreading northward to Meso- and North America from the Andes. Instead, each development seems clearly separate, with indigenous technology, function, and decorations.

Pottery was well-established in sub-Saharan Africa by the mid-eighth millennium, although its extent and its nature are not known. Pottery sherds survive for thousands of years without difficulty, but the archaeology of the continent is just beginning. It does seem clear that the ceramics have appeared in a variety of archaeological contexts and that the pots served different social and economic purposes in different places. Extensive decoration was common, mostly made with incisions and impressions of cord, among other objects. The pots tend to be well-formed and technically accomplished in their firing. This has led many scholars to theorize that even earlier examples have not yet been found.

Chapter *2*

Ceramics of the First Historical Civilizations, 2500–1000 B.C.

With the coming of the Bronze Age and the development of the great civilizations in the Nile, Tigris, and Euphrates valleys during the third millennium, pottery lost its position of artistic dominance in the Near East. In the urban centers that arose in Egypt and Mesopotamia, architecture, sculpture, and painting became the major arts, while works made of clay settled into a relatively minor place, practiced by skilled craftsmen, usually male. Yet the most important technical innovation in Ancient Near Eastern ceramics during this period, the discovery of glazes or glasslike coatings that fuse to the clay during firing, would influence all later pottery.

From an artistic point of view, the finest works were made by the Hurrians, who ruled northern Mesopotamia and Syria for much of the second millennium. Elegant shapes, including handsome tall cups and jars, and decorations consisting of geometric designs, stripes, vegetables, and animals characterize these pots. Usually referred to as Nuzi ware, they have been found at various archaeological sites. There are also Hurrian clay figures of women with stylized bird faces atop severely simplified bodies. The emphasis on sexual characteristics suggests that they may represent a fertility goddess of the time (fig. 10).

In Egypt, too, ceramics were relegated to the status of a craft. The most celebrated works of clay from this period are not pots but small sculptures. Several representations of the hippopotamus date from the first half of the second millennium. One charming example portrays the beast with what seems to be lighthearted humor, its body decorated with delicate plant, bird, and butterfly designs. It is made of Egyptian faience, a mix of clay and sand to which a fluxing agent has been added. Most distinctive is the deep glossy turquoise color that comes from dusting the surface with copper oxide (fig. 11).

Only in Iran did ceramics hold their place of impor-

tance. At Hissar and other sites bordering the Caspian Sea, a large number of beautiful pots from the third and second millennia have been excavated. Made with a potter's wheel and fired in well-constructed kilns, they are technically superior to the work of the Prehistoric period. Lovely in shape, they usually are not decorated. From a purely aesthetic point of view, however, they are not nearly as fine as the pots made in Susa during the fourth millennium.

Other contemporary wares feature dark brown designs on a white ground, a combination that probably reflects the influence of earlier pots from Susa. Outstanding among these are numerous bulbous jars decorated with bird, solar, and geometric patterns that recall similar designs still used in kilim rugs. The most distinctive examples come from Sialk and date from about 1000 B.C. They are round vessels with short flared necks and spouts in the shape of long beaks. The painted decoration consists of animals, birds, and sometimes human figures rendered with vigorous brush strokes and an abstract style that suits the ceramic forms. These vessels probably were used for sacred libations (fig. 12).

It is during this period that the civilizations of the Aegean became major cultural forces. The most illustrious was Minoan Crete. This Bronze Age culture produced magnificent palaces, wall paintings, and sculptures, while giving ceramics an important place. The centers of production were Knossos and Phaistos, where pottery was made during the Middle Minoan period, or 2100–1700 B.C. Many different shapes were used, and freely painted designs seem to be based on natural observation or geometry. In marked contrast to Greek pots, these do not record human activities or contemporary events. By the middle of the second millennium, however, the once magnificent Minoan civilization had lost its commanding position to the mainland.

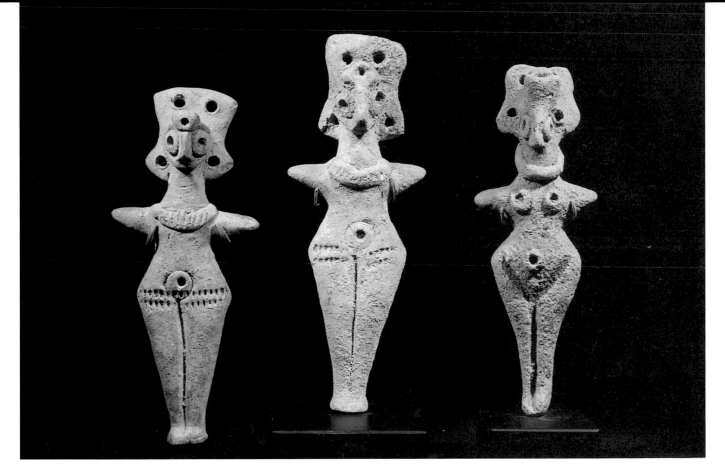

10. Female figures with bird-like faces. H. 4⅝", 5", 4¾". North Syria, Hurrian, mid–2nd millennium B.C. Courtesy Royal-Athena Galleries, New York.

11. Faience hippopotamus. H. 1¾". Egypt, Middle Kingdom, c. 1878–1627 B.C. The Brooklyn Museum of Art, Brooklyn, New York; Charles Edwin Wilbour Fund.

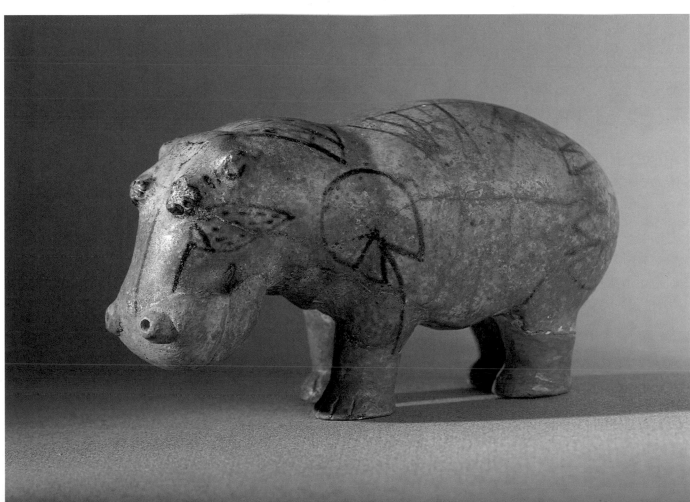

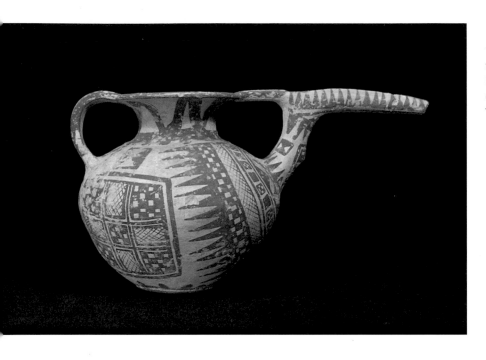

12. Round pitcher with painted geometric designs and beak-like spout. H. 6⅝". Iran, Sialk, c. 1000–800 B.C. Courtesy Royal-Athena Galleries, New York.

13. Three-handled pot decorated with marine motifs. H. 4½". Crete, Minoan, c. 1450–1400 B.C. (A 651) © The British Museum, London, England.

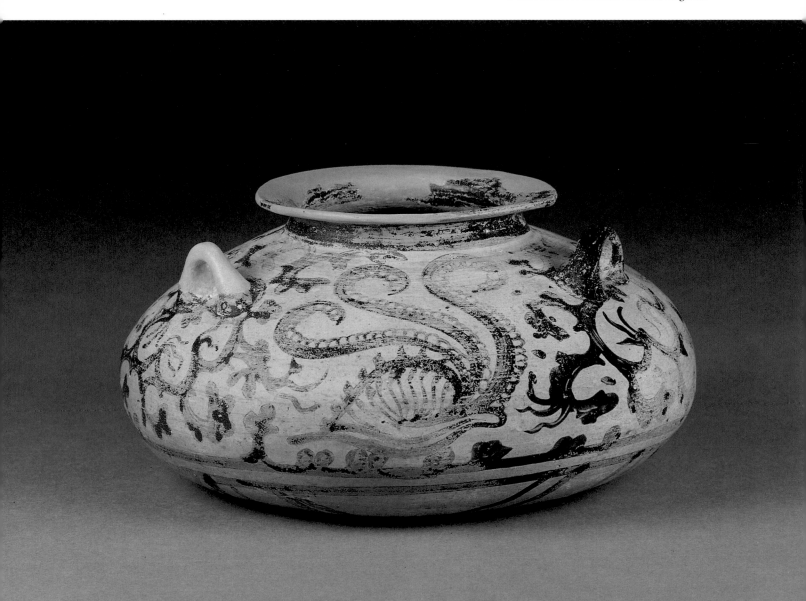

Particularly fine are Minoan Kamares wares, named after the Kamares caves where the most splendid of these jars were found. An elegant and delicate pottery with boldly painted designs, it is also outstanding from a technical point of view. Other types of vessels show marine subjects, fish, algae, sea plants, nets, flowers, leaves, spirals, stars, and suns painted in white, dark red, and yellow on a black background. In later Minoan pottery, octopi, starfish, shells, and other creatures from the sea appear. All of them show the same sophistication of line as contemporary Minoan wall paintings, while the designs are gracefully accommodated to the shapes of the vases (fig. 13).

The Minoans also made small female figures of faience. The women hold snakes, considered to be sacred creatures, and so the sculptures are known as snake goddesses. They wear floor-length skirts, have boldly protruding bare breasts and elaborate headdresses, sometimes with a bird perched on top. Although the significance of these figures is not known, they surely were sacred in character.

Minoan ceramics have been found all over the Mediterranean world, indicating that these masterpieces of the potter's art were valued far beyond Crete itself. Egyptian pharaohs as well as the rulers of Byblos and Ugarit in the Levant acquired pieces. Kamares wares have appeared in Cyprus, at Achaean Greek sites, and as far afield as Qatna in the Syrian Orentes valley. Not until Greek pottery of the Classical age and Chinese porcelains of the Sung and Ming periods did any ceramics enjoy an equivalent popularity, reaching so far beyond the boundaries of the country of origin.

The island of Cyprus was also an important place in the Aegean world, especially active in trading, and its art reflects the many cultures with which it had contact. One terra-cotta figure, as abstract as the nearly contemporary Cycladic marble women so prized by modern sculptors like Constantin Brancusi, is hardly a representation of a person at all. Called Red Polished Pottery because of the high burnish given the red clay, the image could not be more unlike the voluptuous females so commonly found in the region, including on Cyprus itself. Like most plank figures of this type, it is sexless, and what seem to be details of ornament are more important than physical features in the description (fig. 14).

Very different are the Mycenean ceramics of prehistoric Greece, products of a culture that considered clay inferior to metal. The so-called Warrior Vase (National Museum, Athens), believed to date from about 1200 B.C., is decorated with soldiers of the type Homer describes, armed with spears and shields. Other works show the influence of Crete in their motifs from the sea, as in a high-shouldered pot decorated with an octopus, fish, and other marine life (fig. 15). More common are vessels painted with purely geometric ornaments. The Myceneans also made small clay figures of women, sometimes enthroned, whose bodies are often painted with undulating lines. Possibly symbolizing water, the decoration suggests that the women represent water/fertility goddesses. They have been found wherever the Myceneans settled (fig. 16).

Compared to the ceramics of the Aegean world, those from northern Europe seem backward. The earliest pots have been found in the Danube region, an area that includes Romania, Bulgaria, Hungary, the former Czechoslovakia, and Austria. These vessels are known as Linear Pottery, because their most prominent decorations are spirals or incised ribbons, not unlike those seen on the Neolithic pottery of China, southern Russia, and Thessaly. The earliest examples date from the fifth millennium, but most come from the period between 4000 and 2000 B.C. Those found in southern Romania and Bulgaria show simple S-shaped spiral designs painted in red and maroon on a dark, metallic-graphite ground.

Another major ceramics type is the so-called Beaker style that flourished in a number of variations from the southeast to the British Isles and Scandinavia during the third millennium. The name Beaker people was given to the potters who made these wares because their most characteristic creations are bell-shaped beakers, decorated with incised or molded geometric designs arranged in horizontal bands. The most famous examples are today in Danish museums.

In addition to all kinds of dishes, the potters of Europe made ceramic figures, usually of women. Many of them are not unlike the Paleolithic mother goddesses made thousands of years before. The women stand, occasionally recline, or sit on a throne-like chair. Usually they are alone, but sometimes a child is with them, suggesting that the idea of fertility is important. Some are highly abstracted, perhaps covered in costume with only a head showing, while others are openly voluptuous. One example, of which only the upper body remains, describes face, breasts, and hands with graceful lines incised on a bell-shaped field. Almost certainly, the missing half would have been a similarly decorated skirt (fig. 17). Less numerous are representations of birds and animals.

The most interesting south Asian culture of this period is the Indus Valley civilization named after major urban sites found there. We now know, however, that this civilization spread throughout northern India. Its pottery is the most powerful and interesting to come out of a country not otherwise outstanding for its ceramics. During this time, pre-Aryan, possibly Dravidian people, inhabited the region. Vessels of considerable aesthetic merit include large storage jars decorated with black floral, leaf, bird, and animal designs on a red ground. The shapes and ornaments resemble those of earlier pottery from the Near East, especially Mesopotamia and Iran, suggesting possi-

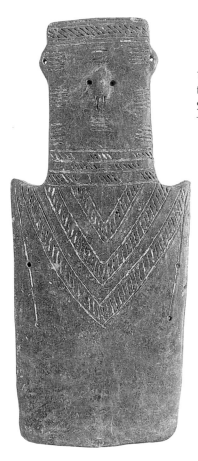

14. Plank figure with incised decoration. H. 9¾". Cyprus, Red Polished Style, 2100–1900 B.C. (CA 62056) The Menil Collection, Houston, Texas.

15. Stirrup jar decorated with an octopus and other marine designs, terracotta. H. 10¼". Greece, Late Helladic (Mycenaean), c. 1200–1100 B.C. (53.11.6) The Metropolitan Museum of Art, New York; Purchase, Louise Eldridge McBurney Gift, 1953. Photograph by Schecter Lee © 1986 The Metropolitan Museum of Art.

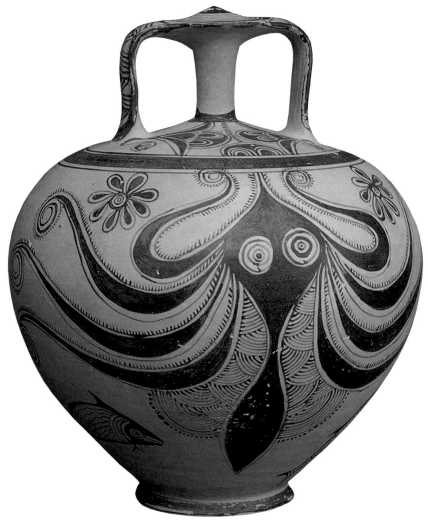

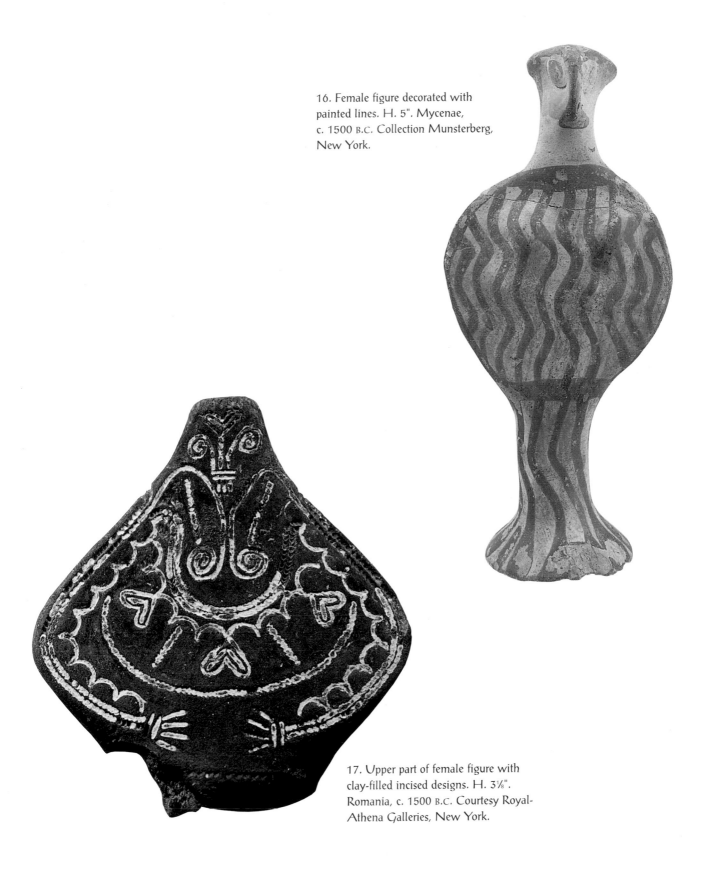

16. Female figure decorated with
painted lines. H. 5". Mycenae,
c. 1500 B.C. Collection Munsterberg,
New York.

17. Upper part of female figure with
clay-filled incised designs. H. 3⅛".
Romania, c. 1500 B.C. Courtesy Royal-
Athena Galleries, New York.

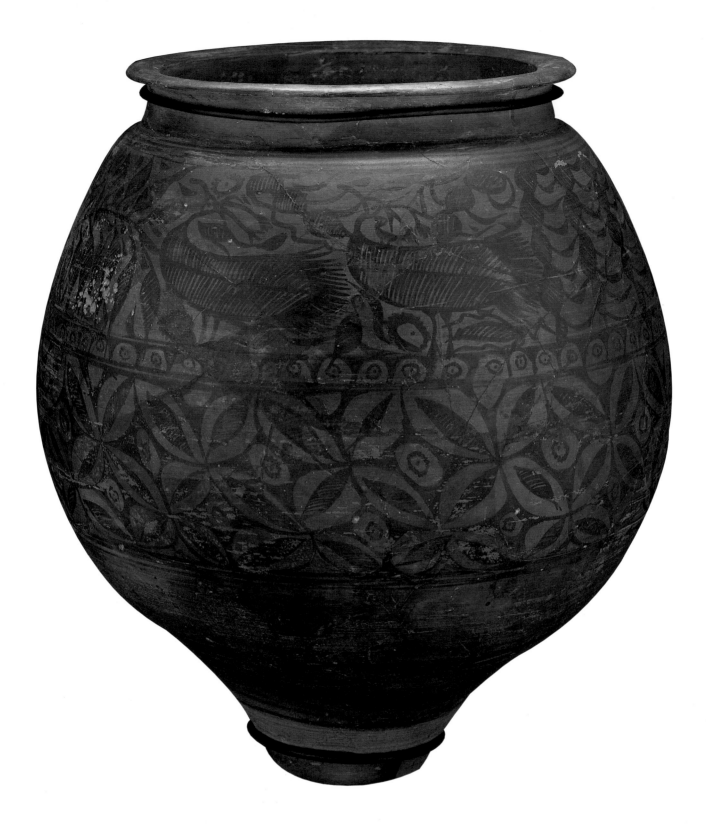

18. Storage jar painted with peacocks and leaves. H. 9¾". Pakistan, Chanhu-daro, Indus Valley Region, c. 2400–2000 B.C. (36.2977) Joint Expedition of the Museum of Fine Arts and the American School of Indic and Iranian Studies. Museum of Fine Arts, Boston, Massachusetts.

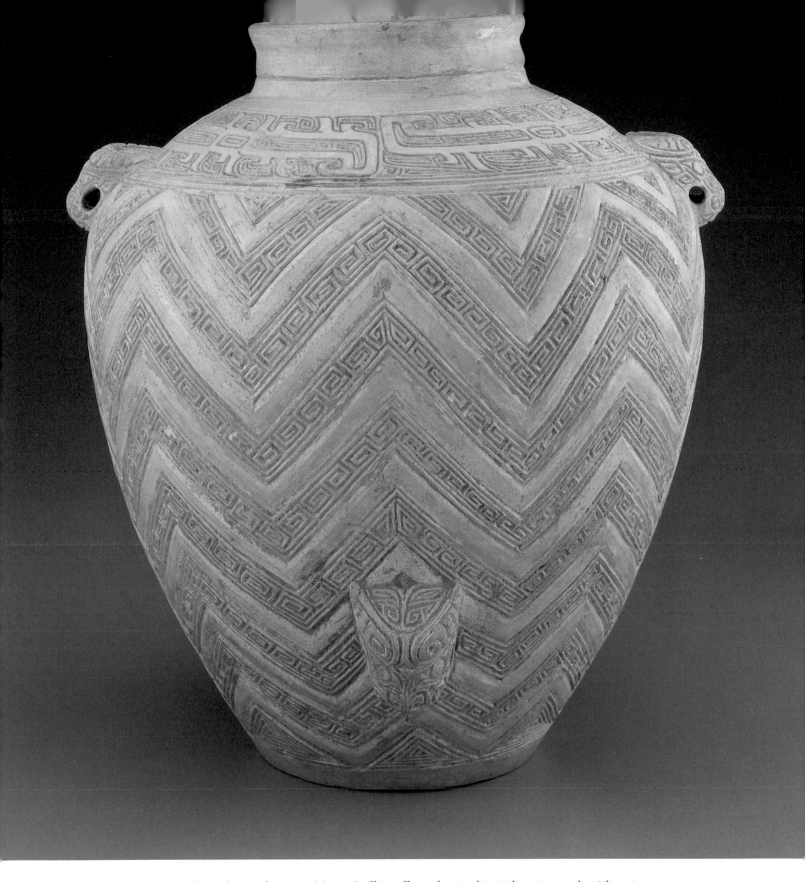

19. Lei-shaped jar, white earthenware. H. 13¹⁄₁₆". China, Shang dynasty, late 13th century–early 12th century B.C. (39.42) Freer Gallery of Art, Smithsonian Institution, Washington, D.C.

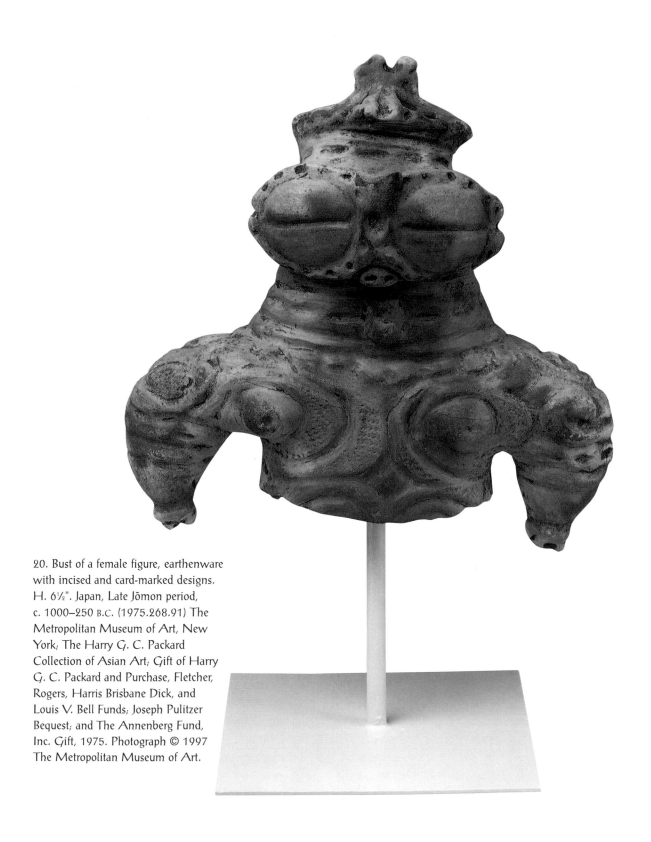

20. Bust of a female figure, earthenware with incised and card-marked designs. H. 6½". Japan, Late Jōmon period, c. 1000–250 B.C. (1975.268.91) The Metropolitan Museum of Art, New York; The Harry G. C. Packard Collection of Asian Art; Gift of Harry G. C. Packard and Purchase, Fletcher, Rogers, Harris Brisbane Dick, and Louis V. Bell Funds; Joseph Pulitzer Bequest; and The Annenberg Fund, Inc. Gift, 1975. Photograph © 1997 The Metropolitan Museum of Art.

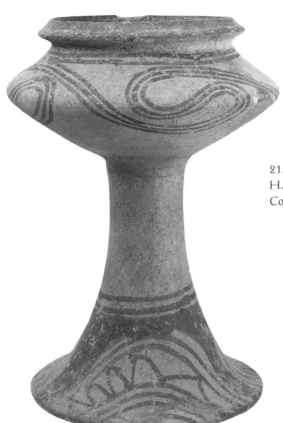

21. Stem cup with painted spiral designs.
H. 8¾". Thailand, Ban Chiang, c. 3000 B.C.
Collection Munsterberg, New York.

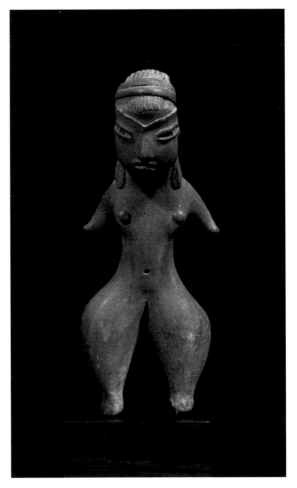

22. Female figure with head ornaments
and earrings. H. 4½". Mexico, Tlatilco,
c. 1200–500 B.C. Courtesy Royal-
Athena Galleries, New York.

ble influence from those sources (fig. 18). There are also the remains of many roughly made pots that seem to have been thrown away after casual use.

Far more important in terms of the history of ceramics are the works produced in China during this age. From an aesthetic point of view, the Neolithic ceramics are finer than those made during the early historical period, but great technical advances had occurred. Most important was the invention of nonporous stoneware, a discovery probably made during the middle of the second millennium, which was the early part of the Shang dynasty. The mixture of clay with a material that fuses when fired results in a watertight bond. Chinese potters also discovered glazes which both decorated and sealed the clay body. These new techniques produced a hard, impermeable vessel superior to anything known before this time.

Shang potters also created a refined white ware. Very rare and found in the Shang capital of An-yang, it probably was intended for use in imperial ceremonies. Although made of a clay related to the white kaolin necessary for porcelain, the ware is not yet a true porcelain. It lacks certain necessary ingredients and was not fired at a high-enough temperature. The decoration resembles that of contemporary bronzes, consisting of spirals and meanders as well as symbolic animals carved into the thick white body. The finest example of this type of ware, and one of the few well-preserved pieces, is a jar in the shape of a bronze lei (fig. 19).

Neolithic pottery continued to be made in Japan during this entire period. In contrast to the very expressive sculptural forms used by Japanese potters during the third millennium, late Jōmon forms are more subdued. Favorite shapes are tall jars with slightly flared walls and low pots with rounded bodies and projecting spouts. Cord-marked spiral designs decorate them. More interesting are clay figures of women with large eyes, resembling those of some strange insect, and powerfully modeled bodies and limbs. Marked sexual characteristics, including large thighs and breasts, yet again suggest a connection to fertility magic (fig. 20).

Another remarkable Neolithic pottery culture flourished in Thailand. Impressive archaeological finds have come to light, especially in the northeastern Thai village of Ban Chiang. Thousands of prehistoric pots have been excavated, surely made over many centuries. The oldest probably date from the fourth millennium, which would make them the earliest known ceramics in southeast Asia. They are simple gray pots with cord- or mat-impressed designs, not unlike early ceramics found in many other parts of the world.

Later Thai pots are painted with bold, decorative patterns, similar to those found on prehistoric pottery from Neolithic China and the Near East. The spiral is a favorite motif, painted in red against a beige ground on a black ceramic body. Two popular shapes are a stem cup and a bulbous jar resting on a foot with a well-modeled lip. The combination of strong shapes with vigorously painted designs makes these works among the most aesthetically pleasing of all the prehistoric pots found in Asia (fig. 21). Just what the connection is between this Thai culture and those of India and China is not known, but the similarities are striking.

The oldest pottery known in Mexico dates from the early second millennium and has been found in coastal lowlands of the Pacific shores, but the most important Mexican site of this period is Tlatilco, which is today part of Mexico City. Scholars believe that Tlatilco, settled around 1200 B.C., was the center of an important ancient civilization. Discovered by chance during the construction of buildings on the modern city's outskirts, the site has yielded a wealth of vessels and small clay sculptures of extraordinary quality. It is with these works that a distinct and original ceramics industry began in Mexico. Many of the forms that became typical of this tradition, such as stirrup-spout pots and long-necked bottles, appear here. Some works are colored with a red or white slip, but most have a highly polished clay surface, often with incised designs.

The clay figures from Tlatilco are among the loveliest found in Ancient America. They vary in size and design, some large and hollow and others small, solid figures of great charm. Especially fine are the voluptuous female figures, but male figures, children, dogs, and other animals also appear (fig. 22). Most distinctive are strange figures with two heads and three eyes, or faces split in two, one side showing a skull and the other a living being. These latter works perhaps symbolize the dualism of death and life that subsequently played such a great role in religion and was often represented in the historical civilizations of Mexico.

Next to Mexico, Peru was the most important country for art in Ancient America during this period. The culture that produced it, the Chavin civilization, flourished during the first millennium B.C. and influenced the artistic styles that succeeded it in the Andes. Perhaps its greatest contribution was the stirrup spout, which became a characteristic shape for pottery throughout Pre-Columbian America. A form that resembled a rider's stirrup, hence the name, it allowed easy carrying, easy drinking, and prevented dust from getting to the liquid inside the jar.

Chapter 3

The Great Age of Greek Ceramics, 1000–200 B.C.

Greece became the Mediterranean center of ceramics around the year 1000, while China continued to be the leading country in Asia. The Near East, which had played such a prominent role in earlier times, declined in significance when metal rather than clay became the major medium of artistic expression. In Greece, by contrast, a rich and varied ceramics culture arose. Modern art historians have tended to concentrate on the paintings that decorate the vases, but the great majority of Greek ceramics were undecorated and served purely utilitarian purposes. In fact, the forms of Greek pots are beautiful in themselves.

The major shapes used by the Greeks developed very early and, with minor variations, continued to be made for nearly a thousand years. Most were designed to hold some kind of liquid for daily use as well as for ceremonial occasions and the burial of the dead. In contrast to much Far Eastern pottery, which tends to emphasize surface texture and color on a wide variety of forms, Greek wares rely upon a few standard shapes, a crisp, clean surface, and subdued color patterns. The designs, on the other hand, are often of extraordinary ambition in detail and composition. Meant to be recognized and understood by the viewers as dramatic episodes from familiar stories, they draw upon a shared culture of myth and symbol.

The most common Greek vessel is the amphora, a storage jar with a clearly articulated foot, rounded body, lip, and two curved handles. The krater, used for mixing water and wine, is broader and heavier, with a large opening and two handles, while the hydra has three handles and was used to hold water. A shape found only in the Greek world is the kylix, a low-profile cup with a raised foot and two handles, used for drinking wine. A particularly fine form is that of the oinochoe, as well as the closely related olpe, a jug with a bulbous body and a curved handle, used for pouring liquids. The pyxis, a rounded jar, was used to hold cosmetics or trinkets. Perhaps the most elegant shape of all was the lekythos, a tall bottle intended for holding oil.

Greek potters and vase painters of the Classical period were much esteemed and associated with their patrons as social equals. The names of the most famous of them have come down to us, for they often signed their work. Thus modern scholars have been able to associate specific vases with artists and workshops. Brygos, Exekias, and Amasis, for example, were well known in antiquity, and masterpieces by these men have been preserved. Usually the potter and the painter were different people, but there are several instances where the inscription indicates that the same individual made the pot and also decorated it. Apparently, workshops employed between ten and twenty potters and painters who worked together.

Often vessels were made for special occasions. At the Panathenaic Festival, ceramic trophies were given to the victors of the games. Others were dedicated to gods or were intended for religious festivals. Inscriptions suggest that some particularly fine vases were given as presents. The white-ground lekythoi, among which are some of the most delicate painted designs, seem to have been offerings to the dead. The idea of making a vessel simply for display was not native to the Greeks.

The two great centers of decorated ceramics were Athens and Corinth. Attic clay, dug from the borders of the city, fired a rich red, while the yellowish clays in Corinth were lighter in color. Using a relatively fast wheel, carefully prepared clay, a fine slip for decoration, and sophisticated manipulation of a simple kiln, these potters perfected their wares. Apparently they never felt the need to develop their kilns, firing methods, or glazes. More ordinary vessels also were made at many places within Greece itself, the Greek islands, notably Rhodes and Cyprus, and Greek settle-

ments in Asia Minor. Greek colonies in Italy and Sicily imported and later also produced pottery. In fact, Greek pots have been found in Syria, Egypt, southern Russia, and northern Italy, testifying to their great popularity.

Scholars of Greek art have assigned the pottery to historical periods that cover about seven hundred years in all. It is generally agreed that ceramics ceased to be a major art form in Greece proper after about 300 B.C., and that by 200 B.C., production of any aesthetically significant pottery had ended. The major periods are the Proto-Geometric (about 1000–900 B.C. in Greece itself, but longer in provincial places), the Geometric (900–725 B.C.), the Proto-Corinthian (720–620 B.C.), Corinthian (620–590 B.C.), Proto-Attic (710–600 B.C.), and, beginning in the sixth century, the fully developed black-figure, red-figure, and white-ground styles for which Classical Athens became so famous.

The earliest of these wares already embody the Greek ideal of geometric harmony and order. Abstract designs decorate Proto-Geometric pots from Attica itself, as well as from Cyprus, where the style continued long after it had been replaced in Athens. Plain circles, lines, and other geometric patterns appeared in Cypriot wares as late as the eighth century, as in the bull's eye design so beautifully adjusted to the shape of a small jug (fig. 23). By this time in Athens, Geometric pottery showed horses, birds, and human figures arranged in bands. The most impressive of these are enormous vases, as tall as five feet, intended to mark graves and hold offerings for the dead. One example from the Dipylon Cemetery in Athens shows the funeral procession in all its ritual splendor arranged in registers across the body of the vase (fig. 24).

A more elegant pottery came from Corinth, which was the great rival of Athens in the production of ceramics during the seventh century and beginning of the sixth. The most characteristic decoration is called the Orientalizing

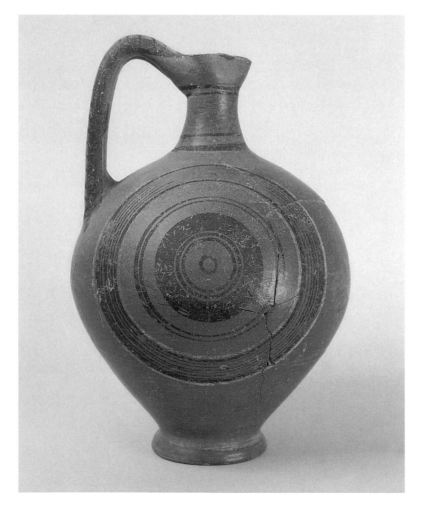

23. Oinochoe with circular designs. H. 8". Cyprus, Geometric style, 8th century B.C. Collection Munsterberg, New York.

24. Funerary krater, terracotta. H. 42⅝". Greece, Attic, Geometric style, second half of 8th century B.C. (14.130.14) The Metropolitan Museum of Art, New York; Rogers Fund, 1914. Photograph © 1996 The Metropolitan Museum of Art.

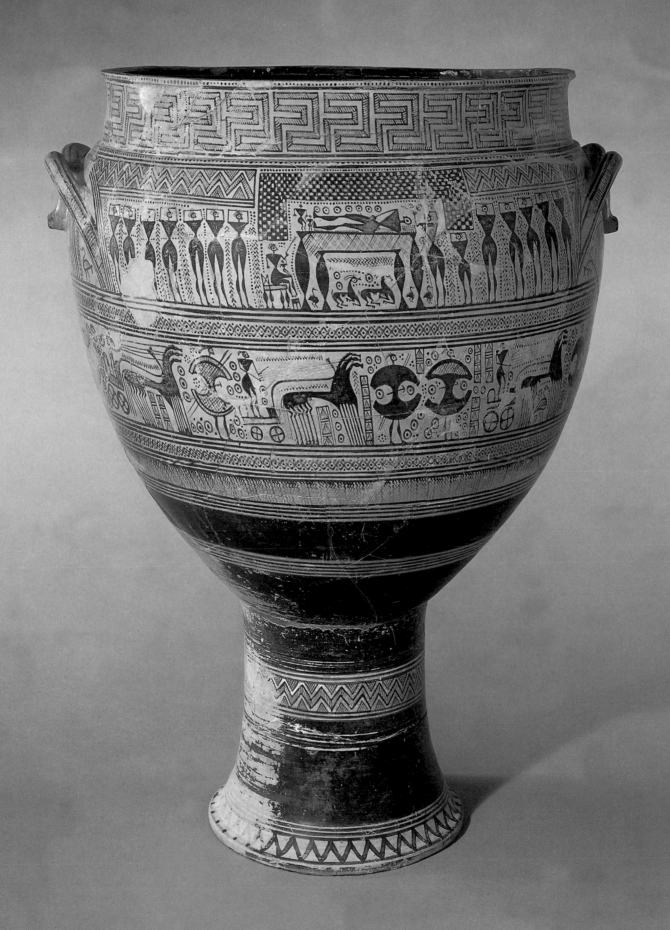

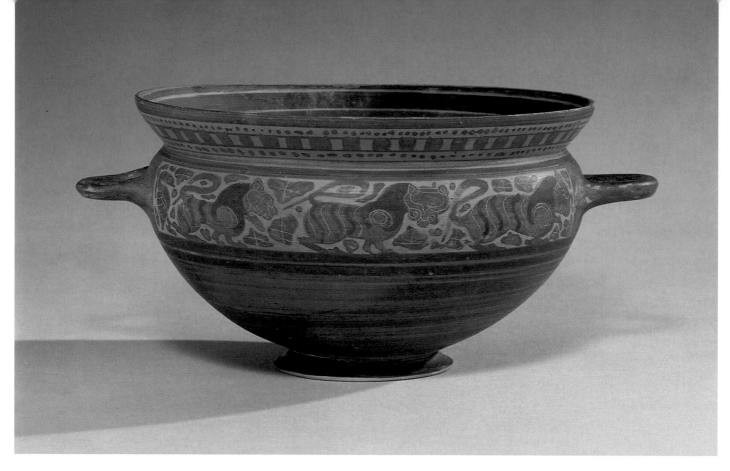

25. Pylix with Orientalizing motifs. H. 7". Italy, Etrusco-
Corinthian, 6th century B.C. Courtesy Royal-Athena Galleries,
New York.

26. Black-figure eye cup with Herakles. H. 2¾". Greece, Attic,
c. 520 B.C. Courtesy Royal-Athena Galleries, New York.

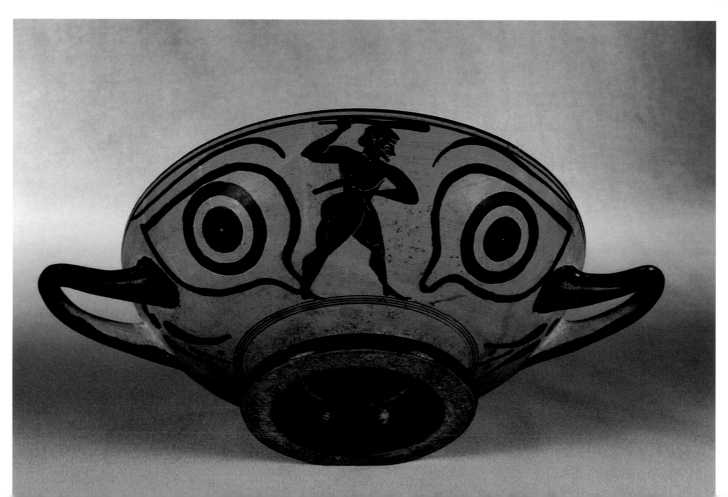

style (also found in the pottery of Rhodes, Cyprus, and southern Italy), because it uses animal, bird, and flower forms derived from Oriental (or Near Eastern) sources. Especially striking are the lions, recalling the heralded animals of the Ancient Near East, and the goats, which resemble the ibexes of Near Eastern art. Other animals include swans, geese, and roosters, as well as female-faced bird figures in the form of harpies, sphinxes, and griffins. Cups, jars, jugs, perfume bottles, and ointment jars were particularly popular shapes for these designs (fig. 25).

By the middle of the sixth century, Athens had gained complete supremacy over Corinth as the center of Greek ceramics. The Attic black-figure style flourished from around 600 B.C., displaying painted decorations that are often pictorial masterpieces. They are executed in a shiny black pigment on a red-orange surface, sometimes with touches of red, violet, or white. The subjects come from Greek mythology, literature, and history, as well as contemporary scenes from athletic games, chariot races, and social life. These works represent our main source of information about Greek painting, since the much-praised wall paintings have not survived. Typically, a few large figures replaced the many registers of the Geometric style. In one kylix, a youthful and muscular Hercules strides between the two eyes that give the type its name of eye-cup (fig. 26).

By the end of the sixth century, red-figure wares became popular. Identified by red figures against a black ground, these pots reached an aesthetic peak between 530 and 480 B.C., although they continued to be produced into the fourth century. Details now could be drawn with black pen or brush on the red surface, making more naturalistic renderings possible. One fine column krater combines decorative, nearly abstract, designs around the neck with heroic mythological figures moving across the surface of the vase (fig. 27). Less grand is a kylix with an imitation of basketweave on its exterior, a lighthearted conceit that recalls the many Classical stories about perfect pictorial illusion as well as the idea that the first pots came from clay smeared over baskets (fig. 28).

A third type of vase painting is called white-ground style, in which black- or red-figure designs appear on a matte white ground. Sometimes additional colors were added in tempera paint after firing. The most common shape is the lekythos, intended for tombs, and the best period for these wares was between 450 and 400 B.C. Rarer than either black- or red-figure vases, these white-ground oil bottles are among the masterpieces of Greek pottery. The influence of their elegant lines and graceful shapes reached all the way to the twentieth century and Picasso's Classical period paintings (fig. 29).

During the fourth century, small ceramic sculptures known as Tanagra figures became popular. Thousands were found in grave sites at Tanagra in Boetica, but they also come from other places and perhaps originated in Athens. Their purpose is not known with certainty, but since many have appeared in tombs, they may have had a funerary function. Made from molds, the figures are hollow and sometimes were modified into vessels. A favorite subject was a lovely young woman, dressed in flowing garments that heighten the grace of her pose (fig. 30).

The other European country with a rich ceramics heritage is Italy. Beginning with the Villanovan civilization, which flourished in central and northern Italy during the ninth and eighth centuries B.C., and continuing with the Etruscans, splendid pottery was made there. The Villanovans were skilled metalworkers and potters, who produced burial pots for the ashes of the dead. Sometimes the surface was burnished or decorated with incised or painted geometrical designs. The example illustrated here is an unusually fanciful shape, with white circles and zigzags adjusted to the shape and scale of the vessel (fig. 31).

The Etruscans, creators of splendid terra-cotta sarcophagi with lifesize sculptures of the dead lying on the lids, also excelled in pottery. Best known is Bucchero ware, a black, wheel-made ceramic, often shaped in imitation of metal forms. The most unusual examples of these jars have human faces as lids or embossed decoration, while the large pots are ornamented with relief designs showing animals and dancers (fig. 32). By the fifth century, however, Greek influence became overwhelming and later Etruscan ceramics show a Corinthian or Athenian style. One distinctive variation combines the supple line of caricature, much like that used in contemporary Etruscan wall painting, with red-figure painting techniques to create delightful vessels (fig. 33).

During this later period, the center of production in Italy shifted to the south and Sicily, where fine ceramics were made even after the Greek style had declined in the country of its origin. Apulian potters generally followed an Athenian red-figure model, but architectural frames, self-consciously "posed" gestures, and sheer scale give these imposing volute kraters a theatrical presence (fig. 34). Like the huge kraters from the Geometric period, these also were meant to stand in cemeteries. Another popular type was a red-bodied plate from Apulia and Campania decorated with fish and other forms of sea life. In their freedom of painting and wealth of natural observation, they resemble earlier Minoan ceramics (fig. 35).

Northern European ceramics were not comparable to those from Greece and Italy, despite contact between the two regions. One important culture that flourished in the north during the first millennium was named Hallstatt, after a burial site in Austria where thousands of objects were found. Bronze, gold, ivory, amber, and clay appear in works that include sculpture, jewelry, and armor. The pots

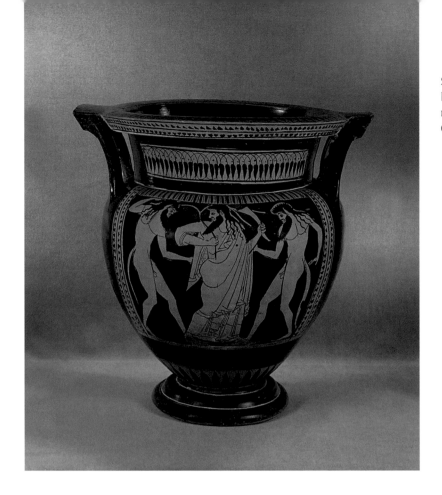

27. Red-figure column krater by the Camucia Painter, showing Dionysus between two maenads. H. 12¾". Greece, Attic, c. 470–460 B.C. Courtesy Royal-Athena Galleries, New York.

28. Red-figure kylix by the Lid Painter with basketweave design on the exterior. Diam. 8⅞". Greece, Attic, c. 450–440 B.C. Courtesy Royal-Athena Galleries, New York.

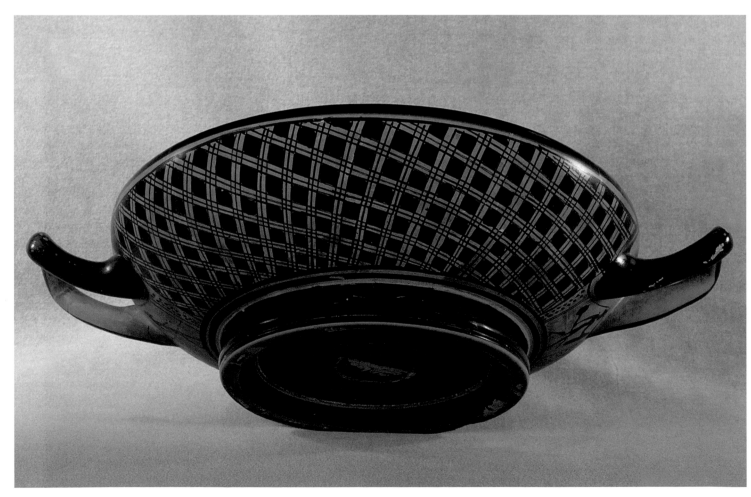

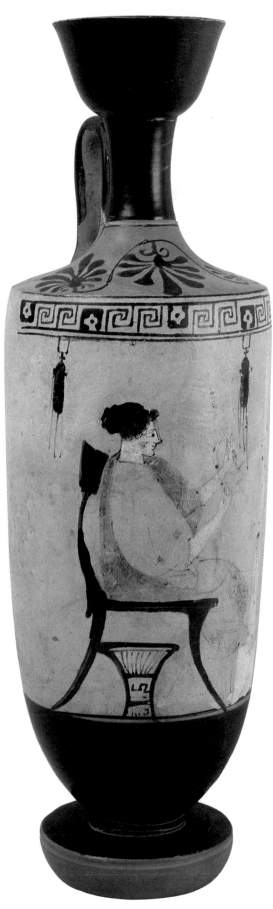

29. White-ground lekythos painted
with a seated woman. H. 11¾".
Greece, Attic, c. 440 B.C. Collection
Munsterberg, New York.

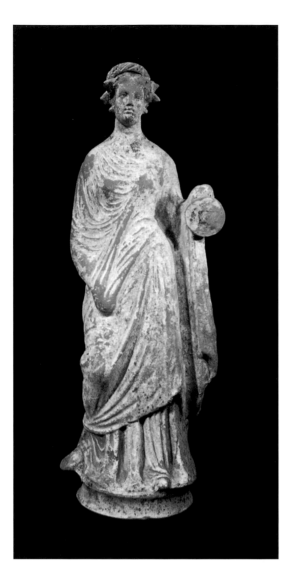

30. Tanagra-style female figure with traces of polychrome paint. H. 13¼". Italy, Hellenistic, c. 3rd century B.C. Courtesy Royal-Athena Galleries, New York.

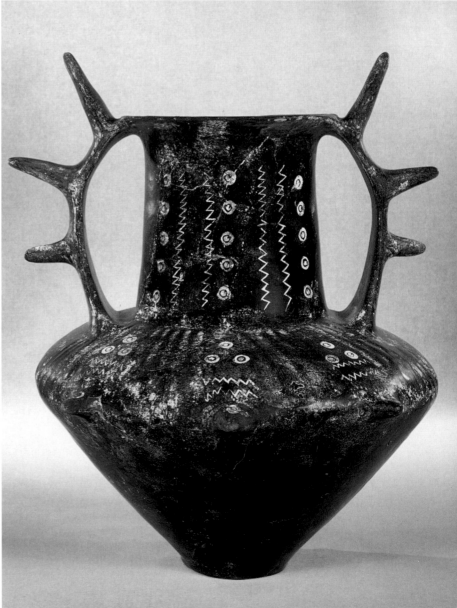

31. Black jar with "cornuta" handles. H. 15⅝". Italy, Villanovan, mid-9th century B.C. Courtesy Royal-Athena Galleries, New York.

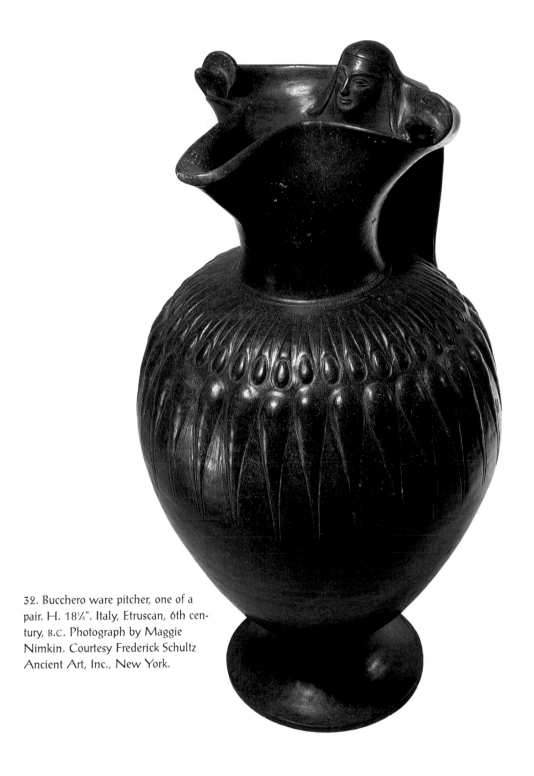

32. Bucchero ware pitcher, one of a
pair. H. 18¼". Italy, Etruscan, 6th cen-
tury, B.C. Photograph by Maggie
Nimkin. Courtesy Frederick Schultz
Ancient Art, Inc., New York.

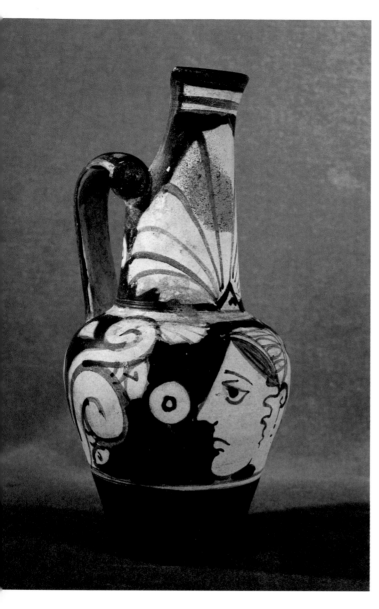

33. Red-figure oinochoe with female head painted in profile. H. 5⅝". Italy, Etruscan Caeretan, late 4th century B.C. Collection of Dr. and Mrs. Jerome M. Eisenberg, New York.

are simply shaped with incised or stamped geometric designs. Representational subjects were highly stylized.

In the Near East, the most important country for pottery during this period was Iran. Beautiful vessels shaped like animals have been found at Amlash and Marlik. Made of polished red clay, they exhibit a wonderful sense of plastic form that is much admired by modern collectors. Impressive glazed tiles and ceramic relief sculptures decorated the walls of Archemenidian palaces and temples in Susa and Persepolis. A graceful Parthian horn-shaped drinking vessel, or rhyton, reflects the influence of contemporary metalwork (fig. 36).

China produced the finest ceramics in Asia during this time. The plain gray ware of earlier centuries was still made, sometimes ornamented with wonderful arabesques of brightly painted decoration. One technique that highlights colored lines over a dark background with white edges replicates patterns used in contemporary lacquers (fig. 37). At the same time, technical developments continued to take place. More sophisticated kilns were built, and potters were able to make stoneware with a hard, fused body. Many of the shapes used during this time come from highly valued works in metal and have a distinctive elegance (fig. 38). Potters also used glazes far more frequently, having discovered, perhaps from the Near East, the recipe for lead-based glazes. These allowed a much lower firing temperature and, therefore, cheaper and easier production.

The Jōmon culture continued to flourish in Japan, but without the artistic originality of its earlier phases or the technical progress found in China. The vessels were still coil-built and fired at a low temperature. Glazes were not yet known, although black and red lacquers were sometimes used for decoration. Most shapes were simple and practical, such as jars and low pots with spouts. These were decorated with bands and whirlpool patterns, executed in low relief or incised on the highly polished clay surface. Female figures with large eyes and clay masks also were made, probably intended for burials. By the second century, this type of ceramic ware ceased to be produced.

In Ancient America, Mexico and Peru produced very fine pottery, although in neither country did potters use the wheel, kilns that could be fired at high temperatures, or glazes. The two great centers for Mexican ceramics were the valley of Mexico City in the north and the Gulf Coast, where the Olmec civilization ruled. While the north continued the traditions established at Tlatilco with small female figures, Olmec potters made new and far more sophisticated ceramics. Their vessels tend to be flat-bottomed and often have delicate incised designs. Most remarkable are the hollow clay figures of sexless infants that sometimes combine features of the jaguar, an animal sacred to the Olmec, with those of human beings. They are modeled in a sophisticated naturalistic style and have a

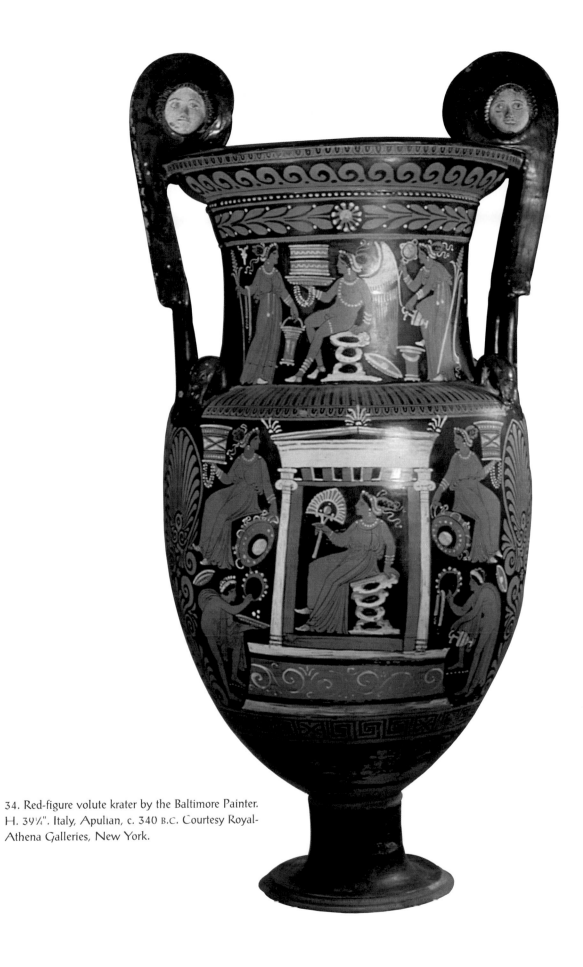

34. Red-figure volute krater by the Baltimore Painter.
H. 39¼". Italy, Apulian, c. 340 B.C. Courtesy Royal-
Athena Galleries, New York.

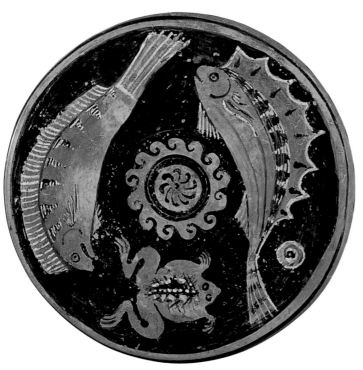

35. Plate with painted marine designs attributed to the Frog Painter. Diam. 7". Italy, Apulian, c. 340 B.C. Courtesy Royal-Athena Galleries, New York.

36. Rhyton with ibex-head spout. H. 11". Iran, Parthian, end of 1st millennium, B.C. Photograph by Maggie Nimkin. Courtesy Frederick Schultz Ancient Art, Inc., New York.

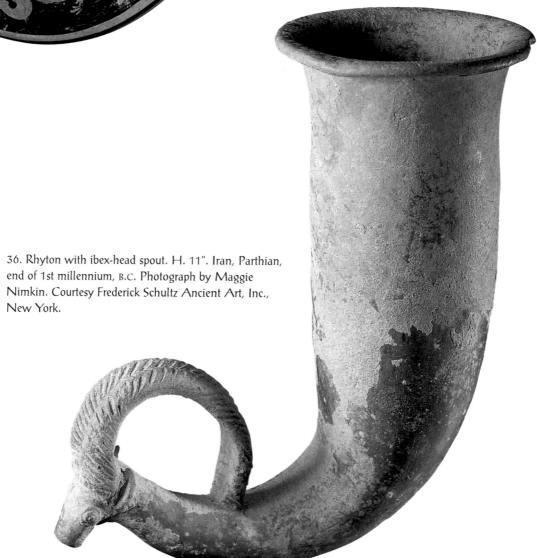

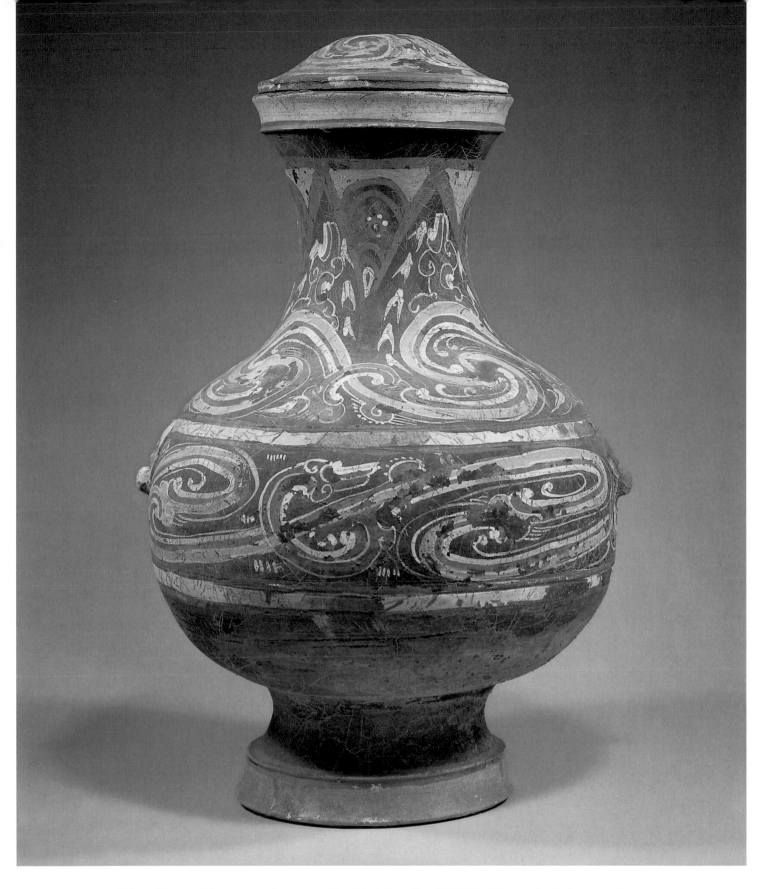

37. Jar with cover (Hu), gray earthenware with painted decoration. H. 22⅛". China, probably from near Loyang, Honan province, c. 1st century B.C. (1986.170ab) The Metropolitan Museum of Art, New York; Purchase, Mr. and Mrs. Oscar Tang Gift, 1986. Photograph © 1987 The Metropolitan Museum of Art.

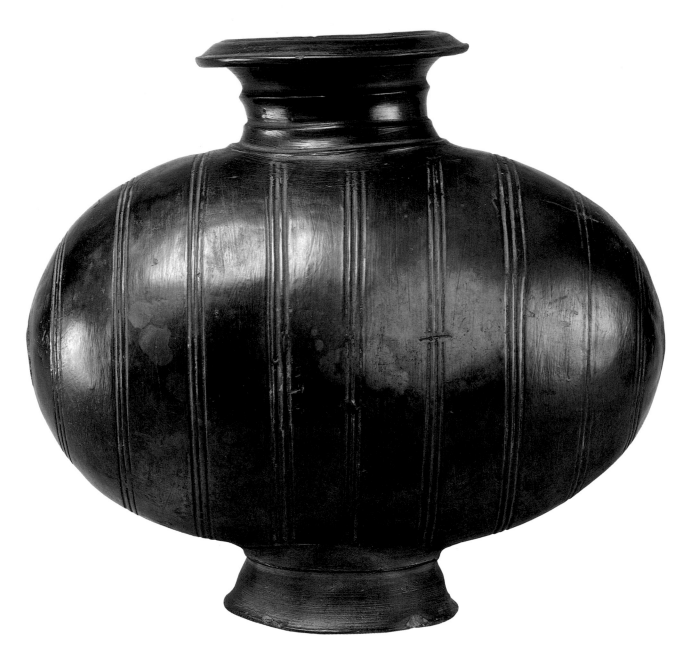

38. Flask (Ts'an-Chien Hu), burnished earthenware. H. 10¾". China, Late
Eastern Chou (Warring States era)–Western Han dynasty, c. 3rd–1st century
B.C. (1981.466) The Metropolitan Museum of Art, New York; Gift of Mrs.
Richard E. Linburn, 1981. Photograph © 1982 The Metropolitan Museum of
Art.

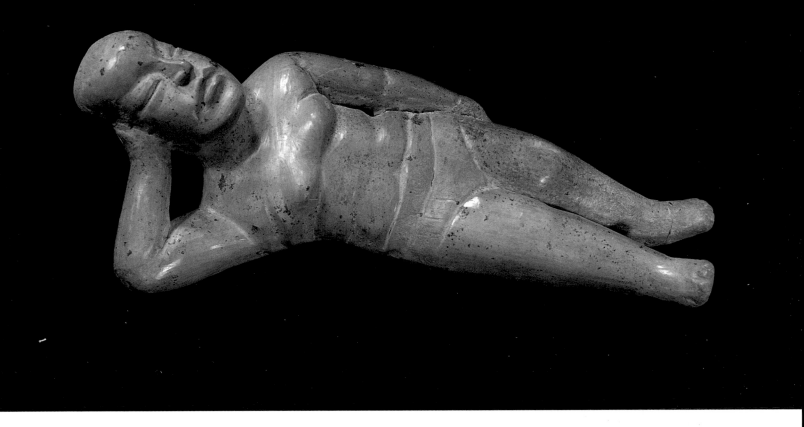

39. Las Bocas reclining male figure. L. 7½". Mexico, Olmec, c. 1150–550 B.C. Courtesy Royal-Athena Galleries, New York.

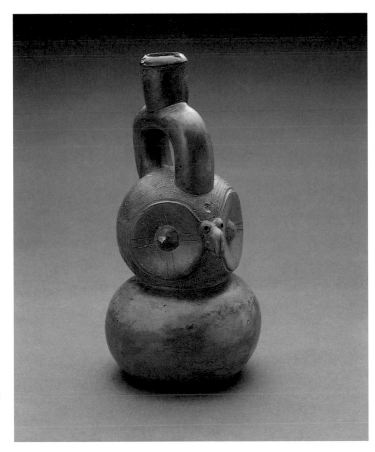

40. Black stirrup-spout pot in the shape of an owl. H. 9½". Peru, Cupisnique, 15th–9th century B.C. Fowler Museum of Cultural History, University of California, Los Angeles.

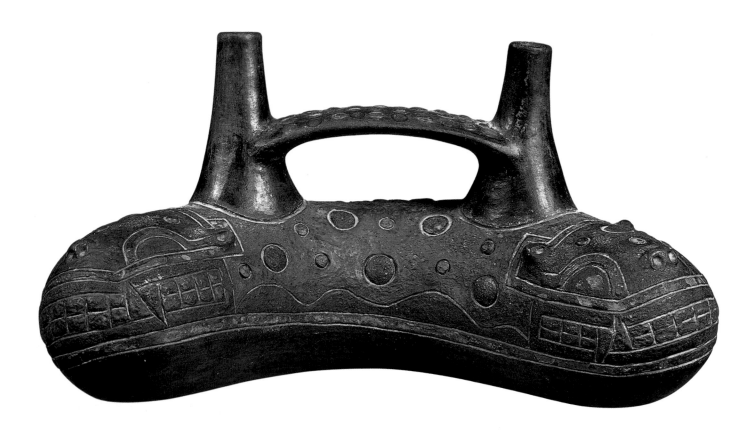

41. Pot in the shape of a double-headed snake, with bridge and stirrup-spout handles. L. 7½". Peru, Paracas Cavernas, 2nd to 1st century B.C. Fowler Museum of Cultural History, University of California, Los Angeles.

42. Male head with facial hair, scarification marks, and hat. H. 9". Africa, Nok culture, c. 200 B.C.–A.D. 200. Photograph by Maggie Nimkin. Courtesy Frederick Schultz Ancient Art Inc., New York.

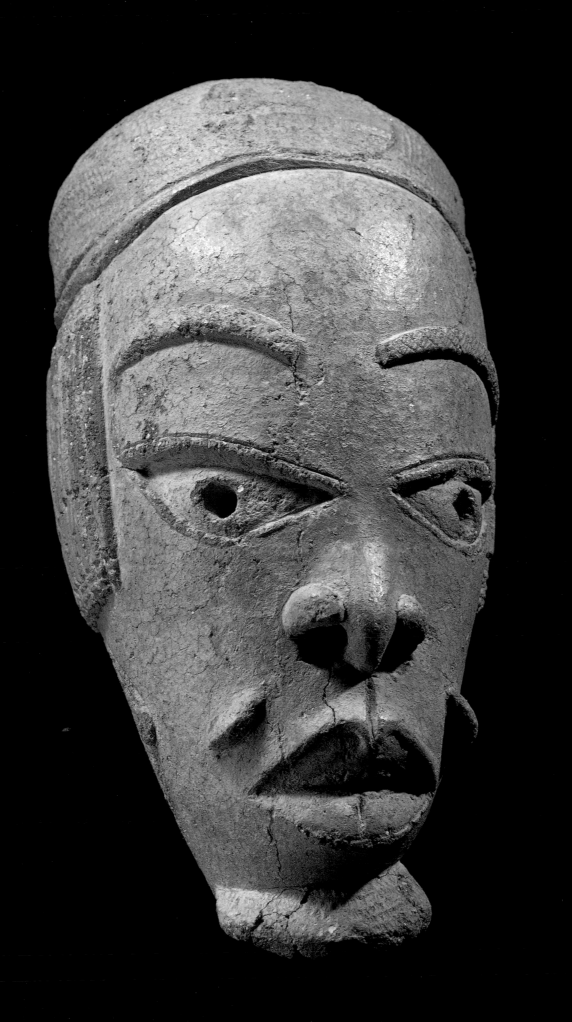

great sculptural presence, very different from the works of the village cultures of the Mexican highlands (fig. 39).

A major center of Peruvian pottery was Cupisnique in the Central Highlands. Distinctive shapes are stirrup vessels modeled with feline and snake motifs as well as seated human figures and birds, anticipating the effigy jars of later times. The representations are usually simple and the arrangement of geometric forms discovered in the subjects highly pleasing (fig. 40). Since the pots were placed in tombs, they probably held the food and drink believed necessary to nourish the dead in the underworld.

In southern Peru, three burial sites with thousands of graves were discovered on the Paracas peninsula in 1925. Wrapped in splendid textiles were pots completely different from those found in the north. Bowls, jugs, bottles, and vessels with a double-spout and bridge have painted and incised designs that represent deities and sacred animals of the ancient Indians. Symmetry and highly stylized forms characterize the Paracas work (fig. 41).

It is from this period that archaeologists have begun to find important ceramic works in sub-Saharan Africa. Knowledge is still incomplete, but the artistic quality of what has been recovered is impressive. Most famous is the Nok culture, named after the Nigerian village on the Jos Plateau in which clay sculptures of people and animals were discovered in 1928. Later discoveries came to the attention of the historian Bernard Fagg, who undertook more systematic exploration of the area. Unfortunately, many of the pieces had been uncovered by erosion and swept from their original sites, but stylistic similarities establish a single culture and scientific dating methods reliably place the works between 500 B.C. and A.D. 200. More recent excavations and dating methods have confirmed the antiquity of the culture.

There is evidence of ironworking throughout Africa during the first millennium B.C., and presumably these large and technically very accomplished sculptures originally belonged to a sophisticated material culture. They show rich details of costume and hair style, even while the bodies and faces have been simplified into underlying geometric forms. Some of the hollow heads clearly once fit lifesize statues and a very few nearly complete figures have been found (fig. 42). The obvious importance of the sculptures and the care taken to indicate physical details suggest that they might have been part of an ancestral cult or religious rituals.

Chapter 4

Ceramics from the Roman and Chinese Empires, 200 B.C.–A.D. 500

With the decline of Greek ceramics during the third century B.C., Roman pottery became the dominant ware in the West, spreading with the legions throughout the Roman Empire. Eventually it reached such diverse places as Germany and England in the north, Spain in the west, Hungary and Romania in the east, and Sicily in the south. More distant outposts included Anatolia, Syria, and North Africa. While there are local variations depending on native traditions, a remarkably uniform style existed throughout this vast realm.

Huge quantities of utilitarian ceramics, ranging from elegant red wares to coarse ordinary ones, were produced for distribution in the Empire. The most ambitious of these works imitate the relief designs and sculpting of metal or marble prototypes. Others are undecorated wheel-thrown pots and dishes with the simple lines and plain forms we still associate with industrial production (fig. 43). Long, pointed amphoras used for the storage and transportation of wine have been found in the holds of many sunken ships. Another common type is the face jug, a memorable and often entertaining modification of a basic shape that has been popular all over the world (fig. 44). A rarer kind of Roman pottery is white with veins of color, a pattern intended to resemble marble. Finally, there is pottery decorated with a green lead glaze, probably derived from traditions in Anatolia and Egypt. Painted designs, so common in Greece, rarely appeared.

The most important centers of production were Arezzo in central Italy and Lezoux and La Granfesenque in Gaul. The works from Arezzo, called Arretine, are regarded as the best artistically and the most accomplished technically. They were particularly outstanding from about 30 B.C. to A.D. 50, and never more so than during the reign of the Emperor Augustus. Signatures and stamps on the works suggest that most of the potters were Greeks and Asians, both freedmen and slaves, which fits with the dependence of Roman pottery on late Greek Hellenistic traditions. Similarly, the shapes chosen were traditional ones, bowls, cups, beakers, and various kinds of kraters. The designs on the earliest pieces are almost always floral, but human and animal scenes, sometimes from Roman history and mythology, became popular later. The style resembles that of contemporary Augustine silverwork.

While Rome dominated the West, Han China was the most powerful realm in the East. From about 200 B.C. to A.D. 200, the Han dynasty ruled China itself as well as most of central Asia, Manchuria, north Korea, and parts of Indochina. To this day, the Chinese refer to themselves as the people of Han. The most notable achievement of the Han potters was the creation of an ash-glazed stoneware, sometimes described in the older literature as proto-porcelain. Efficient potter's wheels as well as the use of molds, taken from the techniques of bronze casting, also made the forms of the pots more regular. Two shapes were favored. One is a jar with a rounded body, a high neck, a flat base, and two low-relief ring handles in the form of stylized T'ao T'ieh masks derived from Chinese bronzes. The other has a round low neck and a flat mouth with an upturned rim (fig. 45).

Most of surviving Han ceramics come from tombs, which sometimes contain thousands of pottery vessels as well as clay figures. These pots are often heavy gray or red earthenware painted or glazed with a green or brown lead glaze. The green results from an admixture of copper, while the brown was made with the help of iron. The painted pottery is covered with a white slip and then decorated with colorful designs. Many of the glazed jars also have molded decoration showing hunting scenes or styl-

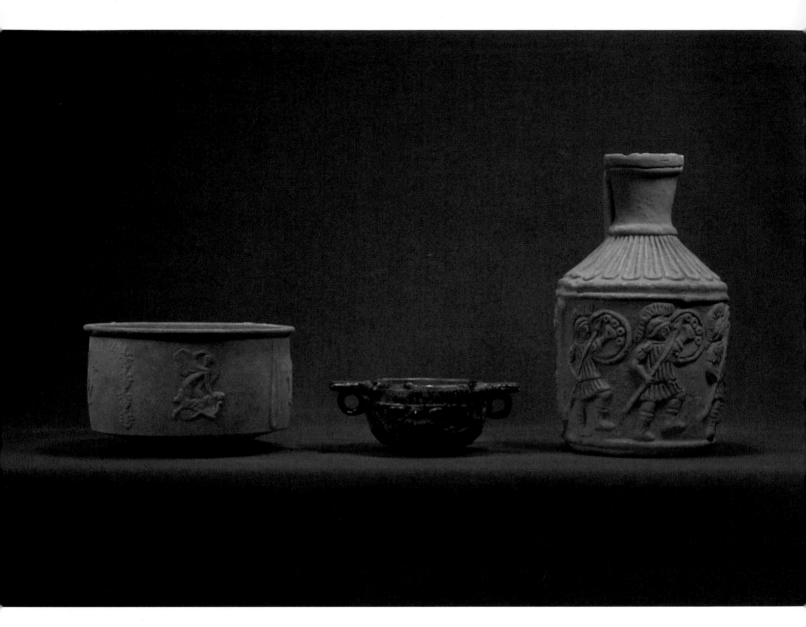

43. *(Left)* Red-gloss ware bowl with mythological scenes in relief.
H. 4". Roman, Gaul, A.D. 2nd century; *(Center)* Green lead-glazed
skyphos with ring handles. H. 2⅛". Roman, Asia Minor,
c. 50 B.C.–A.D. 50; *(Right)* Single-handled pitcher with relief decora-
tion. H. 9¼". Roman, Asia Minor, Pergamon Workshop, A.D. 4th
century. All courtesy Royal-Athena Galleries, New York.

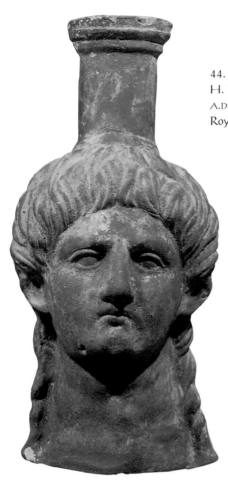

44. Jug in the shape of a female head.
H. 7⅞". Roman, North Africa,
A.D. c. 3rd–4th century. Courtesy
Royal-Athena Galleries, New York.

45. Jar with incised lines around
shoulder, stoneware. H. 8½". China,
Han dynasty, c. 100 B.C. Collection
Munsterberg, New York.

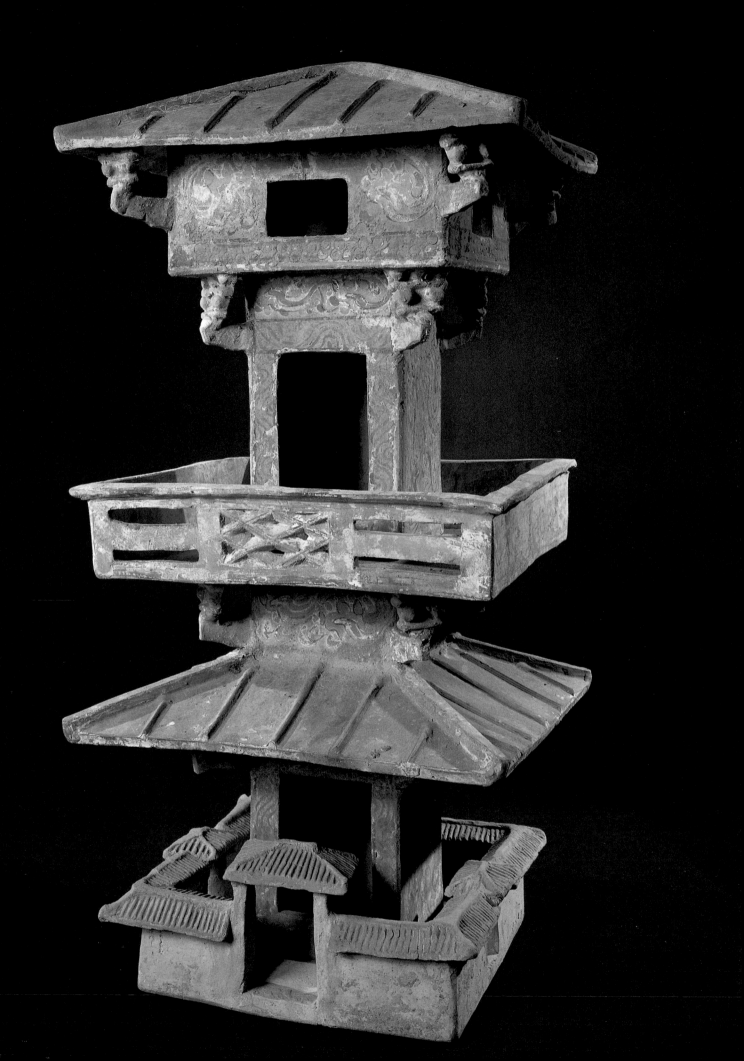

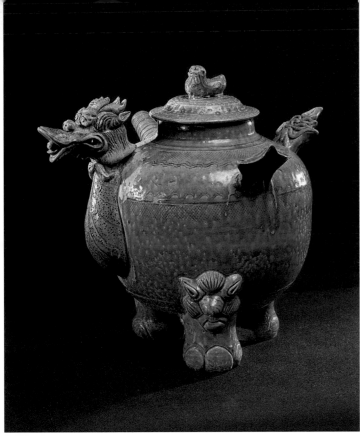

47. Ewer with dragon-head spout and elephant feet, stoneware. H. 12". China, Yueh ware, c. A.D. 4th century. Courtesy Weisbrod Chinese Art Ltd., New York.

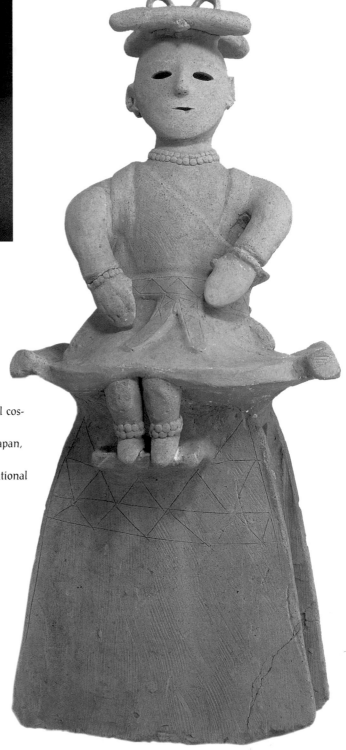

48. Seated female figure in ritual costume, possibly representing a shamaness, fired clay. H. 27". Japan, Late Kofun (Tumulus) period, A.D. 5th–6th century. Tokyo National Museum, Tokyo, Japan.

46. Unglazed painted watchtower. H. 35¼". China, Han dynasty, c. 100 B.C. Courtesy Weisbrod Chinese Art Ltd., New York.

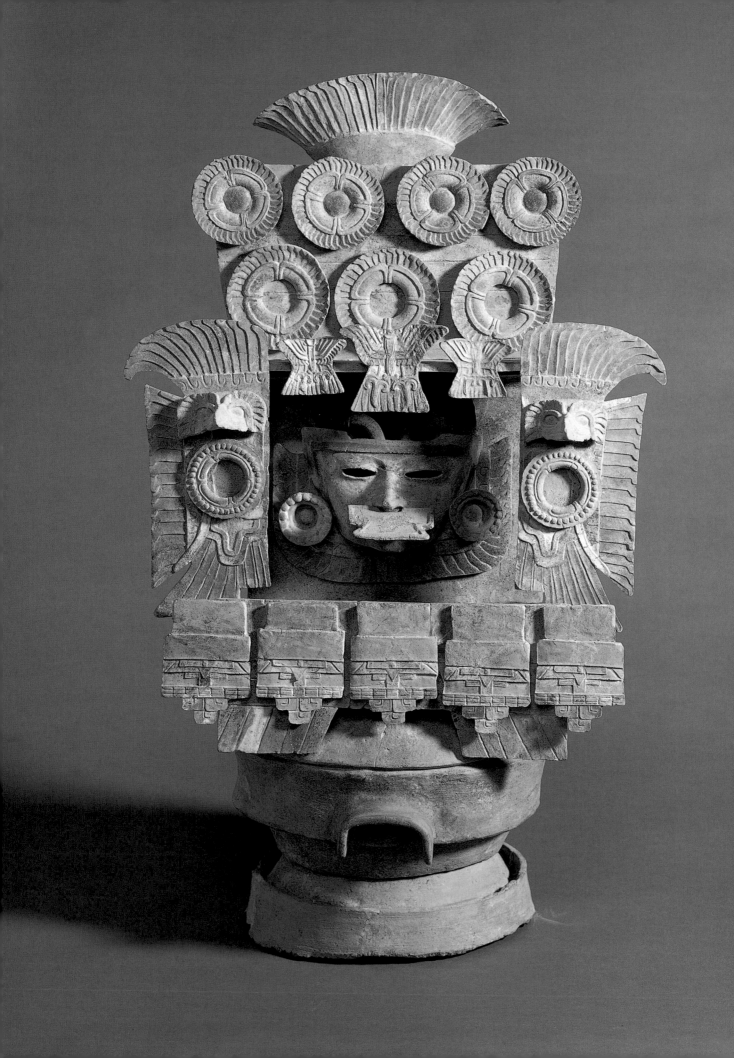

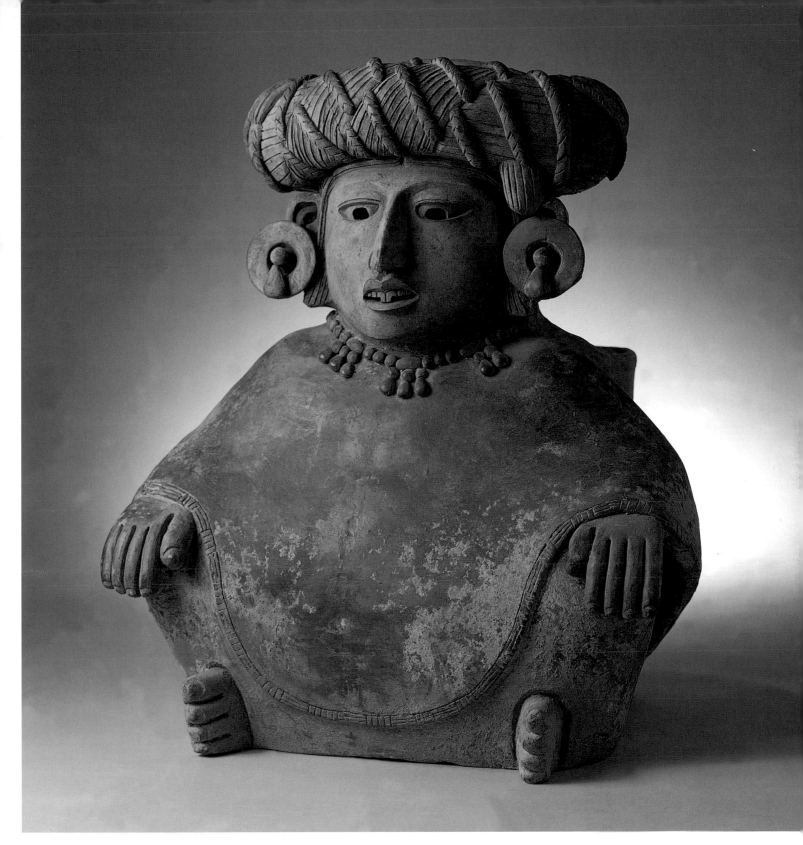

49. Composite incense burner in the shape of an elaborately ornamented head, polychromed buff earthenware. H. 30". Mexico, Central Highlands, Teotihuacán, Middle Classic, 400–600. (205:1979) The Saint Louis Art Museum, Saint Louis, Missouri; Gift of Morton D. May.

50. Urn in the form of a seated woman with Yalateca-style headdress, gray earthenware. H. 14". Mexico, Oaxaca, Zapotec, Monte Alban, 300–600. (305:1978) The Saint Louis Art Museum, Saint Louis, Missouri; Gift of Morton D. May.

ized landscapes. The so-called hill-jar type replicates the mountains on the Taoist Isle of the Blessed in the shape of its cover.

From a historical point of view, the most interesting Han ceramics are the grave figures that represent the period in all its detail, from gods and spirits to houses, barns, and watchtowers. One three-story tower rises above a walled courtyard with an imposing gate. The details in clay and the painted ornament on the building possess all the fascination of a Victorian dollhouse (fig. 46). Human and animal figures, especially elegant ladies and horses, were manufactured with molds in huge quantities. The imperial burials in particular are sometimes astonishing in their grandeur. Most dramatic is the tomb of the first Emperor of the Qin dynasty, where an army of thousands of lifesize soldiers carefully made from clay stood prepared to defend him in the afterlife. This is exceptional, but many contemporary burial sites showed ever-increasing size and ambition of representation.

After the Han dynasty came the Six Dynasties period, named for the six native Chinese dynasties that ruled southern China. Northern China was dominated by Tartar and Mongol tribes who, although great patrons of Buddhist art, were not very interested in ceramics. In the south, however, especially in Chekiang province, the pottery industry continued to flourish and various technical improvements appeared. The most innovative work is conventionally called old Yueh ware, after the region from which it comes. A stoneware thrown on a potter's wheel, the pale gray body turns to a reddish brown when fired, and then is glazed greenish gray or pale brownish yellow. If a great deal of iron is added, the color changes to dark brown or black.

A typical shape used in old Yueh ware is a ewer with a chicken-head spout, but many other kinds survive. Some of them, especially from the end of this period, have extensive molded decorations. A particularly imposing example combines a dragon head holding a pearl in its duck-like beak with elephant feet and monster heads. The pitting and dripping of the glaze adds to the visual interest of the piece (fig. 47). Regarded as the ancestor of celadons, Yueh ware plays an important role in the history of Chinese ceramics.

It was at this time that the important pottery tradition of Korea began to flourish. Most common are gray stoneware vessels of great hardness and simple but beautiful shapes. They are called Silla wares after the name of the kingdom that ruled southeastern Korea. Although Korean potters were no doubt inspired and influenced by those of Han China, they never used glazes. At times, a natural ash glaze accidentally covered part of the pot during firing. The most distinctive shape employed by Silla potters was a covered circular bowl, resting on a tall foot pierced with triangular or square openings. Probably the openings allowed

fires to be lit beneath the pots when they were used in funeral ceremonies. Grave figures like those from China also have been uncovered in Korean tombs. The most striking are vessels in the shape of horsemen.

In Japan, this period saw the end of the Jōmon culture and the birth of a new, far more advanced civilization. Known as Yayoi from the section of Tokyo where the first archaeological remains were found, it lasted from roughly 200 B.C. to A.D. 300. While the Jōmon people were Caucasian, related to the Siberians, the Yayoi people were Mongolians, related to the south Chinese and Southeast Asians and ancestors of the modern Japanese. Yayoi pottery exhibits none of the imaginative sculptural forms so characteristic of the best of Jōmon ceramics, but relies upon simple shapes and plain surfaces for its effect. The color is red, sometimes bordering on pink and yellow. Particularly fine are the stem cups that display the subdued, rustic beauty later Japanese tea masters praised so highly.

Then followed the Grave Mound period, which is outstanding for its large tumuli erected over the graves of rulers. The grave figures are called haniwa, a name that describes their position in a circle around the burial mounds. The haniwa, often of considerable size, were built by the coil method and are hollow inside. They represent men and women, horses and birds, houses and boats, rendered in a naïve but pleasing manner. Some show considerable detail, allowing identification of societal roles. A female figure with a cloth wrapped across her chest, jewelry, and hair combs, is seated on a raised stool that may indicate the ritual status of a shamaness (fig. 48). Although produced in huge quantities by ordinary potters, the haniwa sustain a remarkably high level of artistic quality.

In Ancient America, great artistic achievement came during these centuries. The most important cultural center in Mexico was Teotihuacán, not far from modern Mexico City. Believed to have had about 200,000 inhabitants by the year 500, it was one of the largest cities in the world. Its huge temple complex with magnificent sculptures and paintings is well known, but Teotihuacán also produced beautiful ceramics. Made without a wheel by highly skilled potters, they are earthenware, fired at low temperatures without glazes. Clay figures of the time reflect the same aesthetic sensibility and iconography as the painted decorations.

Some of these ceramic works have the presence of freestanding sculptures. Large incense burners, showing a face surrounded by stylized jewelry, nearly defy the practical considerations of the vessel. They also beautifully illustrate the characteristic interest of Ancient America in costume and ritual (fig. 49). A typical vessel is cylindrical with three slab feet. Some of these pots have lids in the shape of birds, while others are open. Since they were found in tombs, they probably were used to hold offerings to the

51. Tripod jar with lizard feet, red earthenware. H. 13½". Mexico, Colima, 200 B.C.–A.D. 300. (176:1980) The Saint Louis Art Museum, Saint Louis, Missouri; Gift of Morton D. May.

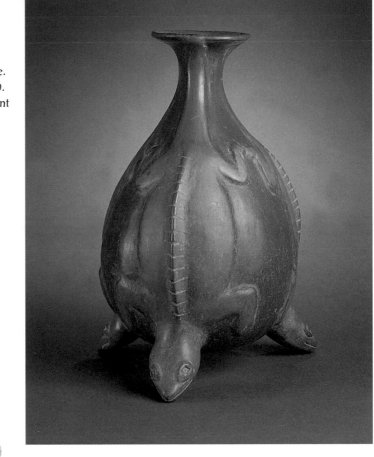

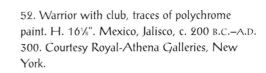

52. Warrior with club, traces of polychrome paint. H. 16⅛". Mexico, Jalisco, c. 200 B.C.–A.D. 300. Courtesy Royal-Athena Galleries, New York.

59

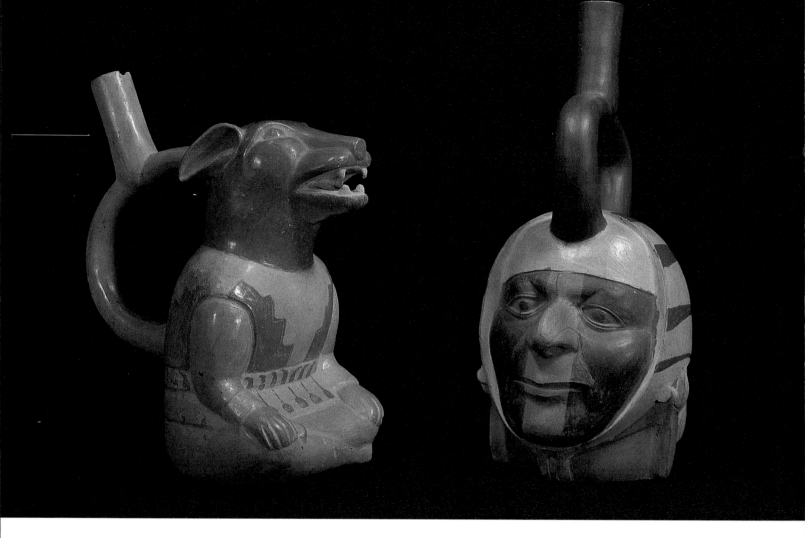

53. Stirrup-spout pots in the form of a fox-headed man and a male head. *(Left)* H. 10¼"; *(Right)* H. 8⅞". Peru, Mochican, A.D. 3rd–4th century. Courtesy Royal-Athena Galleries, New York.

54. Globular pot painted with the face of a dog. H. 6¾". Peru, Nazca period, A.D. 6–7th century. (3217-2) Photograph by R. P. Sheridan © American Museum of Natural History, New York.

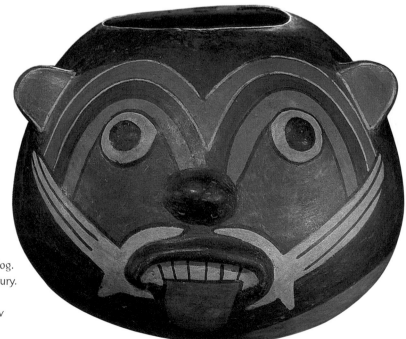

dead. Decorations appear in bright colors on a white stucco ground or are carved into the surface of the clay. The subjects come from Ancient Indian mythology and include the Rain God, the Feathered Serpent, and the Sacred Jaguar, rendered in an abstract manner of great expressive power.

Monte Alban in Oaxaca is the other major archaeological site of Mexican art. Here the Zapotec people of southern Mexico produced a remarkable civilization. Earlier phases had been much influenced by the Olmec, but during the first centuries of this era, the Zapotecs developed a culture of their own. Clay was their favorite artistic medium. The most impressive and aesthetically outstanding creations are effigy vessels, usually referred to as funerary urns since they were mostly found in tombs. Although serving as containers of food and drink for the honored dead, the effigy vessels are at the same time highly expressive sculptures.

In contrast to the restraint found in the ceramics made at Teotihuacán, those from Monte Alban have an intense and sometimes even bizarre quality. The most popular subjects are the Rain God Cocijo, always recognizable by his long, forked snake tongue, the Corn God with his upturned nose, and the Fire God. All are shown seated and decorated with elaborate ornaments. Other subjects include gods and priests, as well as sacred animals, notably the jaguar, the bat, and composite creatures combining human and animal features. An urn in the shape of a seated woman describes her face, including jewelry, headdress, and filed teeth, with an almost hallucinatory crispness of detail (fig. 50).

While these two highly developed Classical Mexican cultures existed in the Central Highlands and the south, a village culture still prevailed in the west. Although the people responsible for the objects found here have not been identified, the art has been called Tarascan after later inhabitants of the region. A wealth of ceramic vessels and sculptures has been recovered. Little of it was excavated scientifically, so the exact dates of thousands of ceramics found here cannot be determined. The best estimates suggest that manufacture was between A.D. 50 and 650.

The main finds of this so-called Tarascan art have been in the modern Mexican states of Najarit, Jalisco, and Colima, an area that extends from the Gulf of California in the north to Guerrero along the Pacific coast. The finest of these works are the clay sculptures from Colima, hollow red clay figures with highly burnished smooth surfaces. Subjects range from proud warriors to sensuous women, to animals and birds, all shown in graceful and sometimes even acrobatic poses (fig. 51). Unlike the ceramics from Teotihuacán and Monte Alban, these rarely show gods.

The clay works from Najarit and Jalisco, like those of Colima, reflect a village culture. Paint sometimes decorates the figures from Najarit, and sometimes they are seen in action. Musicians play musical instruments, children play games, women carry babies, and people celebrate festivals at local shrines. The Jalisco figures, on the other hand, consist of broad-bodied, seated women with large breasts and men holding symbols of their authority (fig. 52).

In Peru, two remarkable cultures coexisted. In the north, centered around Moche, was the Mochican civilization, while in the south was the Nazcan culture, named after its most significant site, the modern town of Nazca, not far from Paracas. Ceramics and textiles played an important role in both, while painting and stone sculpture were relatively insignificant. Since much of the pottery was made to be buried with the dead, many ceramics have survived.

The most striking Mochican works are the effigy vessels. They are distinguished by the amazing naturalism of their portrayals of human faces, so detailed as to convince us that they must be portraits of actual contemporaries. While many of the works describe impressive chieftains, others show strange and deformed men with blind eyes or mutilated noses. The most startling of all describe erotic scenes, including not only heterosexual relations but oral and anal sex and sex with animals. Combinations of human and animal parts also exist. The meaning of these images remains a mystery (fig. 53).

The Nazca culture also had its most creative phase from about 200 B.C. to A.D. 600. In contrast to Mochican pots that depend largely on sculptural forms, Nazcan ceramics are brightly colored and the designs are often outlined in black. The potting is rather thin and the shapes themselves elegant, especially those intended for religious ceremonies and for burial with dead nobles. The iconography of the decoration is very rich. The great jaguar deity was a favorite motif, but birds, snakes, and all kinds of human figures also were popular. The handling of these designs is highly stylized and even abstract, showing a fantastic and imaginative approach to the imagery (fig. 54).

Chapter 5

The Classic Age of Chinese and Mayan Ceramics, 500–1000

With the decline of the Roman Empire around the year 500, European ceramics ceased to be of major importance. Both from a technical and an aesthetic point of view, the achievements of one thousand years disappeared as nomadic tribes overran Europe. Even in Italy, the productions of the second half of the first millennium were of no great distinction. It was not until the ninth century, under the Carolingians, that a revival of the ceramics industry took place in the Rhineland. Even this pottery, however, was a simple redware with incised decoration.

Only in the Byzantine provinces of Eastern Europe and Anatolia did the technical knowledge and aesthetic sensibilities of the late Classical world survive. Roman techniques of lead glazing and the potter's wheel continued to be used here, and some fine earthenware pottery decorated with green and pale yellow glazes and delicate incised designs resulted. Compared to the superb contemporary works in gold and silver, however, ceramics played a minor role.

The Near East, on the other hand, emerged as a major center of ceramics production. In Persia, Mesopotamia, and Egypt, where pottery had languished for centuries, new interest under the Islamic rulers created a flourishing industry. Since Islam forbade the use of precious metals and discouraged the making of images, artistic creativity that might have gone into the production of metalwork, sculpture, or painting focused on ceramics. Decorations include large geometric patterns, human figures, animals, plants, and auspicious inscriptions taken from the Koran or other religious texts, written in a beautiful kufic script.

Two technical innovations with far-reaching consequences were made. The first was the rediscovery of tin-glazing to make an opaque white surface, a process first used by the Babylonians one thousand years earlier and then, apparently, forgotten. This time the technique spread from Mesopotamia to north Africa and then to Spain and Europe, where it became the basis of faience or Delftware. The second development was lustreware, identifiable by the dull metallic sheen of its surface. Perhaps intended to resemble the surface of metal, the glaze was extremely difficult to apply to ceramics. During the entire golden age of Islamic pottery, only a few production centers mastered it.

The first great center of ceramics was Baghdad which, under the Abbasid rulers of the eighth and ninth centuries, had become one of the great cities of the world in both splendor and commerce. The ruins of their palace at Samarra, north of Baghdad, show the extent of their patronage of the arts. The most outstanding Abbasid ceramics are the lustrewares, popular as far away as Samarkand, India, Egypt, and Spain. Favorite shapes for Abbasid potters were dishes, plates, and bowls, decorated in lustre, green lead glaze, or cobalt blue. The designs often reflect older Byzantine motifs and, especially in Samarra, consist largely of stylized floral and animal shapes (fig. 55).

The most important Egyptian city for ceramics was Fastat, near Cairo, where the Fatimid dynasty had established itself during the tenth century. With the decline of Baghdad at the end of the tenth century, many of the Mesopotamian artists moved to Egypt, taking the secrets of lustreware with them. Thus the best ware comes from the eleventh and twelfth centuries, but the origin of Islamic ceramics in Egypt dates from the very end of the period under discussion. Not surprisingly, the style and decoration of Egyptian pottery closely resembles that of Mesopotamian ware, although the bodies are coarser and the colors tend to be buff or reddish. Floral designs, ani-

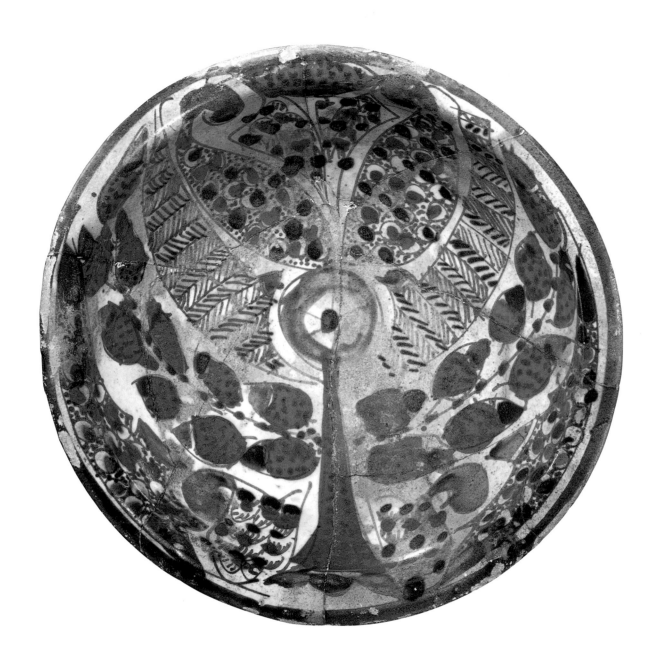

55. Bowl, lustreware. Diam. 9¾". Iraq, Samarra, Abbasid period, 9th century. (41.165.1) The Metropolitan Museum of Art, New York; Gift of H. O. Havemeyer, 1941. The H. O. Havemeyer Collection. Photograph © 1985 The Metropolitan Museum of Art.

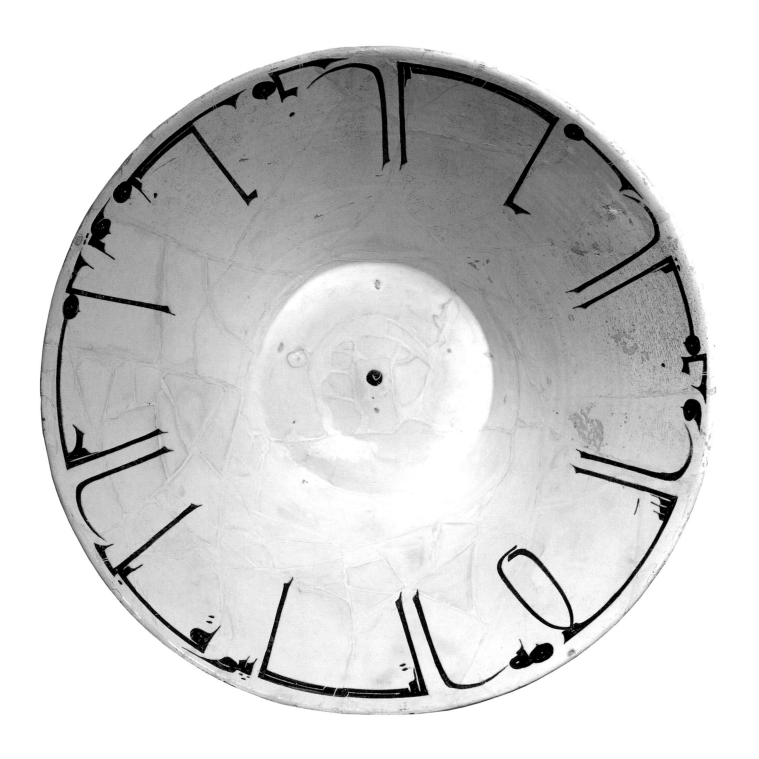

56. Bowl, earthenware with Arabic inscription in Kufic that reads "Planning before work protects you from regret. Prosperity and Peace." Diam. 18". Iranian or Transoxianan, Nishapur or Samarkand, 10th century. (65.106.2) The Metropolitan Museum of Art, New York; Rogers Fund, 1965. Photograph © 1983 The Metropolitan Museum of Art.

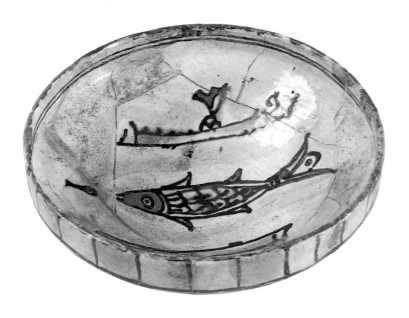

57. Bowl painted with fish and boats. Diam. 8½". Iran, Nishapur, 10th century. Collection Munsterberg, New York.

58. Rooster, san-ts'ai (three-color) grave figure. H. 6⅛". China, T'ang dynasty, 7th–8th century. Formerly collection of Gerald I. Weisbrod, Toronto.

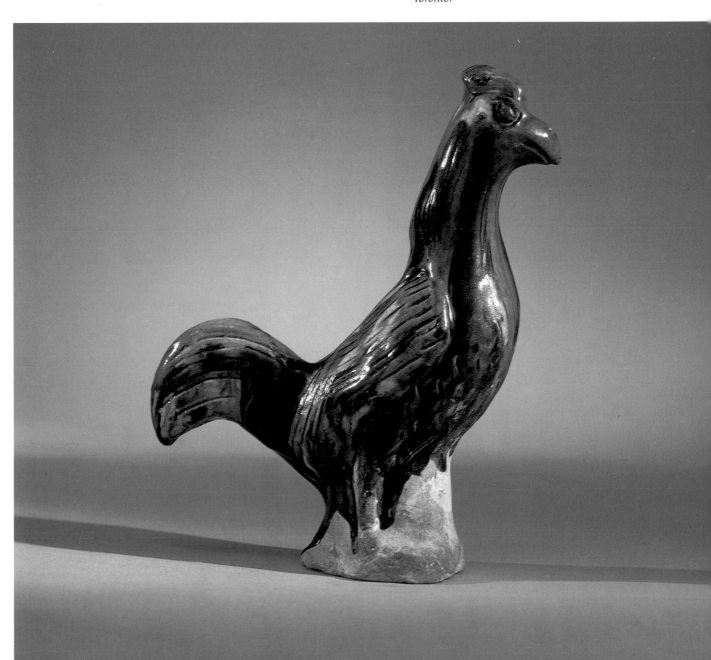

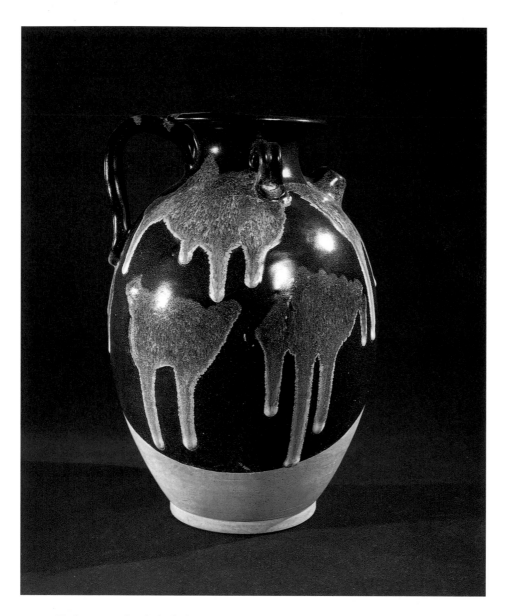

59. Black ewer with splashed glaze, stoneware. H. 9¾". China, T'ang dynasty, 7th–8th century. Courtesy Weisbrod Chinese Art Ltd., New York.

60. Dragon-handled white amphora. H. 12¾". China, T'ang dynasty, 7th century. Courtesy Weisbrod Chinese Art Ltd., New York.

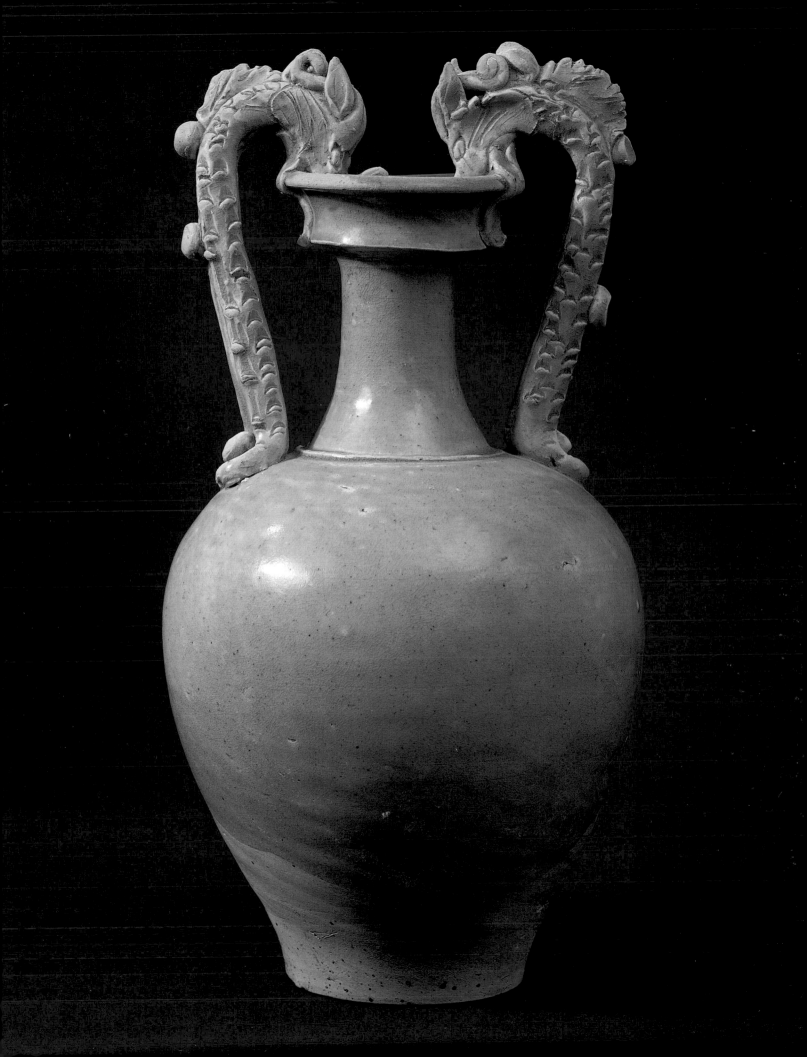

mals, and birds are among the most popular decorative motifs, but Christian subjects and scenes from contemporary life also appear.

Islamic ceramics from Persia formed part of a remarkable tradition beginning thousands of years before in prehistoric Iran. In eastern Persia, notably in Nishapur and Sari, and in the central Asian city of Samarkand, where the Islamic Samanid dynasty had its capital, magnificent pottery was made as early as the ninth century. Although not as sophisticated as they would become later, the ceramics show a wonderful feeling for decorative design with something of the spontaneous quality of folk art. The plates, dishes, and bowls are made of a soft reddish earthenware, covered in a white slip and painted in bright colors.

The finest and most typical of Persian ceramics made during the last centuries of the first millennium are magnificent plates decorated with stylized Arabic calligraphy around the inner rim. This type of ware, found in both Nishapur and Samarkand, often displays popular sayings of a moral nature. The example illustrated here says: "Planning before work protects you from regret. Prosperity and Peace" (fig. 56). Also characteristic are the Nishapur bowls decorated in purple, black, yellow, and green, with human figures, animals, and birds recalling earlier Persian motifs in a delightful manner (fig. 57). In freedom of handling and charm, they resemble the plates from Sari decorated with stylized bird designs boldly painted in folk-art style and beautifully adapted to the rounded shape.

Of all the ceramics produced in the world during these centuries, the work from China is the most outstanding. The Chinese themselves always have regarded the T'ang period (618–906) as one of their greatest epochs, a time when culture flourished as never before. This estimation particularly characterized the ceramics, which enjoyed great popularity in the Middle Kingdom itself as well as in Japan and the Near East. In addition to all kinds of jars, bottles, vases, ewers, bowls, cups, and plates, T'ang potters made many grave figures.

The most colorful T'ang pottery is the so-called three-color or san-ts'ai ware, intended for tombs and decorated with lead glazes produced by metal oxides. Common colors are a yellow or amber brown made with iron, a copper blue or green, and a creamy white. The body is a buff earthenware, fired at a low temperature. Both the shapes and the colors of these vessels are beautiful. A particularly unusual example shows a rooster. The mix of colors in the glaze seems an especially effective description of a cock's feathers (fig. 58).

The most typical of T'ang ceramics are the so-called Yueh wares, a fine-grained stoneware decorated with a greenish or putty glaze. Modern excavations suggest that about three-quarters of all T'ang kilns produced this type of ware, which has been found in Korea, Japan, Southeast Asia, the Near East, and the east coast of Africa. The center of production seems to have been in southern China, with kilns all over Chekiang province. The potters used many shapes, with bowls, vases, ewers, and boxes being the most common. Decorations often consist of only engraved and incised patterns, although there are a few pots with sculpted or molded decorations.

Another type of glazed stoneware comes from Honan province. Typically, the dark-glazed body is splashed with a cream or lavender glaze, which drips and spreads unevenly across the surface. The design created by the irregular shapes and thicknesses of the splashes seems remarkably modern to our eyes. The potters often allowed the unglazed buff-colored stoneware to show around the foot of the pots, a device that emphasizes the colors and fluidity of the glazes (fig. 59).

More refined and technically more advanced are the white porcelains, defined by the Chinese as any ware that gives a ringing note when tapped. Thinly potted with a kaolin clay base, they have a pure white body covered with a white slip or a white glaze, sometimes with a bluish tint. They are not decorated, but depend on their lovely traditional shapes for aesthetic effect. Especially fine are the delicate cups. The technical achievement that these represent—the making of porcelain as early as the eighth century—was not equaled in Europe for a thousand years.

During the T'ang period, the Chinese empire expanded and a cosmopolitan culture flourished. Thus it is not surprising that the ceramics reflect foreign influences, notably those of Sassanian Persia and the late Classical art of the Byzantine empire. Among the ceramics influenced by Byzantine prototypes are pilgrim bottles and rhytons decorated with Classical motifs such as vine leaves, cupids, animals, and birds. Others, such as an amphora with elegant arching dragon handles, show the influence of Greece while remaining indisputably Chinese in color, surface, form, and decoration (fig. 60).

Representations of Turks, Armenians, Syrians, and even Jews among T'ang grave figures also testify to the broad range of contemporary cultural contacts. Charming ladies, musicians, officials, and warriors give a vivid picture of the world around. The most beautiful creations may be the splendid proud horses, shown in all sorts of moments and positions from hunting and war to the tense stillness of attention. The horses, like their riders, are filled with a sense of physical vigor, as they turn or twist or stop in the immediacy of movement. In one unusual example, a bearded rider pulls the horse short with reins held high in his right hand, while gripping a small fighting tiger by the neck in his left (fig. 61). The bulk of these figures are plain or painted, although some are glazed in bright colors. The last probably were intended for the graves of the well-to-do and the nobility, and therefore are rarer and more highly valued today.

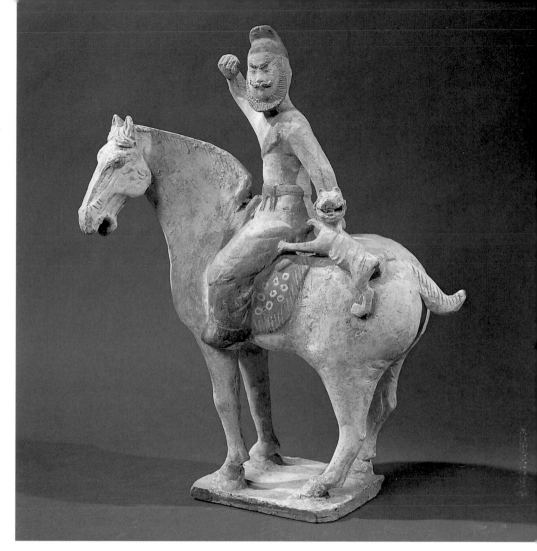

61. Painted horse and rider with
snarling tiger, grave figure. H. 13".
China, T'ang dynasty, 7th century.
Courtesy Weisbrod Chinese Art Ltd.,
New York.

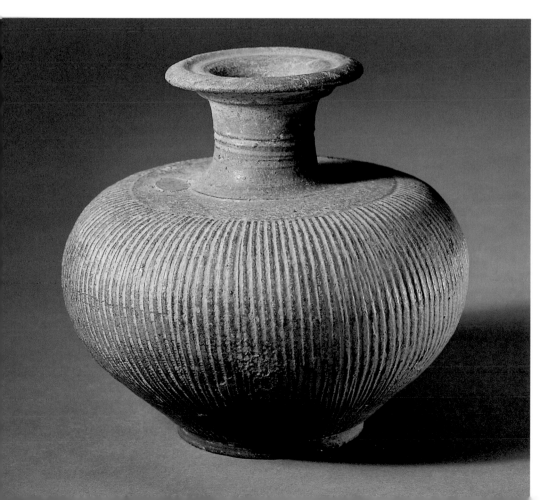

62. Bottle with carved design,
stoneware. H. 3¾". Korea, Unified
Silla period, 8th–9th century. (1989.1)
Photograph by Lynton Gardiner. Asia
Society, New York; Gift of Mr. and
Mrs. Byung and Keum Ja Kang.

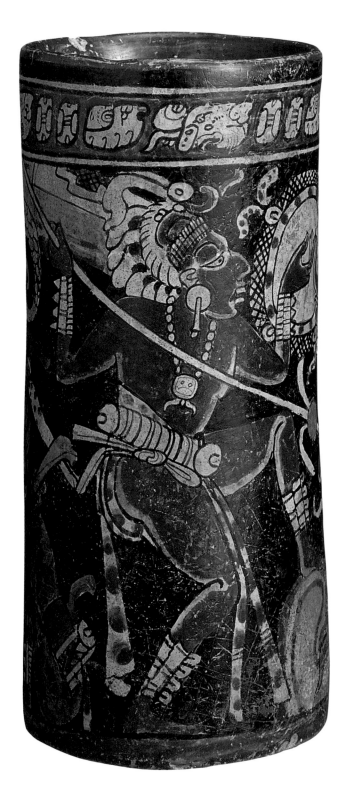

63. Cylinder vessel with underworld scene. H. 9". Guatemala, Maya, Late Classic period, 670–750. (1990.011.076) Michael C. Carlos Museum, Emory University, Atlanta, Georgia; Gift of William C. and Carol W. Thibadeau.

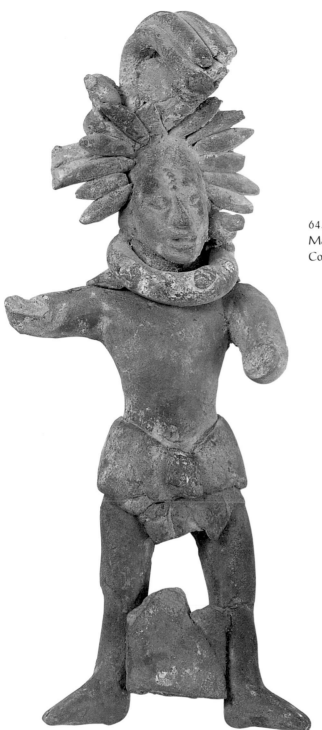

64. Male figure. H. 7⅞". Mexico,
Maya, Jaina Island, 7th century.
Collection Munsterberg, New York.

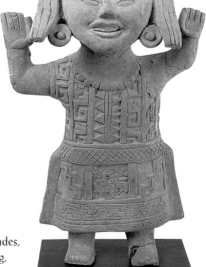

65. Smiling figure. H. 15½". Mexico, Remojades,
Veracruz, 8th century. Collection Munsterberg,
New York.

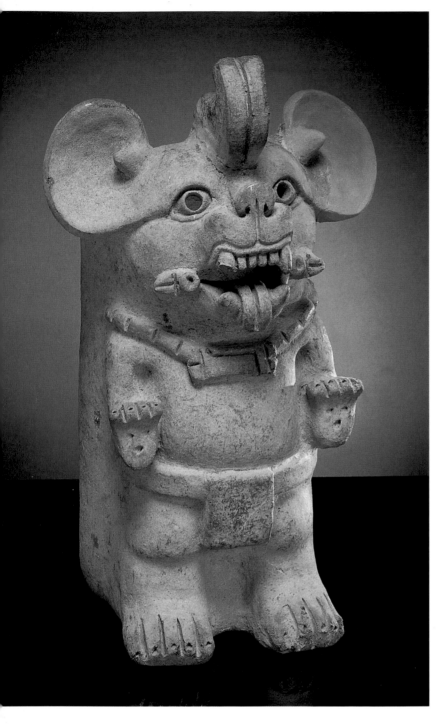

66. Funerary urn in the form of bat god. H. 12½". Mexico, Zapotec, Monte Alban, c. 500. (4689-2) Photograph by Craig Chesek © American Museum of Natural History, New York.

67. Kero with painted designs, earthenware. H. 8⅝". Bolivia, Highland Tiahuanaco, c. 300–600. (1963.476) © The Cleveland Museum of Art, Cleveland, Ohio; John L. Severance Fund.

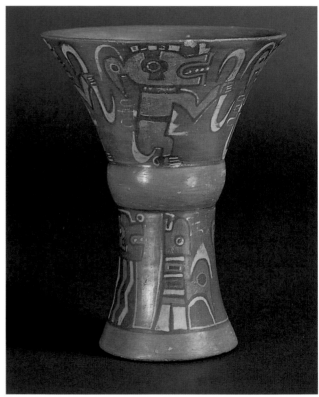

68. Helmet-shaped head, terracotta with traces of white slip and specularite. H. 15". South Africa, Lydenburg, Eastern Transvaal, 500–700. (3.10a) University of Cape Town Collection, South African Museum, Cape Town.

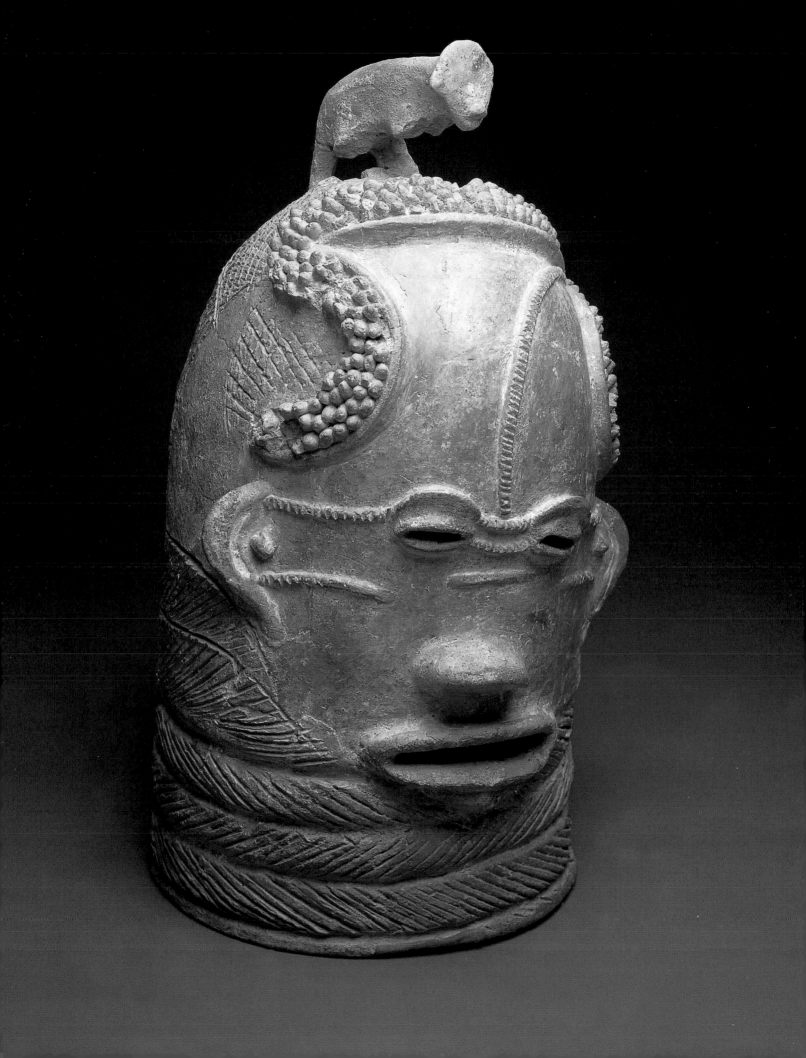

Compared to the brilliant output of the Chinese kilns during this period, those of the Koreans and Japanese were less outstanding. In Korea, the same kind of stoneware was produced in the Great Silla period as during previous centuries. Individual examples are still lovely, although stamped decoration often replaced hand-incised or carved designs. Popular motifs include all kinds of circles, lozenges, lines, birds and flowers (fig. 62). The only innovation was the use of an olive glaze, no doubt indicating the influence of T'ang China.

The most notable development in Japan was Sue ware, a dark gray stoneware of a hard fine texture. This ware depended upon the importation from Korea of more sophisticated kilns, which allowed the Japanese potters to fire at much higher temperatures. The shapes of these pots reflect a distinctively Japanese sensibility. By contrast, the green-glazed or three-colored ceramics made in eighth-century Nara for the Imperial Court clearly show the influence of T'ang China.

In Ancient America, the second half of the first millennium was a period of great brilliance. The Mayan areas especially produced an abundance of magnificent art, much of it made from clay. While earlier Mayan pottery reflects Olmec influence and then that of Teotihuacán, works of the Classical period exhibit their own style. Furthermore, the vessels were ubiquitous in Mayan life. Excavations in present-day El Salvador at the Mayan village of Ceren, buried under volcanic ash during the sixth century, have revealed large numbers of finely painted ceramics in the possession of ordinary people. One modest house, for example, contained more than seventy pots, many still filled with food.

The most characteristic Mayan shape is the high cylindrical jar. The pots are beautiful for their form and outstanding for their decorations, which consist of designs executed in reds, browns, and yellows, sometimes with a bit of blue and black. Their style resembles that of contemporary Mayan wall paintings, and their subjects are scenes from Mayan life and mythology, showing the elaborately costumed priests and deities of the Indians. Inscriptions in Mayan glyphs placed beside or above the scene may describe the subject or give the date when the vessel was made (fig. 63). Other pots, especially the incense burners, have relief decorations showing gods and deities.

The other notable art form chosen by Mayan potters was that of small clay statues. Often called Jaina figures, after the island off the coast of Campeche in southern Mexico where a great many of them were found, they have been discovered in large numbers at many burial locations. Despite their small size, the Jaina figures are major manifestations of Mayan art and reflect the high artistic culture of the time. Like the Tanagra figures of ancient Greece and T'ang grave figures, they are masterpieces of small-scale sculpture.

The subjects of Jaina figures come from contemporary Mayan life and include warriors with their shields and weapons, noble priests with rich jewels and feathered headdresses, beautiful young women with soft, sensuous bodies, and old women with wrinkled flesh. A strange type shows an old man making love to a young girl. All of these figures show great attention to naturalistic detail, and so they give us a vivid sense of the refinement and sophistication of Mayan culture (fig. 64).

While Mayan civilization flourished in the Yucatán, Guatemala, and Honduras, several other civilizations existed in Mexico proper. In the east, in what is now the state of Vera Cruz, there arose a culture called Remojadas, after the site where thousands of hollow clay figures were found. In contrast to the Jaina figures, these sculptures are usually quite large and less naturalistic. The faces of the images were made with molds and often decorated with black asphalt paint. The finest among them are charming figures of smiling children, said to represent child victims sacrificed during religious rites and joyful about entering Paradise (fig. 65).

In southern Mexico, the Zapotec civilization continued to be important. This phase of Zapotec culture, called Monte Alban III by archaeologists, maintained the artistic traditions of the earlier period. Its most remarkable ceramic creations are funerary urns that often represent strange and haunting forms of the Indian gods in a highly expressive manner. A figure of the bat god, for example, combines human, animal, and mythical features to create a genuinely horrifying face (fig. 66). Intended as containers to hold offerings for the gods, and food and drink for the world of the dead, they are magnificent sculptures.

In South America, great artistic activity appeared in the highlands of Peru and Bolivia. The most remarkable civilization was that of Tiahuanaco, located high in the mountains of the Andes. Characteristic works of pottery are tall, graceful, concave-sided beakers known as kero, decorated with brightly colored designs. These pictures are so highly stylized that even felines and condors appear as abstractions that relate to the shape of the vessel (fig. 67). There are also effigy vessels incorporating all kinds of subjects, including human forms.

The most remarkable find in sub-Saharan Africa from the middle of the first millennium was made in the eastern Transvaal, South Africa. In a field outside Lydenburg, pottery sherds were found that, when painstakingly fit together, made up seven helmet-shaped heads. Two of them are large enough to be worn, although the mouth and eye openings do not seem to be positioned comfortably. With abstracted and stylized features, both incised and added to the surface, the heads have a commanding and somewhat disturbing presence. They may have been used in initiation rites. Scientific dating of the works places them between A.D. 500 and 700 (fig. 68).

Chapter 6

The Golden Age of Islamic and Chinese Ceramics, 1000–1400

The Medieval period, in many respects an enormously creative time, was also one of the most splendid in the history of ceramics. The Islamic world and China were the most important centers, but in Europe, too, there was a revival of pottery production during the eleventh and twelfth centuries. From both a technical and an artistic point of view, European work of this period surpassed anything previously made in the area.

The outstanding European regions were Germany, especially the Rhineland, and Britain. Most common was a low-fired earthenware covered with a white or cream slip, often splashed with a lead glaze. The shapes were sturdy utilitarian ones. For the first time since Classical Antiquity, high-fired stoneware was also made in Europe. Unlike the earthenware, which had a red-colored body, the stoneware was gray or brown. The other great innovation of the time was the use of a salt glaze, probably introduced in the late fourteenth century by German potters. The process was invented in Raeren, near Aachen, where a dark brown stoneware resembling metal was made. It became popular throughout Europe, particularly for beer mugs.

The finest European Medieval pottery came from England. Especially during the thirteenth and fourteenth centuries, English potters made tall, slender earthenware jugs and pitchers with simple decorations of trailed or painted colored slip. The glaze was yellow-brown, sometimes tinted with a green derived from copper. These vessels were used for the storage of food and drink as well as for serving ale and wine. They were not highly valued at the time of their production, however, for ordinary people used wooden plates and bowls, while the nobility preferred pewter and silver.

Very different from German and British ceramics were those made in the Byzantine realm, including not only Anatolia and Greece but southern Italy and Sicily. The finest pottery is the so-called sgraffiti ware, red earthenware vessels dipped into a white slip. Designs were then cut into the surface and covered with a transparent glaze. Favorite decorations were birds and animals of all kinds, especially the popular Christian symbols of the dove and the eagle and lions and griffins from the Classical world. The drawing is often elegant, with a sophistication not found in northern European pottery.

Far more remarkable are the ceramics of the Islamic countries. It is this period, between the years 1000 and 1300, that constitutes the golden age of Islamic pottery. Mesopotamia, Syria, Egypt, and Spain continued to play significant roles, but the most important region for ceramics production was northern Persia. Under the tutelage of the Seljuk Turks, who conquered first Persia and then Mesopotamia, and became great patrons of the arts, the ceramics industry flourished as never before. By the twelfth century, a new style of pottery had developed that displayed rich decoration and brilliant color.

The most important sites for the manufacture of these wares were the cities of Rayy located on the major road across northern Persia and not far from Teheran, and Kashan some 125 miles to the south. After the Mongols destroyed Rayy in the thirteenth century, Sultanabad also became an important place for ceramics manufacture. Excavations carried out at these sites have brought to light many fine pots and millions of fragments. Nonetheless, it has been difficult to assign specific pieces to particular kilns, since the same type of ware was made in several different locations.

Kashan, a center of art and craft rather than government, was famous for its artist families, some of whom formed lineages lasting hundreds of years. One particularly admired product was wall tiles painted in lustre. Tradition has it that most of them were made by a single

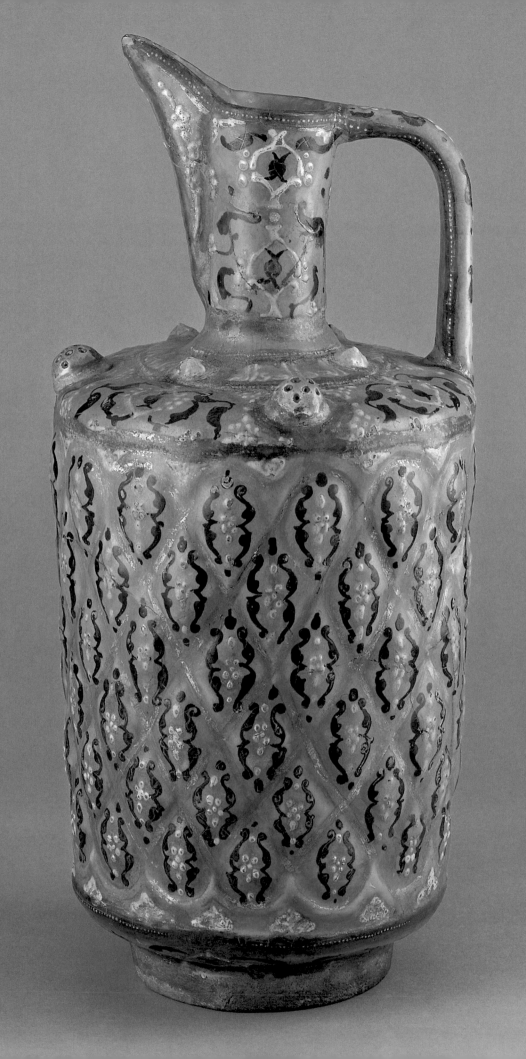

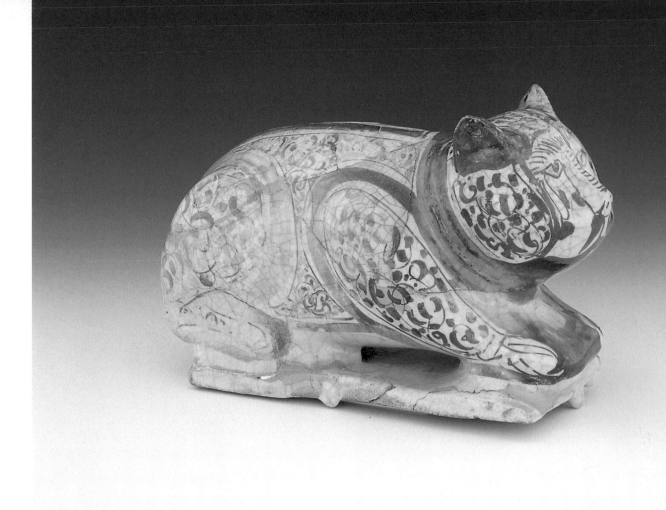

70. Painted cat, lustreware. L. 7⅝". Iran, Rayy, 13th century. (1924 4-23.1) © The British Museum, London, England.

71. Cup decorated with horsemen and falcons. H. 4½". Iran, Minai, 13th century. Collection Munsterberg, New York.

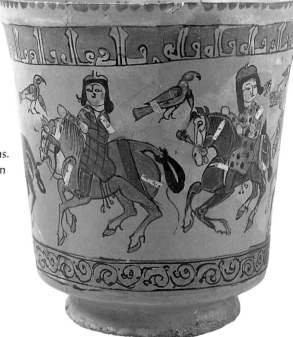

69. Ewer, earthenware with overglaze painted decoration. H. 12½". Iran, Kashan, mid–13th century. (35-31/5) The Nelson-Atkins Museum of Art, Kansas City, Missouri; Purchase, Nelson Trust.

family of potters active between 1205 and 1334. The tiles, sometimes shaped like stars and crosses, were decorated in cursive Arabic script with passages from the Koran or beautiful designs taken from the *Rubaiyat* of Omar Khayyam or poems by Nizami. The same artists also made a great variety of vessels, including plates, bowls, and decanters of low-fired earthenware like that found in earlier Islamic pottery. The decorations are subtle, with elegant arabesque patterns, floral designs, and human and animal figures (fig. 69).

From Rayy, the Seljuk capital, came the wares generally regarded as the masterpieces of Persian Islamic pottery. Although not as technically advanced as Chinese work, these ceramics are outstanding for the beauty of their colors and the loveliness of their painted decorations. Among the monochromes, the turquoise and bright blue pieces are the most striking, but soft purple, yellow green, and brown also were used. Most refined are the white wares, inspired by Chinese Ting and Ch'ing-pai ceramics exported to Persia around the year 1000. The potting of their hard white bodies was so thin that, although not actually porcelains, they became translucent. Little holes filled with a colorless glaze sometimes pierce the walls of these vessels, making charming decorative patterns. Other pottery types include lustreware, which was mastered by Rayy potters during the late twelfth century (fig. 70).

The finest polychrome ceramics are Minai wares, an elegant pottery decorated with enamel colors, and Lakabi or painted pots. While most Minai probably comes from Rayy, Lakabi ware seems to come mainly from Kashan. Typically, the body of a Minai pot is covered with a turquoise-blue glaze, described as the color of a hedgesparrow's eggs. The surface was built up in gilded relief and painted in bright enamel colors. This complex process demanded several firings and great technical mastery. Pictorial designs come from the national epic *Shah Nameh*, Persian poetry, or court life. Executed by professional painters who specialized in pottery decoration, they reflect the style of contemporary manuscript illuminations. These pots provide the main source of our knowledge about Seljuk painting (fig. 71).

Lakabi pottery also was decorated in a variety of colors, but with a very different style and technique. The designs on the surface were carved in the manner of cloisonné, with grooves and raised outlines that confined the colored glazes to designated areas. Favorite colors were blue, yellow, purple, and green, which were applied in rich, deep glazes in the hollow areas and a thin, lighter glaze in the raised parts. These decorations, often of great beauty, are simpler and visually stronger than those of Minai wares. The subjects are not literary ones, but heraldic animals such as lions and birds, and the manner of rendition is highly stylized.

The most important ceramics centers outside of Persia were Rakka on the Euphrates River in Mesopotamia, Cairo, and Damascus. Outstanding among the productions of Rakka are lovely bowls and jars decorated with a rich blue ground and chocolate-brown lustre painting. A particularly fine example displays a marvelous bird represented with sweeping, elegant lines (fig. 72). Other characteristic works are large jars and jugs, often carved in high relief with vigorous arabesque patterns and beautiful calligraphy. Typically, the potters painted their designs under an alkaline glaze. After the sacking of Rakka in 1259, ceramics production moved to Damascus, where this technique continued to develop until the fifteenth century.

Egypt, which was ruled by the Fatimid dynasty until 1171, still produced fine lustreware in Cairo and Fayum. The most distinctive of these pots represent scenes from contemporary life and even Christian subjects. The designs show the influence of Classical naturalism as well as a more formal, patterned style of the Near East. With the end of Fatimid rule, however, the ceramics industry declined dramatically as artists left for more promising prospects in Persia and possibly even Spain.

From these centers, Islamic pottery spread all over North Africa and as far as Spain, where the Umayyads had established a caliphate in Cordova in 756. Initially, the ceramics used at the Spanish court were imported from Mesopotamia, but a native Hispano-Moresque pottery industry developed during the eleventh century. Its chief product was lustreware, which influenced the rest of Europe. The main production centers were Málaga and then Valencia. Aragon and Catalonia also had potters, but the Christian conquest of these territories ended their work.

The most celebrated examples of early Spanish Islamic pottery are the Alhambra vases, so named because the finest of them are in the Alhambra Palace in Granada. Sometimes standing as high as four feet, they are among the most impressive ceramics made at the time. Designed for show and displayed in special niches built to accommodate them, the vases reflect the splendor and wealth of Islamic court life. They were made in several sections, with the flat winged handles attached to the body. Decoration consists of stylized animals, flowers, leaves, and Arabic inscriptions executed in golden lustre. The highly developed technical knowledge they rely upon probably came from imported Persian and Mesopotamian workers (fig. 73).

This was the time of the Sung dynasty (960–1279) in China. No other pottery has been so much admired by modern artists and collectors, and prices in excess of a million dollars have been paid for exceptional pieces. In contrast to Islamic ceramics, which largely consist of low-fired earthenware and are outstanding for their colors and dec-

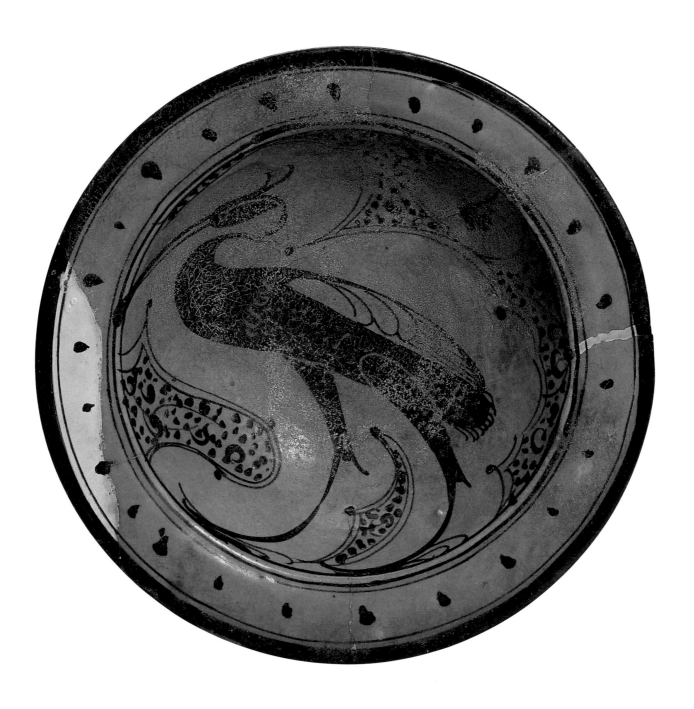

72. Bowl with stylized bird. Diam. 10⅛". Syria, Rakka,
19th century. (47.8) Freer Gallery of Art, Smithsonian
Institution, Washington, D.C.

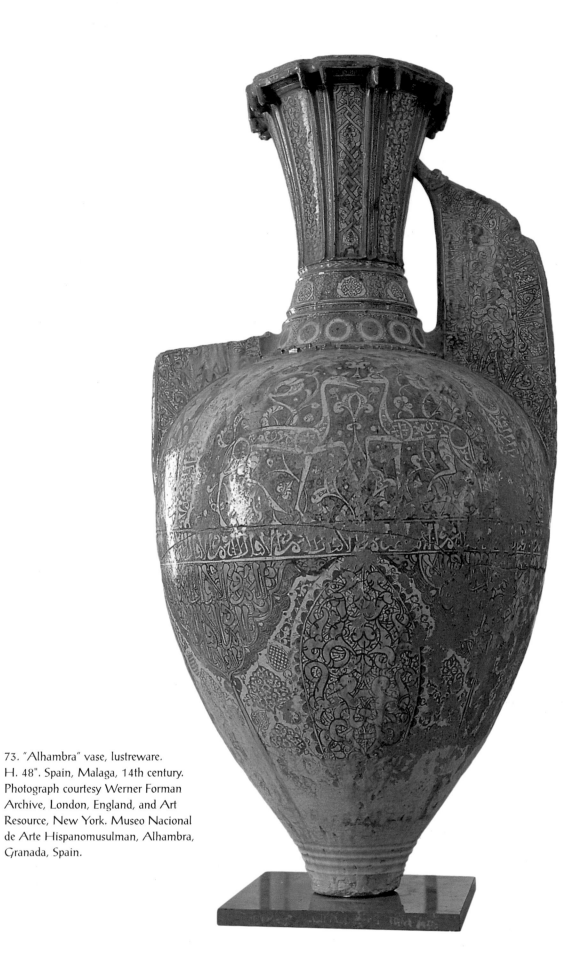

73. "Alhambra" vase, lustreware.
H. 48". Spain, Malaga, 14th century.
Photograph courtesy Werner Forman
Archive, London, England, and Art
Resource, New York. Museo Nacional
de Arte Hispanomusulman, Alhambra,
Granada, Spain.

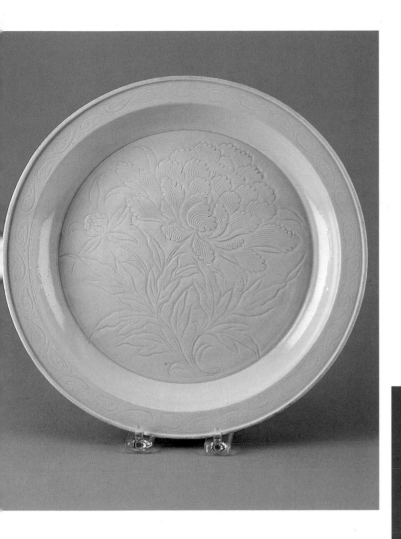

74. Plate with incised designs. Diam. 10½". China, Ting ware, Northern Sung dynasty, 12th century. (33-7/11) The Nelson-Atkins Museum of Art, Kansas City, Missouri; Purchase, Nelson Trust.

75. Covered jar. H. 10½". China, Ying-ch'ing ware, Northern Sung dynasty, c. 1100. (77-10) The Nelson Atkins Museum of Art, Kansas City, Missouri; Gift of Mrs. George H. Bunting, Jr. in honor of Laurence Sickman.

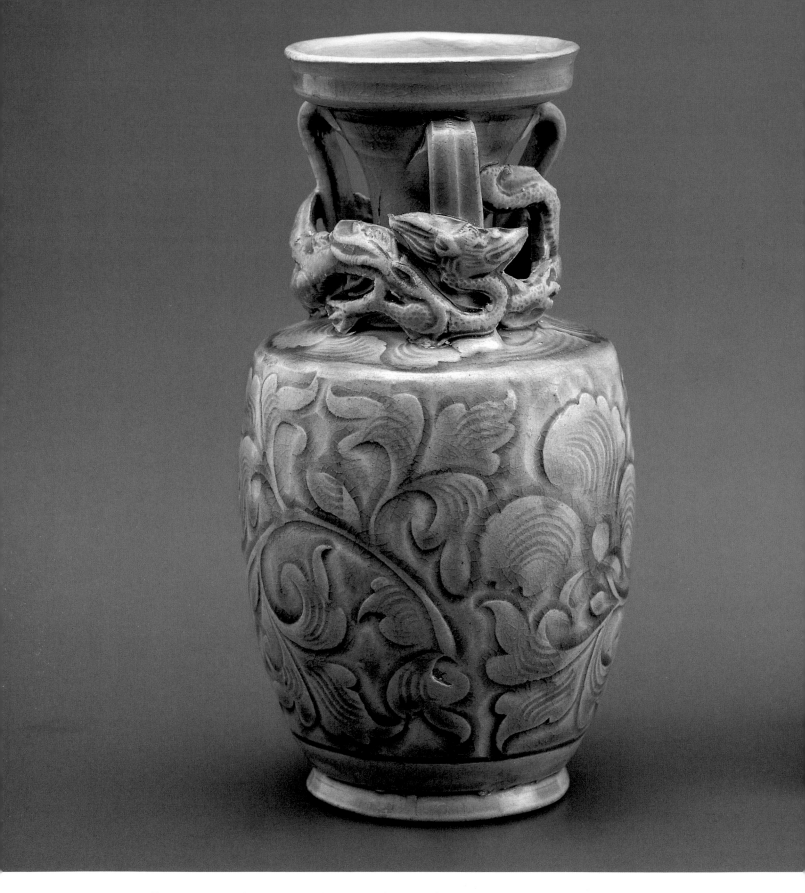

76. Funerary vase, celadon. H. 7¹⁵⁄₁₆". China, Lung-ch'an, Northern Sung dynasty, 13th century. (53.62) Seattle Art Museum, Seattle, Washington; Eugene Fuller Memorial Collection.

oration, Sung pots are either stonewares or porcelains. They rely on the elegance of their shapes and the beauty of their glazes for aesthetic effect.

During the first half of the Sung dynasty, the ceramics industry was centered largely in northern China. After conquest by nomadic tribes in the beginning of the twelfth century, however, the capital moved to modern Hangchow in southern China and with it went much of the pottery production. But modern excavations have shown that kilns scattered all over China still made a variety of wares, apparently responding to the demands of local markets. The same location might produce refined porcelains for the Imperial Court and simple folk pottery intended for ordinary people.

The finest of the northern porcelains is the Ting, named after kiln sites in Hopei province. Although the type goes back to the ninth century, the best Ting ceramics date from the late eleventh and twelfth centuries. They are exquisitely potted white porcelains with a transparent ivory-toned glaze and delicate designs carved or incised on traditionally shaped vessels. Favorite motifs include the lotus or peony, ducks among reeds, dragons, or fish swimming in a pond. Often the incised lines are so delicately applied as to be hardly visible, adding a quality of allusiveness to the design (fig. 74). Ting potters also impressed molds on the surface of the vessels before firing, and there are soft dark brown and dense black wares, but these are not typical.

The best Sung porcelains made in the south come from Kiangsi province, not far from the famous pottery city of Ch'ing-te Chen, which was to become the main center of ceramics manufacture during Ming and Ch'ing times. The porcelain made here is a delicate white ware with a slight bluish tinge. Peking art dealers called it Ying-ch'ing or "shadow blue," but today an older term found in Chinese literary sources, Ch'ing-pai or "clear white," is used. In addition to incising designs, potters practiced combing, which uses broken dotted lines instead of continuous ones, and molding. Favorite motifs were birds, floral patterns, and leaf designs (fig. 75). In contrast to the Ting kilns, which ceased production after the fall of the Northern Sung rulers, the Ch'ing-pai kilns continued to produce excellent pottery well into the fourteenth century. This ware enjoyed widespread popularity in China itself as well as in Southeast Asia and the Islamic world, where it influenced Persian pottery.

The best-known of all Sung ceramics is probably the green ware called celadon in the West and Lung-ch'uan in China after the market town in Chekiang province near which the best of this pottery was made. It is related to the older Yueh ware, which it effectively replaced. The most distinctive feature of celadon is its color, which ranges from a bright bluish-green to an olive or gray green, depending on the composition of the glaze and firing methods. Decoration was carved, incised, impressed with molds, or appliquéd, but here again it is the grace of the shapes and the lovely subdued colors that distinguish the finest of these wares (fig. 76).

There is general agreement that the best celadons were made during the twelfth and thirteenth centuries, but production continued through the Yuan and Ming periods. Already in Sung times, the pots ranged from high-quality porcelains intended for a cultured elite to coarse, heavy stoneware made for the ordinary customer and for export. Mallet-shaped vases enjoyed special popularity in Japan, for example, while small round boxes were popular for cosmetics.

A different type of green ware made in northern China is referred to as northern celadon, although it is not related to Lung-ch'uan pottery at all. The most important kilns seem to have been in Shensi province under the government of Yao Chou. These so-called Yao-Chou pots are porcelaneous stoneware with grayish bodies and an olive-green or olive-brown glaze. Decoration usually is carved or molded in low relief and resembles designs found in contemporary metalwork.

The two stonewares most admired in China were the Chun and Chien, both of which flourished primarily during the Sung period. One of the centers for the production of Chun was Honan province, but it was made in many other sites in this area. The shapes employed are utilitarian and the potting rather heavy. The most outstanding characteristic of these stonewares is their color, which consists of a lovely bluish-purple tone, ranging all the way from a soft, subdued pale blue to a reddish purple. Some of the finest pieces also have splashes of red, which came from adding copper oxide. This technique apparently was developed during the twelfth century (see Frontispiece opposite title page).

Chien ware, on the other hand, was made in a mountain village in Fukien province. Intended for local use, these tea bowls are a plain dark brown or blackish stoneware, with a thick iron glaze that varies from a yellowish-brown to black. They were imported in large quantities to Japan by the tea masters, who called the ware temmoku. These Chien bowls seemed the very essence of the aesthetic they referred to as shibui, meaning that the object had a subdued elegance, simplicity, strength, and chaste beauty. Some of the bowls are decorated with silver spots called oil spots, or streaks called hare's fur, but most are plain brown bowls (fig. 77).

Another Sung pottery traditionally valued more highly by the Japanese than the Chinese is Tz'u-chou ware. It takes its name from the town of Tz'u-hsien in Hopei province, but was made all over northern China. This is truly a folk pottery, made at local centers for local people. It consists of a heavily potted stoneware with strong, solid shapes. The jars are often quite large, for they were used

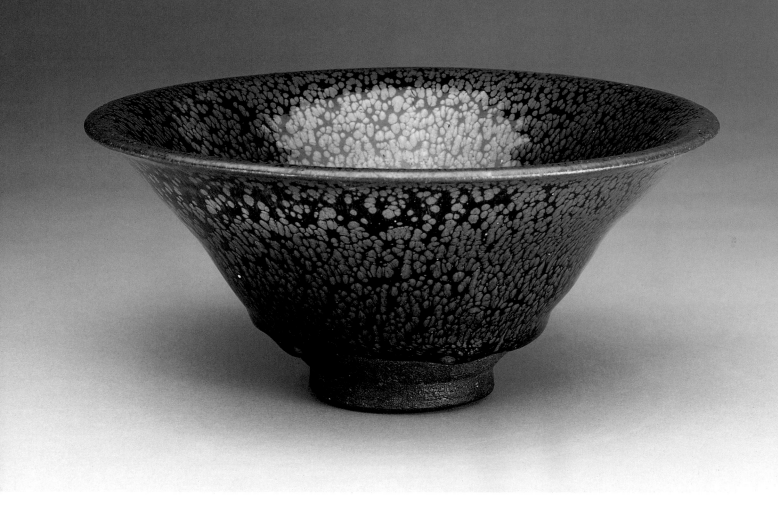

77. Tea bowl with "hare's fur" pattern. Diam. 7⁹⁄₁₆". China, Chien ware, Sung dynasty, 12th century. (09.369) Freer Gallery of Art, Smithsonian Institution, Washington, D.C.

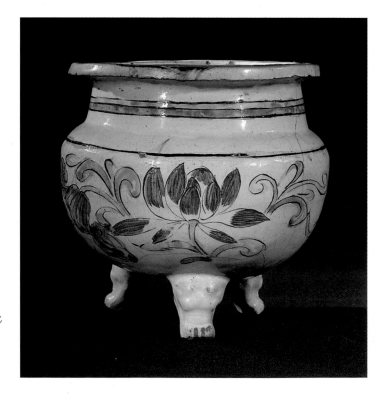

78. Incense burner with overglaze enamel lotus flowers, stoneware. H. 7¼". China, Tz'u-chou, Jin dynasty, 12th century. Courtesy Weisbrod Chinese Art Ltd., New York.

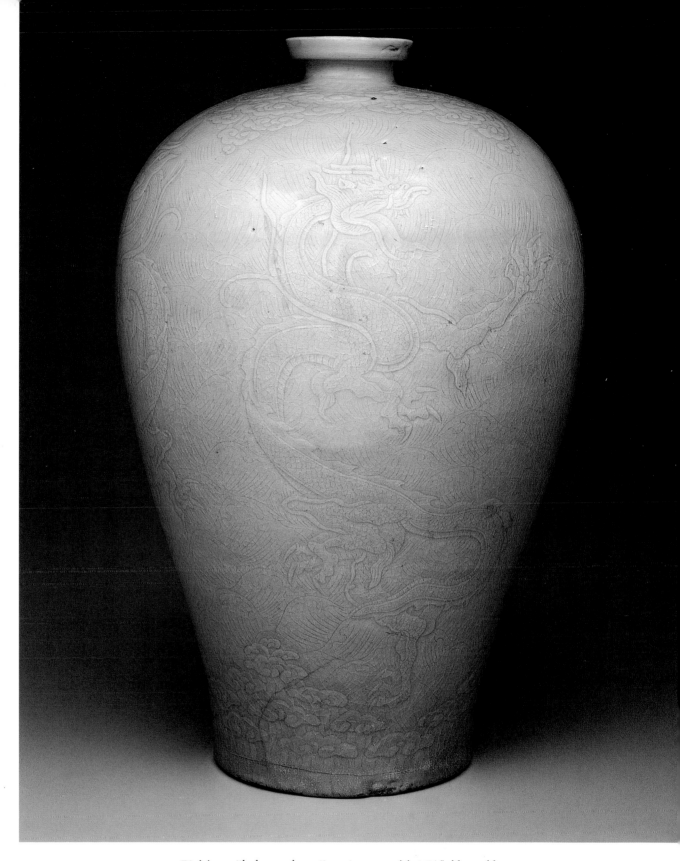

79. Vase with dragon decoration, stoneware. H. 14 1/16". Korea, Koryo
dynasty, 11th–12th century. (11.821) Museum of Fine Arts, Boston,
Massachusetts; Special Korean Pottery Fund.

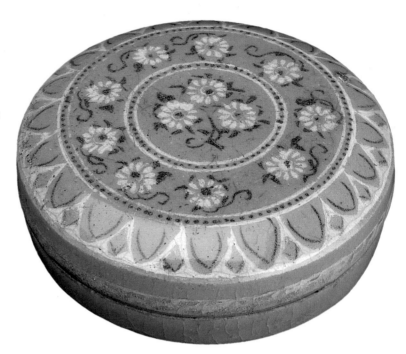

80. Box and cover with inlaid designs. Diam. 3½". Korea, Koryo dynasty, 14th century. (35.1355) Museum of Fine Arts, Boston, Massachusetts; Gift of Frederick L. Jack.

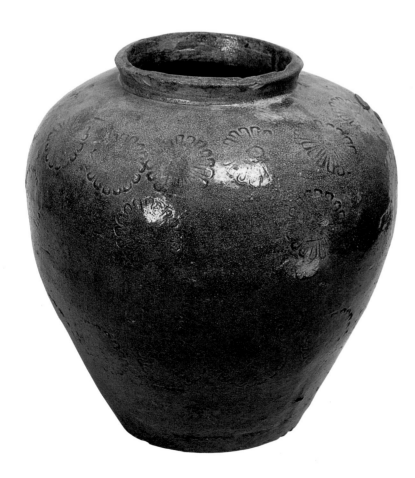

81. Jar with stamped chrysanthemum designs, stoneware. H. 9¾". Japan, Seto, Kamakura period, 14th century. Photograph by Sheldan C. Collins. Mary and Jackson Burke Foundation, New York.

82. Unglazed grain-storage jar, stoneware. H. 20". Japan, Shigaraki, Kamakura period, 14th century. (73.32) The Brooklyn Museum of Art, Brooklyn, New York; Frank L. Babbott Fund.

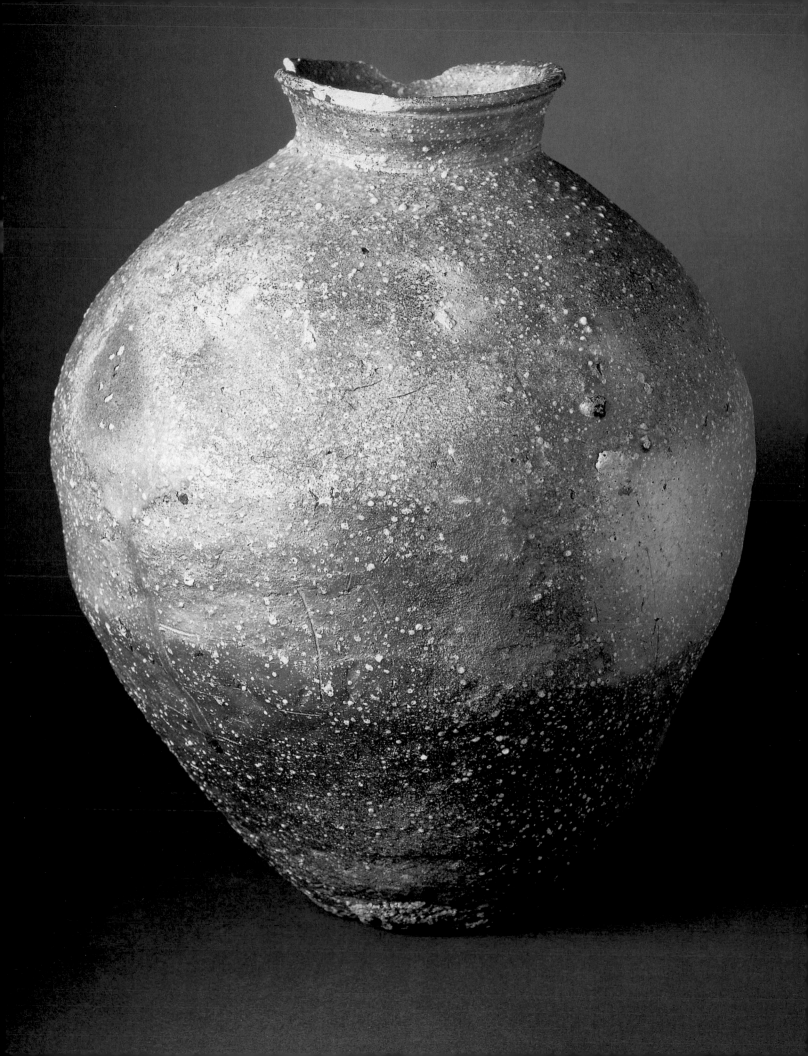

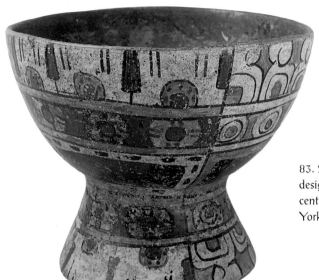

83. Stem bowl painted with geometric designs. H. 5½". Mexico, Mixtec, 14th century. Collection Munsterberg, New York.

for storage in the shops and homes of rural China. Bold painting, incising, carving, sgraffiti designs, glaze enameling, and glaze cutting were all practiced. Designs are the familiar ones of flowers, birds, and animals, especially dragons, but on Tz'u-chou pillows figures in landscape also appear. The most beautiful are often those vessels with a simple brushed design against plain white slip (fig. 78).

In Korea, too, this period was one of unprecedented creativity in the manufacture of fine ceramics. Since Korea was ruled by the Koryo dynasty (918–1392) at this time, the pottery is known as Koryo ware. The most common type was a green-glazed ware referred to as Korean celadon. The earliest of these celadons date from the ninth to the middle of the twelfth century and resemble Chinese Sung wares of the same name, but by the second half of the twelfth century, the Koreans had developed their own style. The high point of this production came during the thirteenth and fourteenth centuries with works that some connoisseurs actually prefer to Chinese examples.

Like the Chinese celadons, Koryo ware may be porcelain or stoneware, but it always is decorated with a bright bluish-green to subdued gray-green glaze. Many of the finest examples have no decoration at all, while others have designs carved or incised on the surface. Sometimes the shapes are very original. Among them are vases in the shape of gourds and melons with spouts and handles, wine pots in the form of bamboo shoots, little flat jars for oil, boxes for toilet articles, and jars with domed or sculptured lids. The modeling of these forms is fine, showing animals, birds, and floral forms (fig. 79).

The most distinctive of all Koryo ceramics are those inlaid with white and greenish-black clay, a technique invented by Korean potters. Favorite motifs were cranes and phoenixes, fish, lotus, and willow designs, executed with great skill. The finest of these inlay wares are true masterpieces, imitated but never equaled by the Japanese. In the example shown here, nearly but not quite identical flowers circle the lid of the box. Much of their vitality and charm come from the slight irregularities in their design (fig. 80).

Japanese ceramics of the time did not compare in technical or aesthetic sophistication. However, two important developments took place that were to have a lasting effect on Japanese pottery. The first was the production of genuinely glazed stoneware in Seto, Owari province, a town that was to become a center of ceramics in Japan. These wares, largely dating from the Kamakura period (1185–1336), are no doubt derived from Chinese and Korean prototypes. They may represent an attempt to make celadons, but without proper technical knowledge. Favorite shapes are broad-shouldered jars with small openings and wide-mouthed jugs. They have a thick yellowish-green, golden-brown, or black-brown glaze and decorative designs are incised or impressed beneath the glaze or applied with a simple stamping device. Seto ware of the twelfth and thirteenth centuries can be especially pleasing (fig. 81).

The other flourishing Japanese tradition of the time was that of the so-called Six Ancient Kilns. Starting with the twelfth century and continuing until the fifteenth, from

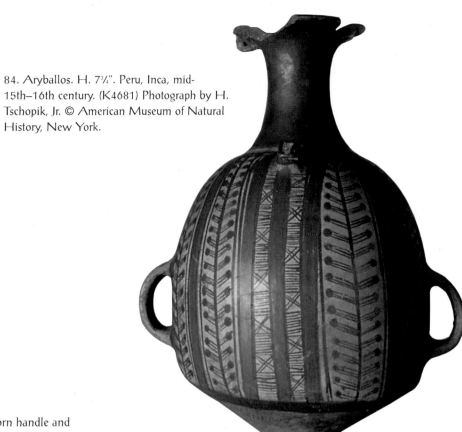

84. Aryballos. H. 7¾". Peru, Inca, mid-15th–16th century. (K4681) Photograph by H. Tschopik, Jr. © American Museum of Natural History, New York.

85. Black-on-white pitcher with double-horn handle and brown-on-cream mug with geometric designs. *(Left)* H. 6⅞"; *(Right)* H. 5". United States, Southwest, Anazasi, c. 1200. Courtesy Royal-Athena Galleries, New York.

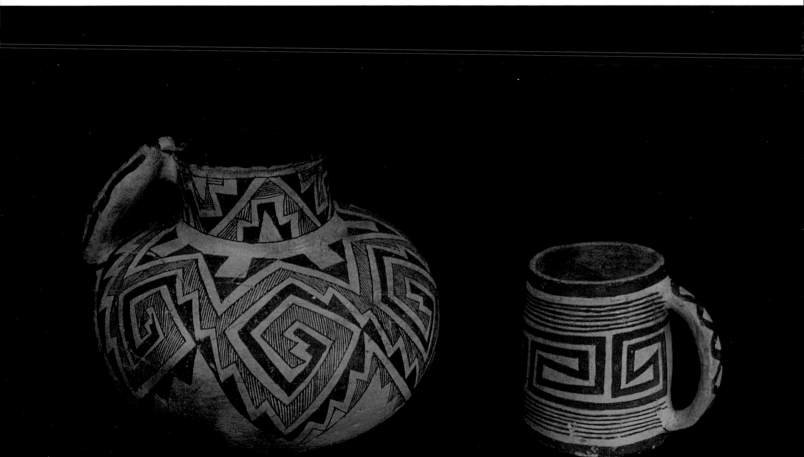

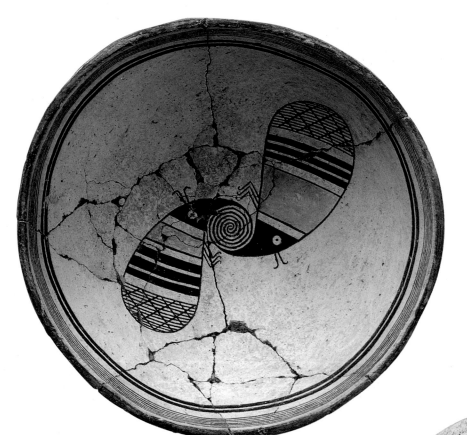

86. Bowl with insect design. Diam.
7¾". United States, New Mexico, Swarts
Ruin, Mimbres Valley, 750–1150. (26-
/-10/96024) Photograph by Hillel
Burger copyright © President and
Fellows of Harvard College. All rights
reserved. Peabody Museum, Harvard
University, Cambridge, Massachusetts.

87. Seed jar. H. 8". United States,
Arkansas, Caddoan, 11th–14th cen-
tury. (1991.69) The Metropolitan
Museum of Art, New York; Gift of Dr.
Rushton Eugene Patterson, Jr., 1991.
Photograph © 1997 The Metropolitan
Museum of Art.

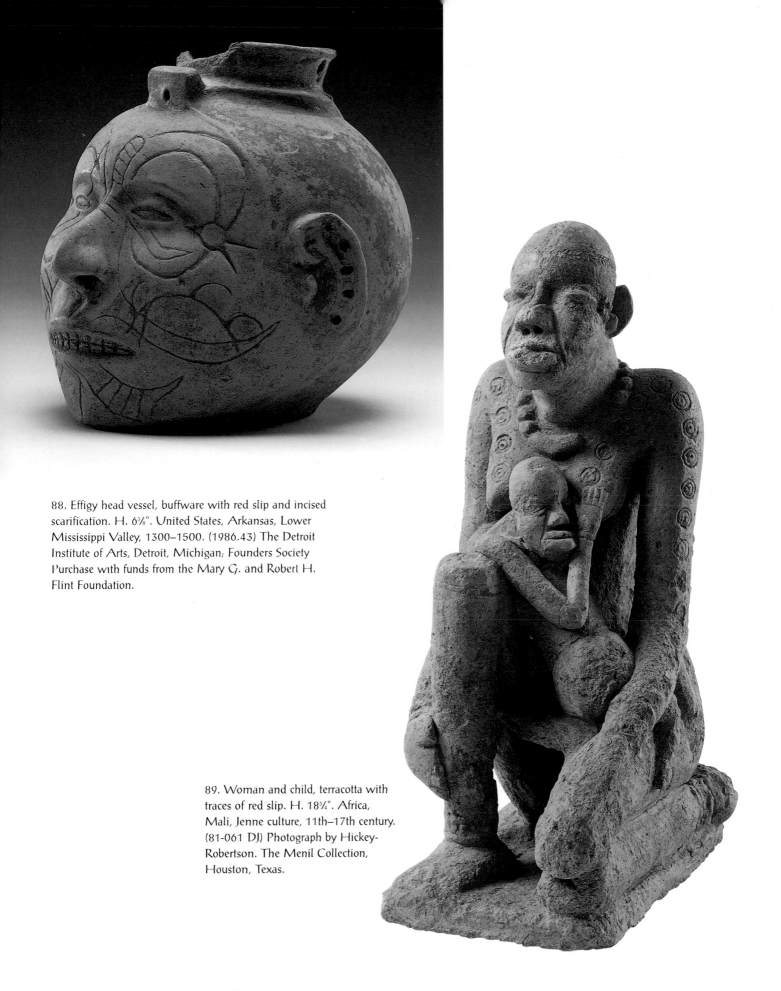

88. Effigy head vessel, buffware with red slip and incised scarification. H. 6⅜". United States, Arkansas, Lower Mississippi Valley, 1300–1500. (1986.43) The Detroit Institute of Arts, Detroit, Michigan; Founders Society Purchase with funds from the Mary G. and Robert H. Flint Foundation.

89. Woman and child, terracotta with traces of red slip. H. 18¾". Africa, Mali, Jenne culture, 11th–17th century. (81-061 DJ) Photograph by Hickey-Robertson. The Menil Collection, Houston, Texas.

the late Heian to the Muromachi period, some of the finest and most typically Japanese ceramics were made. Production centers were located in Owari, Mino, and Bizen provinces, with Tokoname, Tamba, Shigaraki, Imbe, and Seto being the sites of the main kilns. The pots are usually stoneware with a natural ash glaze. They have sturdy forms and utilitarian shapes, with water jugs, storage jars, cooking vessels, and all types of pots being the most common. Although made by ordinary people for their own use, the vessels were highly praised by tea masters as the embodiment of the unpretentious, rustic spirit they admired so much. Modern folk-art enthusiasts also place them among the masterpieces of Japanese pottery (fig. 82).

The Classical period in Ancient America had come to an end around 900 and nothing made subsequently equals the earlier masterpieces. In Mexico, the best pottery comes from the Mixtecs. Their highly decorated ceramics are known as Mixtec-Puebla works, because most of them were made in the city of Puebla south of Mexico City. A low-fired earthenware, the vessels show colorful depictions of ancient Mexican mythology and life, involving all kinds of deities, animals, and priests, as well as abstract patterns. The designs were executed in colored slips, with cream, red ochre, yellow, and black the dominant hues. This ware, it is believed, was used primarily by the priests and the nobility of the Mixtec and Aztec people (fig. 83).

In Peru, the ruling family was the Incas, who had established a great empire. They represent the last flowering of Peruvian culture before the Spanish conquest of the country. The pottery made under their rule is technically competent, but it often lacks aesthetic interest. The two main shapes are a large water jar with a pointed base to facilitate tipping it forward, called an aryballos, and a flat plate that often has handles in the form of birds' heads. Decoration usually consists of geometric designs, such as triangles, diamond shapes, and checker patterns in red, white, black, and yellow, but plant, fish, and bird designs also appear. The more abstract patterns resemble contemporary textiles (fig. 84).

In North America, a new and vital pottery culture came of age among the Indians in what is now the southwestern United States. One of the early traditions, created by the Anasazi, can be traced to about 400, but it was not until 900 that artistically significant pottery, decorated in black and white, was made. As in South America, the potters did not use a wheel and they fired at low temperatures. The clay was gray or red with black and white slip. Decorations were largely simple geometric ones, such as triangles,

zigzag designs, frets, spirals, and checkered patterns (fig. 85). Some of the patterns suggest a basketweave, possibly substantiating the suggestion that pottery began with the smearing of clay over the interior of a basket.

Another early Indian culture, called Mogollon, is most famous for Mimbres ware, named after the Mimbres River along which it was made. The style first appeared about 700 as simple red designs on polished brown pots. Then, under the influence of ceramics made by the neighboring Hohokam people, Mimbres designs became black on white and they filled the interior of bowls. No more advanced technically than ordinary Indian pottery, they show an extraordinary inventiveness and variety in decorations. Animals, birds, and insects appear, as well as human figures in a great range of situations. Found on the skull or body in graves, the bowls are usually pierced in their centers, a kind of ceremonial killing that preceded the actual burial of the deceased (fig. 86).

Eastern North America also had flourishing pre-European cultures that produced pottery. During the first millennium, from Canada to Florida, huge burial mounds were made out of earth by the people of what is called the Eastern Woodlands culture. Many ceramics have been found, but not much of particular artistic interest. In the lower Mississippi Valley, on the other hand, rich burial sites in Arkansas and Louisiana have yielded beautiful pots. Some suggest earlier traditions in Mexico and Peru, but others are quite distinct stylistically. Ovoid seed jars, for example, seem modern in the severity of their design and the elegance of their shape. They could sit comfortably beside pots by Lucie Rie (fig. 87). Entirely different are effigy vessels in the shape of human heads with a single opening at the top. The very particular patterns of scarification on the faces and the distinctive features suggest that these may represent specific individuals (fig. 88).

The most impressive African pottery known from this period comes from the Niger Inland Delta area in Mali near the city of Djenne. Dated between about 1100 and 1400, earthenware sculptures depict everything from grand equestrian figures to a mother with a child, animals, and snakes. Whether kneeling before an offering of food, or hugging one another in what seems to be the intimacy of consolation, or simply sitting male and female together, these representations have an impressive psychological presence. Although the bodies are abstracted and generalized, position, gesture, and costume create the sense of vivid living beings (fig. 89). Their purpose is unknown, although once again religious and funerary functions have been suggested.

Chapter 7

The Ceramics of Europe and Asia, 1400–1700

From the beginning of the fifteenth century to the end of the seventeenth century, ceramics flourished in Europe as well as in Ottoman Turkey, Safavid Persia, the Far East, and Africa. Only in the Americas did they cease to play a major role. In the West, where these centuries correspond to the Renaissance and Baroque periods, ceramics display a vigor and inventiveness not seen before.

The major type of pottery produced in Europe was tin-glazed earthenware, referred to as majolica in Italy, faience in France, fayence in Germany, Delft in Holland, and English Delft in Britain. Each country had a distinctive style, reflecting local traditions. The technique, which uses a lead glaze to which tin oxide has been added, originated in Islamic Mesopotamia. From there it spread to North Africa, to Spain, and then to Italy and the rest of Europe. The tin oxide produces a dense white glaze that conceals the clay body and provides a smooth surface for painted decoration. Popular colors were blue, green, yellow, orange, and purple. While some examples are very elegant with ornate forms and complex decorations, others are simple pots or plates.

In Spain, where this tin-glazed ware is known as Hispano-Moresque, production centered in Manises, a town near Valencia in the south. In contrast to earlier Islamic pottery, which had been purely Muslim with its center in Granada, this ware represents the fusion of Islamic and Christian cultural influences on the Iberian peninsula. Most striking are the boldly painted ornamental designs and decorative patterns consisting of leaves, flowers, and heraldic animals and birds. Arabic script and Gothic letters also are common decorative motifs. The colors often are brilliant, with a rich use of gold, blue, white, and other iridescent hues. Particularly fine are the large plates and medicine jars (fig. 90). Although this kind of pottery continued to be made into the eighteenth century,

the finest pieces are from the fifteenth and sixteenth centuries. A folk pottery derived from this type of tin-glazed ware still is being made in Spain and Portugal.

When Hispano-Moresque pottery reached Italy, it inspired an Italian version known as majolica after the island of Majorca from which it had been imported. In fact, the earliest examples of tin-glazed earthenware date from the thirteenth century, but the first to be known as majolica come from fifteenth-century Tuscany, especially the towns of Faenza and Florence. Lovely floral and oak-leaf patterns are painted green on a white ground. Plates, two-handled globular jars and, above all, tall cylindrical jars called albarellos, slightly waisted to make them easier to grasp, were the most popular shapes. Among them are some of the finest pots produced in Europe at the time (fig. 91).

By the end of the fifteenth century, the technique of making majolica had spread through Italy and, under the influence of Renaissance art, the style of decoration changed. Instead of simple, ornamental designs, sixteenth-century pieces show elaborate historical and mythological scenes, often created by well-known painters for rich patrons. Furthermore, these large jars and plates were intended for display, to be placed on sideboards or hung on walls, rather than as utilitarian objects. This style, known as "stile bello," enjoyed great popularity, especially among nobles and merchants (fig. 92).

Tin-glazed earthenware was also shaped into magnificent large medallions and sculpted reliefs by members of the della Robbia family. Using a technique invented by Lucca della Robbia, Lucca, his nephew Andrea della Robbia, and members of their workshop created graceful decorations that adorned many buildings in their native city of Florence. Most of them place white figures against a radiantly blue ground, but some have other colors as well

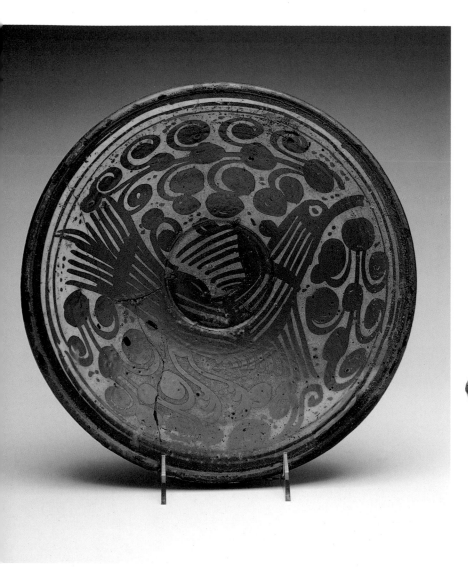

90. Plate with bird design, lustreware. Diam. 12". Spain, Hispano-Moresque, 15th century. Collection Munsterberg, New York.

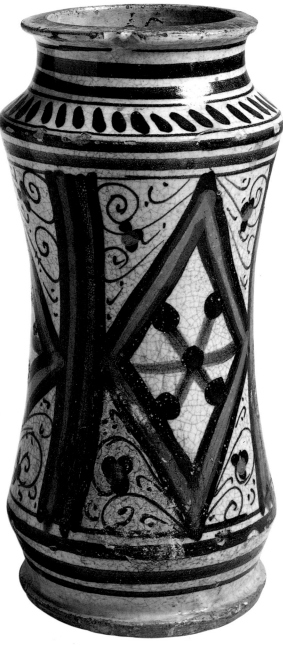

91. Albarello pot, faience. H. 8⅝". Italy, Renaissance, early 16th century. (11.696.6) The Brooklyn Museum of Art, Brooklyn, New York.

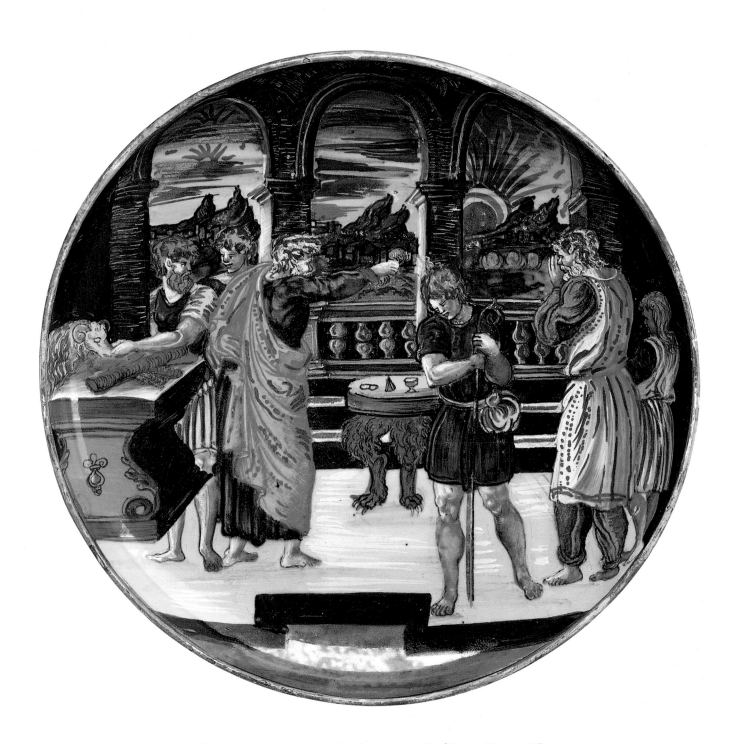

92. Plate, majolica (tin-enameled earthenware), style of Xanto. Diam. 10¾".
Italy, Urbino, and lustred in Gubbio, Renaissance, c. 1535–1545. The decora-
tive scene shows St. Paul baptizing the Corinthians. (27.97.28) The
Metropolitan Museum of Art, New York; Gift of V. Everit Macy in memory
of his wife, Edith Carpenter Macy. Photograph © 1997 The Metropolitan
Museum of Art.

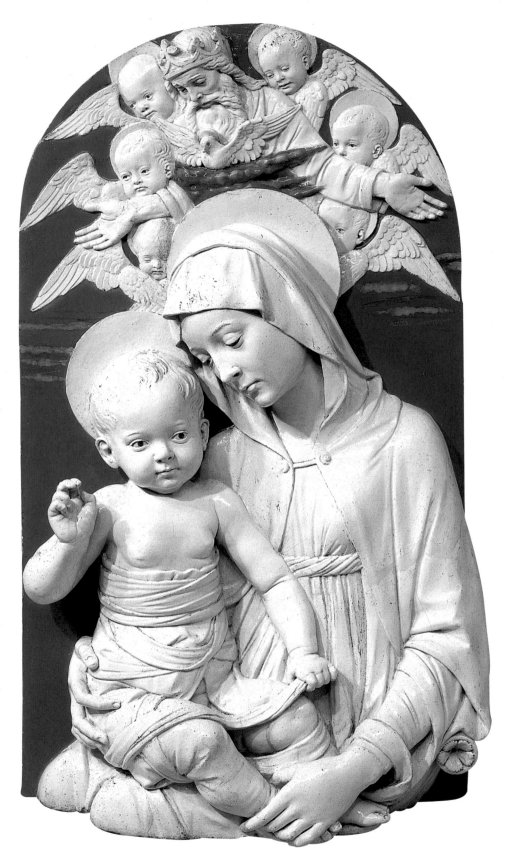

93. Relief sculpture of Madonna
and Child, glazed terracotta, by
Andrea di Marco di Simone
della Robbia (1399/1400–1482).
H. 37⅜". Italy, Florence,
c. 1470–1475. (69.113) The
Metropolitan Museum of Art,
New York; Gift of the Edith and
Herbert Lehman Foundation,
1969. Photograph © 1977 The
Metropolitan Museum of Art.

(fig. 93). Although the style of these works resembles that of contemporary sculpture in marble, the medium with which Luca della Robbia made his reputation, the crispness of the edges and the perfect smoothness of the glazed surface at once distinguish these pieces as ceramics.

In France, the pottery was known as faience, a name derived from Faenza, a town near Florence from which much of this glazed pottery was believed to have come. In historical fact, knowledge of the technique reached France through Spain and Italy. Records indicate that the Duc de Berry brought potters from Valencia to his realm as early as the fourteenth century. It was not until the sixteenth century, however, that locally produced tin-glazed pottery became popular after similar works were imported from Italy. Italian potters settled in Nîmes and Rouen and produced ceramics that closely resembled those made in Italy. By the end of the sixteenth century, a more distinctively French ware featured graceful designs of birds and flowers painted in blue on a white ground. The center for these works was Nevers in central France.

The most famous of all sixteenth-century French potters was Bernard Palissy (1510–1590). He started his professional life as a stained-glass maker, but soon turned to ceramics among other pursuits. His highly original style reflects contemporary Mannerism in its elegance and delight in surprise. All kinds of dishes and platters contain startlingly realistic snakes, lizards, frogs, fish, shells, leaves, and flowers, modeled in high relief and colored bright blue, yellow, purple-brown, and greenish-white. The sophisticated play of these works, with trompe l'oeil and with the notion of the plate as a serving dish, seems very modern. In their own time, too, they enjoyed a great deal of success as well as the compliment of imitation. Palissy produced a large body of work himself, and he inspired many followers. It is difficult, if not impossible, to distinguish among them (fig. 94).

In northern Europe, the Dutch especially took up the making of tin-glazed earthenware with great enthusiasm. As early as 1512, an Italian potter named Guido Andriesz set up a kiln in Antwerp. It was his son who, in 1564, set up the first factory for this kind of ware in Holland. The earliest of these pots resemble Italian majolica, but Dutch potters had developed a native style by the seventeenth century. Delft ceramics, named after the city in which they were made, became the most popular faience in northern Europe. Interestingly, it was skill in painting rather than potting that received the greatest professional recognition among these artisans.

The best period for Delft ware is the century between 1640 and 1740, but Delft tiles and vessels continue to be made even today. The earlier examples tend to be colored blue and white in imitation of Chinese porcelains of the Ming dynasty, which had been brought to Amsterdam in large shipments by the Dutch East India Company. An estimated three million pieces arrived between 1604 and 1637 alone. Not only was the color scheme of Delft ware derived from Chinese sources, but often the scenes represented on the vases and plates were taken from Chinese life and legend. Later Delft ware used all kinds of shapes as well as more colors, such as green, red, and yellow, and imitated Chinese transitional and K'ang Hsi porcelains as well as Japanese Imari enameled ceramics. A tulip vase with necks for individual flower stems and splendid Classicizing designs painted over the body seems particularly Dutch. In fact, it may well have been created for the apartments of Queen Mary in Hampton Court Palace, London, during her reign with William III (fig. 95).

German production of fayence also was impressive. The two most important centers were Hanau, where Dutch religious refugees established kilns in 1661, and Frankfurt, where French faience potters established themselves in 1666. Other important factories existed in Nurnberg, Augsburg, and Hamburg, all of them reflecting a strong Dutch influence. In the eighteenth century, the German fayence potters evolved their own distinct style. Characteristic pieces are jugs with carved handles and decorations of scattered flower designs, exotic birds, and religious scenes. They were painted in blue against a white ground or in rich colors, both of which create pleasing effects.

The most important contribution that German potters made to the history of ceramics was not with their fayences, however, but with their saltglaze stoneware. During the sixteenth century, German factories were the leading manufacturers of this type of pottery and they exported it all over Europe. The major center of production was the town of Raeren near Aachen. Fired to a great hardness, the pots were covered with a saltglaze that produced a rich brown color, similar to bronze. Popular shapes included mugs and tankards as well as round-bodied jugs used for serving beer. Most distinctive are those with human faces on or just below the neck, known as Bellarmines or Bartmann jugs (fig. 96). The best of these date from the second half of the sixteenth century, but they continued to be made in the seventeenth century, and even later in some places.

Although English ceramics production had declined after the great flowering of the twelfth and thirteenth centuries, it revived in the sixteenth century under the stimulus of Continental examples. The most important figure in the development of saltglaze stoneware was a seventeenth-century potter named John Dwight of Fulham, London, who made hard-vitrified wares using German techniques. He decorated his pots with finely detailed designs that had been made with metal molds. Others, especially the Elers brothers, produced an unglazed stoneware inspired by the reddish-brown I-Hsing pottery of China. Like the Chinese precedent, the English work had smooth surfaces and crisply outlined shapes.

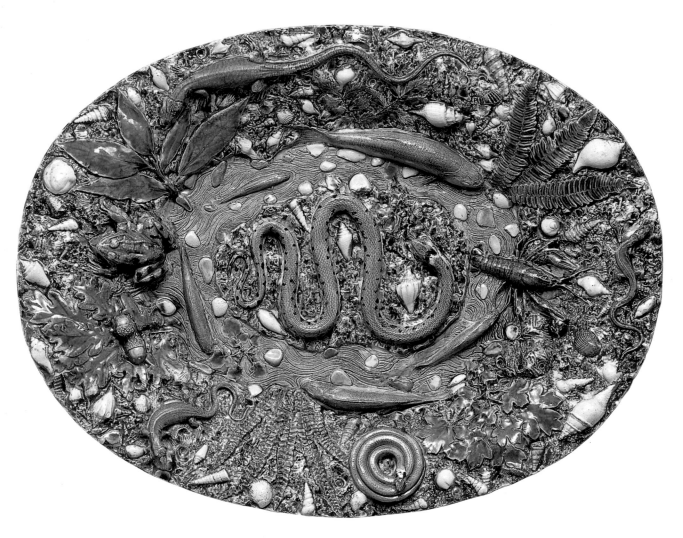

94. Platter, lead-glazed earthenware, workshop of Bernard Palissy (1510–1590). L. 20½". France, Paris, c. 1565–1570. (53.225.52) The Metropolitan Museum of Art, New York; Gift of Julia A. Berwind, 1953. Photograph © 1995 The Metropolitan Museum of Art.

95. Flower vase, tin-enameled earthenware (Delft ware). Designed by Daniel Marot (1663–1752), and probably made for the apartments of Queen Mary II at Hampton Court Palace, London. H. 28½". Holland, Delft, made at "Greek A" factory, period of Adrianus Koecks (active 1687–1701). (1994.218a-c) The Metropolitan Museum of Art, New York; Purchase, Bequest of Helen Hay Whitney and Gift of George D. Widener, by exchange, 1994. Photograph © 1995 The Metropolitan Museum of Art.

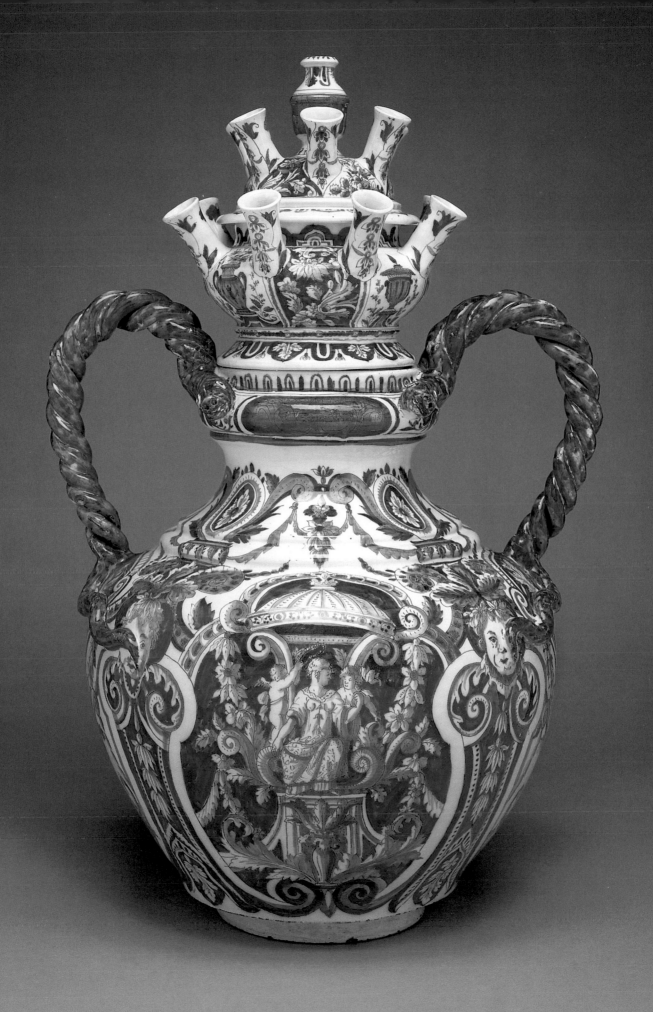

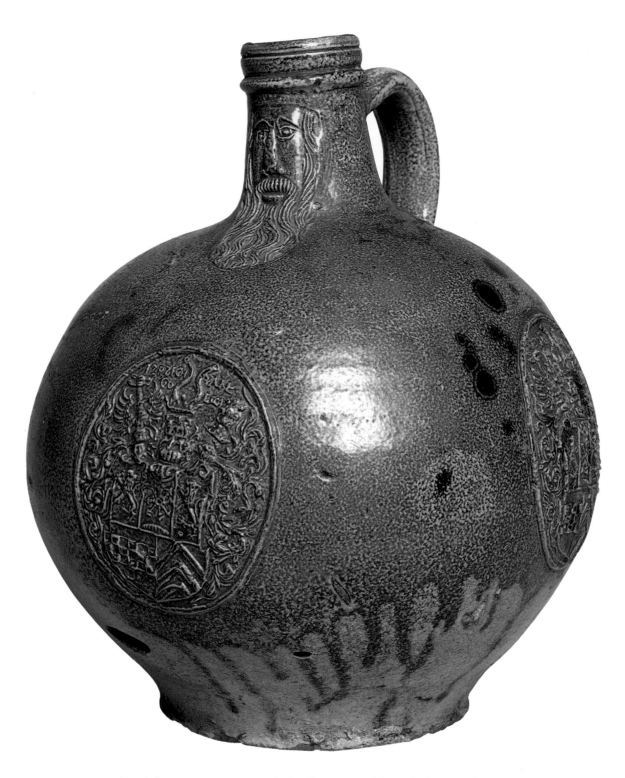

96. Bearded man wine container, salt-glazed stoneware. H. 10⅜". Germany, Raeren, c. 1600.
(BR66.39) Busch-Reisinger Museum of Art, Harvard University, Cambridge, Massachusetts.
Copyright © President and Fellows, Harvard College, Harvard University Art Museums.

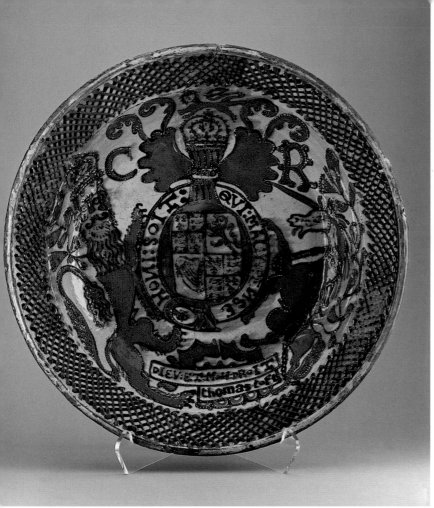

97. Royal Arms charger, slipware, made by Thomas Toft (active 1660–1680). Diam. 20½". England, 1660. (41-23/789) The Nelson-Atkins Museum of Art, Kansas City, Missouri; Gift of Mr. and Mrs. Frank P. Burnap.

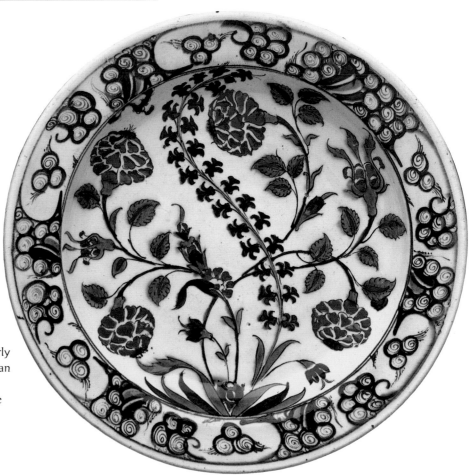

98. Plate with floral designs, glazed pottery. Diam.12⅝". Turkey, Iznik, early 17th century. (28.21) The Metropolitan Museum of Art, New York; Rogers Fund, 1928. Photograph © 1997 The Metropolitan Museum of Art.

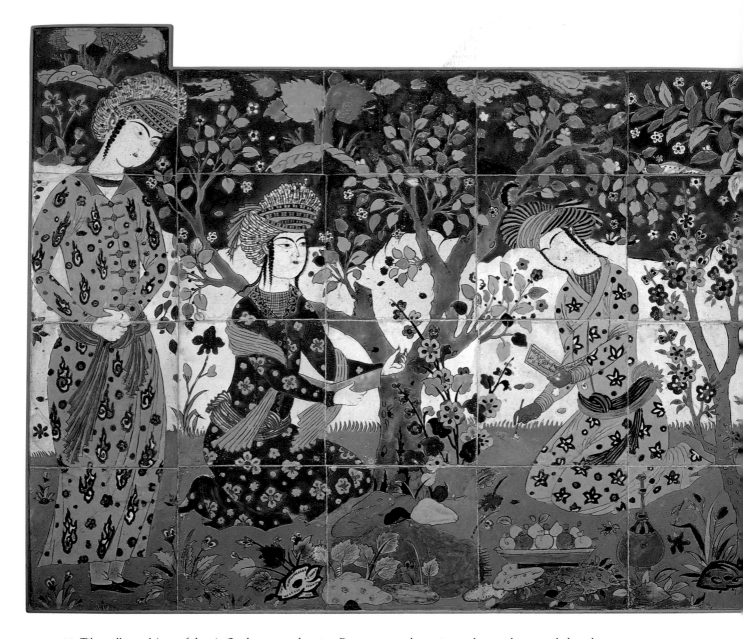

99. Tile wall panel (one of three): Garden scene showing European merchants in royal grounds, enameled earthenware. H. 38", W. 63". Iran, Isfahan, 1600–1650; probably from the palace pavilion Chehel Sutun built by Shah Abbas (1583–1627). (03.9b) The Metropolitan Museum of Art, New York; Rogers fund, 1903. Photograph © 1983 The Metropolitan Museum of Art.

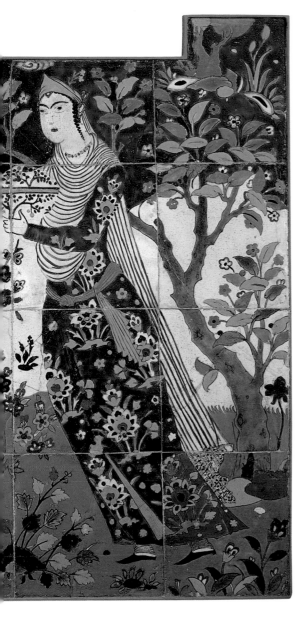

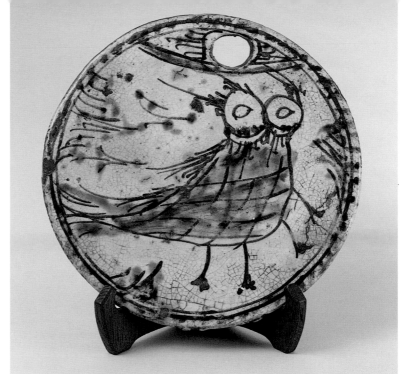

100. Beehive cover painted with a bee-bird. Diam. 8¼". Iran, 17th century. Collection Munsterberg, New York.

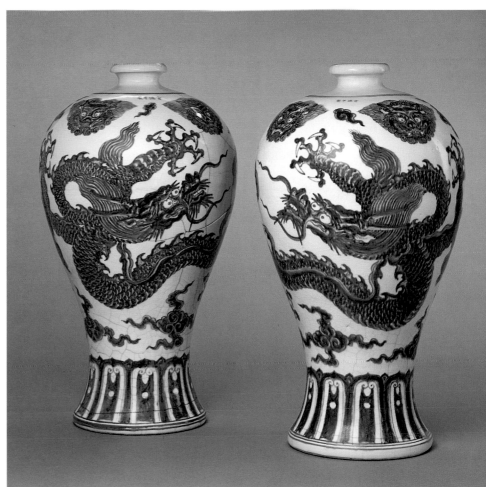

101. Pair of left and right vases, porcelain with underglaze blue dragon designs. H. 21¾". China, Ming dynasty, 1426–1435. (40-45/1,2) The Nelson-Atkins Museum of Art, Kansas City, Missouri; Purchase, Nelson Trust.

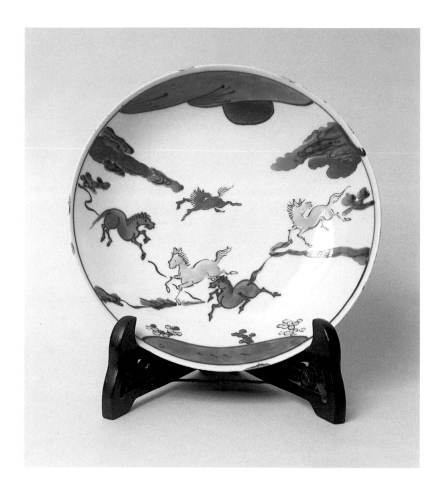

102. Five-color plate with horse designs, porcelain. Diam. 6¼" China, Ming dynasty, 17th century. Collection Munsterberg, New York.

A Dutch potter in Norwich introduced the Dutch Delft technique to England. The centers for English Delft pottery were the Lambeth district of London and Bristol. These produced very beautiful ceramics, a distinctly English type of faience. The most striking pieces are the large plates referred to as chargers, intended for display on the sideboard. Popular subjects included Adam and Eve, the kings and queens of England, famous figures of contemporary history, such as the Duke of Marlborough or Prince Eugene of Savoy, and animals. These designs were painted in an often delightfully naïve style. Bristol potters also made wares decorated with stylized floral designs in bright blues, greens, and oranges. This tradition of faience lasted until about 1800.

Another important center was Staffordshire, in the Midlands, where lead-glazed earthenware decorated with colored slips was made by the Toft family. A true folk pottery, Toft ware displays a remarkable boldness and vitality in its designs. Although all kinds of vessels could be treated in this style, the best-known shapes are dishes and plates. Such was its popularity that many potters signed their works with the name of Thomas Toft, in effect creating an entire school from the style of a single family. These works still enjoy great popularity among potters and collectors today (fig. 97).

In the Islamic world, Ottoman Turkey and Safavid Persia contributed most to the history of ceramics. Isnik, located near Istanbul in western Turkey, produced brilliantly colored plates, dishes, jugs, and lamps from the beginning of the sixteenth to the beginning of the eighteenth century. Also outstanding are the ornamental tiles that decorate the walls of the palaces and mosques in Istanbul. Favorite colors were turquoise, blue, purple, green, and red, painted onto a creamy white ground. Designs were usually of flowers rendered in a realistic style, with tulips, roses, carnations, and hyacinths being the most popular (fig. 98), but sometimes boats and genre scenes decorate the pieces. These same motifs appear in contemporary textiles.

The Persian ceramics industry had declined after the Mongol conquest. For a time, local potters tried to imitate Chinese blue-and-white porcelains as well as celadons, but

they never equaled the originals in technical or artistic quality. Nevertheless, these Persian ceramics in Ming style enjoyed great popularity in India, Europe, and England. Around 1600, however, under the ruler and grand patron of the arts, Shah Abbas, the capital was moved to Isfahan and a Safavid style developed. Magnificent examples of architecture, tilework, metalwork, textiles, glass, and ceramics were made to decorate the new city. An enameled earthenware wall panel suggests the visual delights. Possibly from one of Shah Abbas's royal pavilions, the tiled scene shows four European merchants resting in the beautiful gardens of the palace. Clearly they savor the elegance and abundance of the nature around them (fig. 99).

Ceramics made under the Safavid rulers included a soft-paste porcelain and a revival of lustreware in Kashan. There was also a new, truly native style of pottery. Known as Kubachi after the small town in the Caucasus where most of the work has been found, large plates and dishes display rich polychrome decorations painted under a clear glaze. Designs represent human figures, animals, and floral patterns, with the last most common in later works. Other pieces from the period reflect more provincial folk traditions, such as a lid to a beehive decorated with a charming bee-bird (fig. 100).

The ruling family in China was the Ming dynasty (1368–1644), which was a great patron of the arts. In contrast to Europe and the Islamic world during this time, the output of the Chinese kilns consisted largely of porcelains. They exhibit a sophistication and technical mastery far superior to anything being made elsewhere. The production center was Ching-te Chen in Kiangsi province, which became the greatest city for the making of ceramics the world has ever known. Although the industry began there in the tenth century, it was not until the fourteenth century, under the reign of the Emperor Wu, that it became an official, Imperial enterprise. No fewer than several thousand kilns employed over 100,000 craftsmen.

Blue-and-white porcelains were the most characteristic product of these kilns. Those made during the fifteenth century, under the Emperors Hsuan-te (1426–1455) and Ch'eng-hua (1465–1487), are generally considered the finest porcelains of this type ever made. With pure white bodies, refined shapes, and handsome decorations painted in a cobalt-blue underglaze, they reflect Ming taste at its best. The making of these wares represents collaboration among different specialists. The pictorial designs were the work of professional porcelain painters, who provided splendid dragons, birds, flowers, and scenes from Chinese life and legend to decorate these pots (fig. 101). The cobalt, which had been imported at great expense from the Near East in earlier centuries, now came in part from local sites.

Ming potters also made several other types of wares, among which the so-called five-colored ceramics are the most prominent. While the blue of blue-and-white porcelains was painted under the glaze, these polychrome works were decorated with overglaze enamels, a technique that became popular during the fifteenth century. The earliest are ornamented in red and green, but a great variety of colors was in use by the end of the century. Although the term wu-ts'ai or five-color often refers to these pots, the actual number of colors varied. Brilliant reds, yellows, greens, and purples were applied on top of a pale white glaze. Only cobalt blue was put beneath the glaze (fig. 102).

Another Ming polychrome ware is known as fa-hua, meaning cloisonné-type enameled ware, for on these ceramics the areas of colored glaze are separated by slightly raised lines of clay. The bodies of these pots are rather heavy, tending toward porcelaneous stoneware rather than pure porcelain. The colors are subdued, with deep blues, turquoise, white, and black being the most prominent. Shapes tend to be utilitarian, although they do include garden seats in the shape of drums. Fa-hua pottery usually displays floral and leaf designs and scenes from Chinese history and mythology as decoration (fig. 103).

Monochromes, so popular during the Sung period, played a relatively minor role during the Ming dynasty. Nevertheless, potters did make beautiful ones, especially in blue, yellow, copper, red, and white. One particularly lovely example is a so-called anhua stemcup. Anhua, meaning secret, refers to the design incised onto the clay body with a needle, and done so subtly that it can be seen only when light passes through the object (fig. 104). Another type was a pure ivory-white porcelain made at Te-hua in Fukien province, called Blanc de Chine in the West. By the sixteenth century, the dense creamy white wares made there, compared to white jade by the Chinese, were valued highly. Most distinctive are the porcelain figures that represent Buddhist and Taoist deities. Under the influence of Christianity, which reached China at this time, images of the Madonna also were made.

Several other provincial kilns produced interesting ceramics. Porcelains and porcelaneous stonewares exported from the city of Swatow to Southeast Asia, Indonesia, and Japan as well as Europe, take their name from this port. Relatively crude in execution with a coarse, grainy body and freely painted decoration, the ware has a spontaneous quality particularly admired by Japanese connoisseurs. Some of the Swatow wares are painted in blue and white, but the most characteristic pieces are decorated in bright red, green, and turquoise. Pictorial motifs consist of traditional bird and flower designs as well as Chinese sailboats, Portuguese galleons, and stylized landscapes. Large plates and dishes lend themselves particularly well to these designs.

Another noteworthy local kiln was I-Hsing in Kiangsu province. In contrast to the colorful Swatow wares, I-Hsing ceramics are reddish-brown stoneware without any color

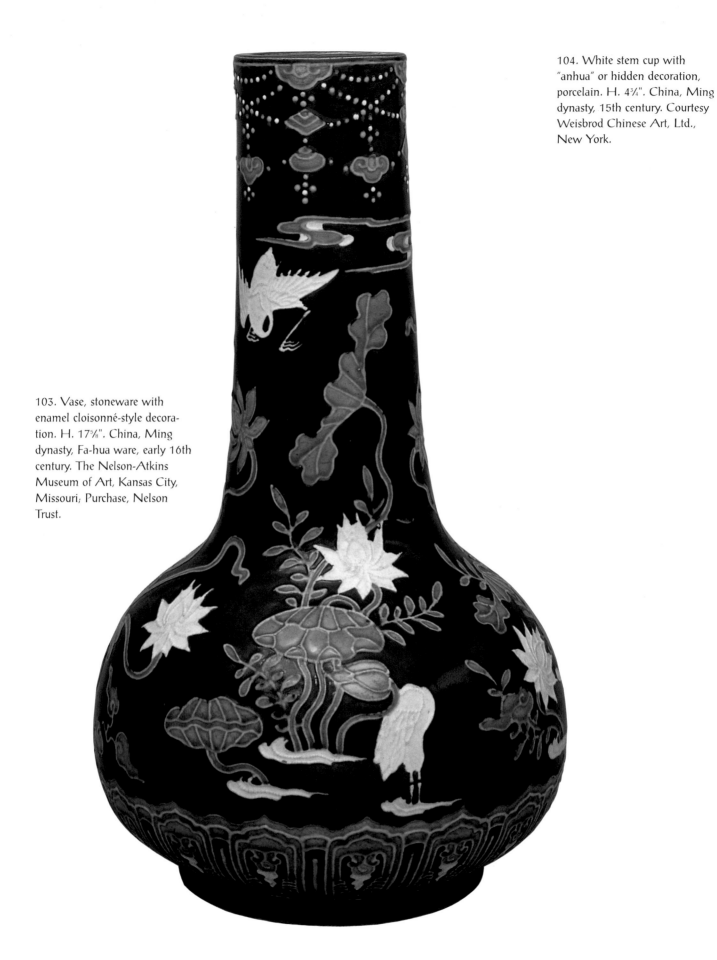

104. White stem cup with
"anhua" or hidden decoration,
porcelain. H. 4¾". China, Ming
dynasty, 15th century. Courtesy
Weisbrod Chinese Art, Ltd.,
New York.

103. Vase, stoneware with
enamel cloisonné-style decora-
tion. H. 17⅝". China, Ming
dynasty, Fa-hua ware, early 16th
century. The Nelson-Atkins
Museum of Art, Kansas City,
Missouri; Purchase, Nelson
Trust.

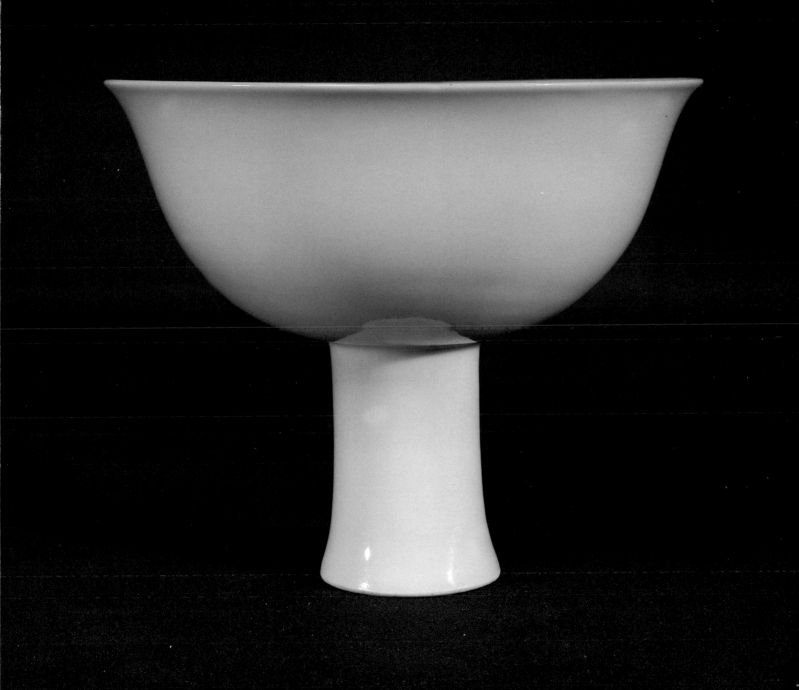

decoration. The body, which consists of a finely prepared clay, acquires a slight gloss during firing. The most common vessel is a teapot, usually a small, rounded shape, but sometimes square or hexagonal (fig. 105). Much more unusual are sculptural forms resembling bamboo, nuts, shells, and lotus pods as well as strange forms that suggest modern abstract sculptures to the contemporary eye. The best of these come from the sixteenth and seventeenth centuries, but they continued to be made into modern times. Imported in numbers to the West, they influenced both English and Continental pottery.

Korean ceramics also flourished during these centuries. In fact, the Yi period is considered the third great age of Korean pottery. In contrast to China, however, where the ceramics industry became ever more sophisticated and technically accomplished, the Korean Yi dynasty wares are less refined than those of the preceding Koryo period. This change reflects a decline in national wealth and power. At the same time, however, it resulted in a kind of unpretentious quality in the shapes as well as the style of painting

that Japanese tea masters and many modern folk-art enthusiasts have admired greatly.

Yi dynasty ceramics usually are considered in two periods. The first lasted from 1392 until 1592, when the Japanese invaded Korea, and the second from 1592 until 1910, when Korea lost its independence. The pottery made during the earlier centuries is mostly gray stoneware with a coarse texture, decorated either wholly or partially with a coating of white slip. This type of ware is known as punch'ong and has stamped or carved decoration (fig. 106). The most typical of early Yi wares are the Ido bowls. Plain rice bowls intended for Korean peasants, they were taken up by Japanese tea masters and pronounced masterpieces. Other works from this time are vases and bottles with designs boldly painted in iron oxide.

The Koreans also made porcelains in imitation of Chinese Ming blue-and-white wares, but they never equaled the originals in technical refinement. The shapes are sturdy, solid ones, well-potted and decorated with great naturalness. Popular motifs are birds and flowers,

105. Reddish-brown teapot, stoneware. H. 3½". China, I-Hsing, 18th century. Collection Munsterberg, New York.

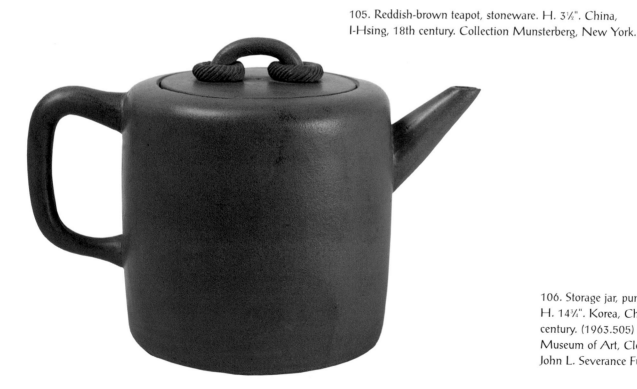

106. Storage jar, punch'ong stoneware. H. 14¾". Korea, Choson period, 15th century. (1963.505) © The Cleveland Museum of Art, Cleveland, Ohio; John L. Severance Fund.

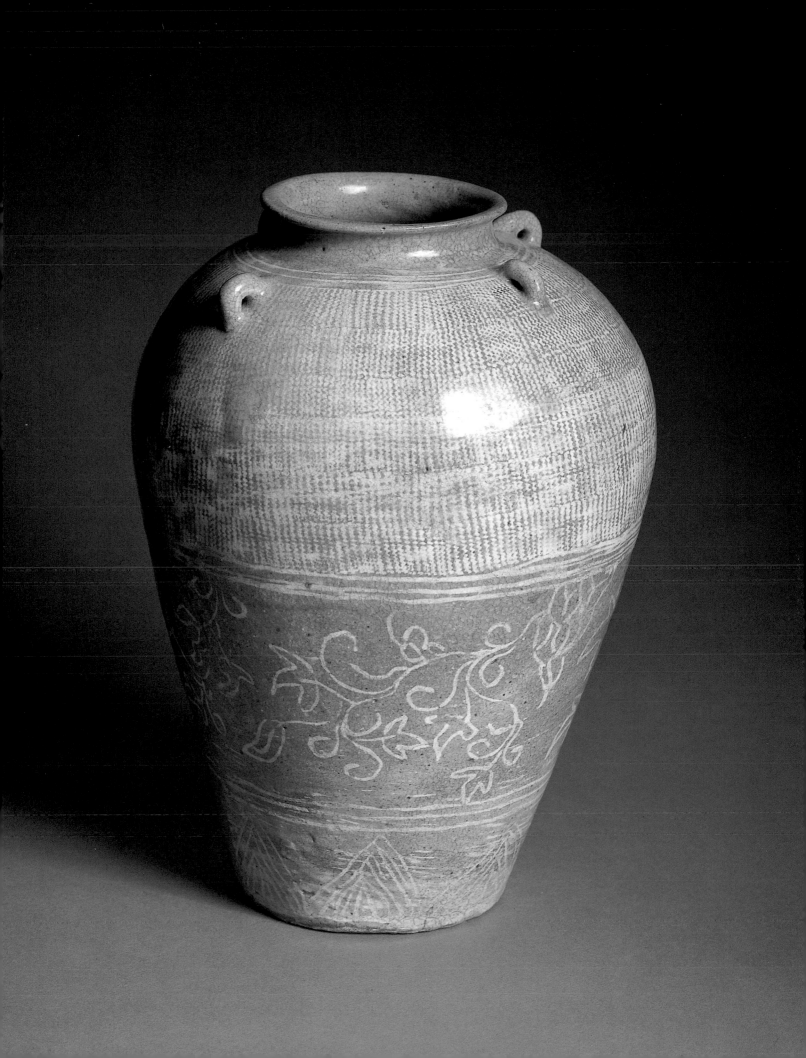

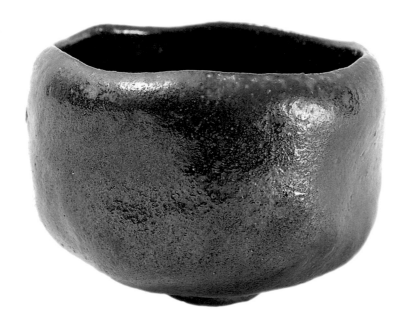

107. Black tea bowl. H. 3¼". Japan, raku, 18th century. Collection Munsterberg, New York.

108. Rounded gray bowl with squared top. L. 9". Japan, Shino, Edo period. Collection Munsterberg, New York.

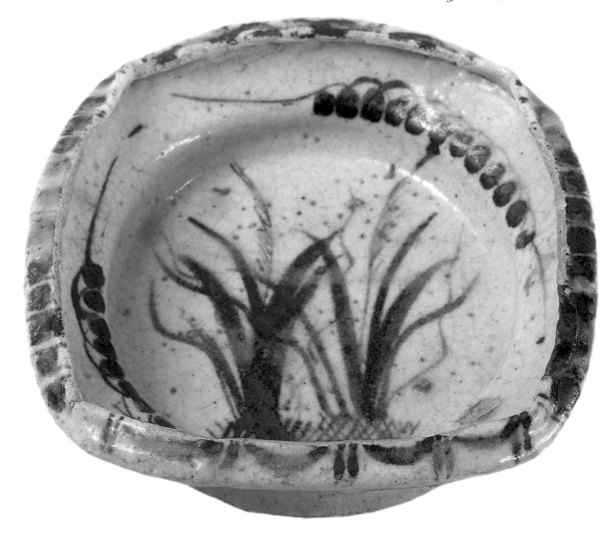

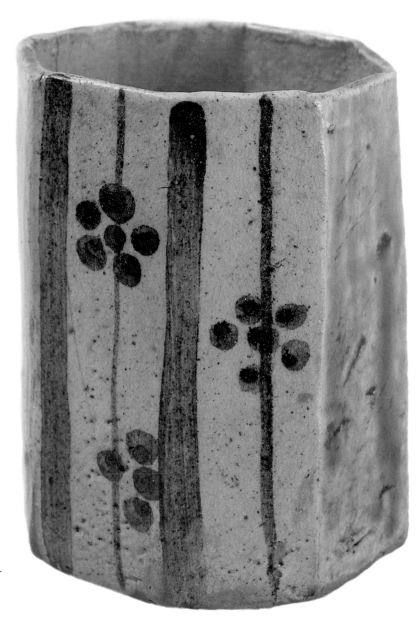

109. Octagonal cup. H. 3⅞". Japan, Oribe, Momoyama period, 16th century. Collection Munsterberg, New York.

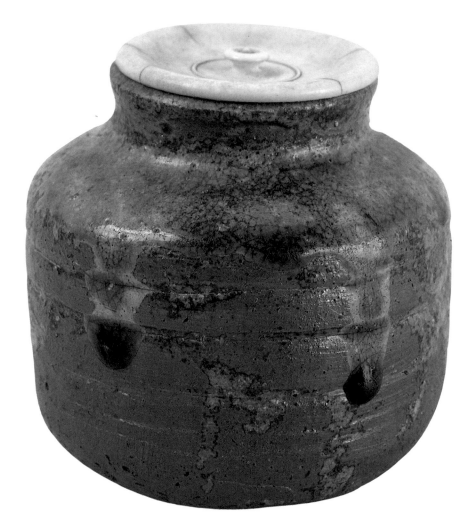

110. Tea caddy with ivory lid. H. 3⅛".
Shigaraki, Muromachi period, 16th
century. Collection Munsterberg, New
York.

dragons, and stylized landscapes rendered in a freely brushed style. Also fine are the bulbous jars covered with a thick, white glaze, and the jars and bottles decorated in an underglaze red with simple, abstract floral and leaf designs.

The third of the great ceramics traditions of eastern Asia is that of Japan, which achieved its finest triumphs during this period. Two factors stimulated this wonderful outpouring of creative energy—the patronage of the tea masters and the influx of Korean potters, forcibly brought to Japan by the warlords of the late sixteenth century. Inspired by the spirit of the tea ceremony, or chanoyu, the Japanese preferred the simplicity and rustic quality they found in Korean ceramics to the elegance and technical mastery of Chinese porcelains.

The Japanese tea ware that is best known in the modern

West, and widely imitated after the British potter Bernard Leach popularized it, is raku. Made in Kyoto, it is still produced today. Raku is a low-fired, hand-built earthenware with a dark brown or black glaze. More rarely, red and white glazes were used. Because of the speed of the firing, the exposure to flame and smoke, and the handling of the pot with tongs, raku ware is characterized by accidental effects. The glazes often develop crackle and unexpected color combinations.

The first of the raku masters, Chojiro, was discovered by the leading tea master of the sixteenth century, Sen-no-Rikyu, and given the name Raku by none other than the famous military dictator Hideyoshi, who was a tea enthusiast. Raku's work and that of his descendants was vastly admired, and it is with them that the tradition of artist-potters, so characteristic of Japan, began. Not only are raku

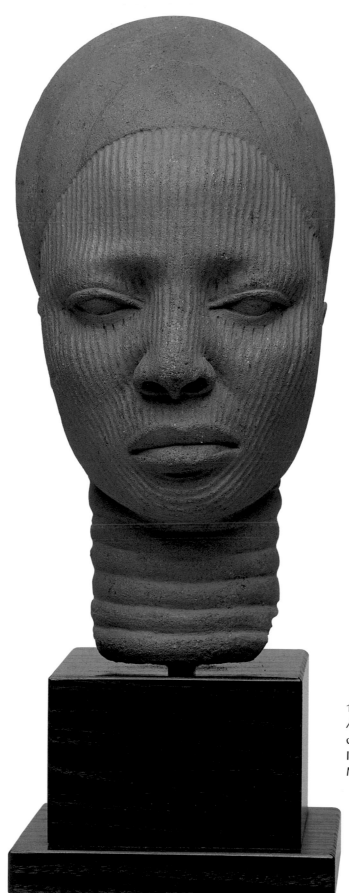

111. Shrine head, terracotta. H. 12¼".
Africa, Nigeria, Ife culture, 12th–15th
century. (95.84) The Minneapolis
Institute of Arts, Minneapolis,
Minnesota; John R. Vanderlip Fund.

pieces stamped with the seal of the potter who made them, but often individual bowls received names. A famous one was called Fuji-san, for it was said that its decoration resembled Mount Fuji on a snowy day. All of them provide splendid tactile experiences when held with hands cupped around the rough walls, warm with tea. Zen masters even licked them to experience the subtleties of the surface with greater intensity (fig. 107).

The second great center of ceramics production during the late sixteenth and seventeenth centuries was the Mino district, not far from Nagoya, a region already important for pottery. In fact, in the ancient pottery city of Seto, two types of tea ware were being produced at this time. Known as black Seto and yellow Seto, both are sturdy stonewares that easily lend themselves for use in the tea ceremony. However, the finest tea wares are Shino and Oribe, named after two illustrious tea masters of the Momoyama period. Both types are still produced today, and the leading contemporary Shino potter Arakawa Toyozo is a Living National Treasure, but it is the work of the Momoyama (1573–1615) and early Edo periods that are admired above all else.

Shino wares display a thick, creamy white glaze on a stoneware body, with abstract floral or ornamental designs executed in red iron oxide under the glaze. Consisting largely of tea bowls, water jars, dishes, and sake bottles, the pieces are highly individual and correspond to the aesthetic ideals of chanoyu. Their combination of a feeling for the shape and surface of the clay with beautiful brush drawing has great appeal for modern potters (fig. 108).

Oribe ware is similar in aesthetic sensibility to Shino, but very different in its colors. Most distinctive is its deep, intensely green copper glaze and a creamy yellowish glaze decorated with brown iron-oxide designs. Other Oribe pieces have a rich, warm green glaze, which varies all the way from light yellowish-green to a dark bluish-green. Oribe pottery is also remarkable for the variety and imagination of its shapes. In addition to tea bowls, there are covered boxes, trays with curved handles, odd-shaped dishes, and even some ceramic sculptures (fig. 109).

Raku and Mino wares were made on the main Japanese island of Honshu, while many of the most characteristic ceramics of the time come from the southern island of Kyushu. A major type of tea ware from this region is called Karatsu, after the port city of this name from which it was exported to the rest of Japan. It was not actually made there, however, but came from several small kilns scattered over northern Kyushu. Most of the kilns were established by Korean potters during the closing years of the sixteenth century and flourished during the next century. One type of Karatsu, known as Chosen or Korean Karatsu, is distinctive for its dark glazed surface partially covered by an opaque milk-white glaze. Most Karatsu ware has a dark brown or gray glaze over a stoneware body and is decorated with beautifully painted designs of grasses, plants, and flowers, executed in iron oxide.

In addition to inspiring new kinds of ceramics designed especially for chanoyu, the tea masters discovered unique beauties in wares from traditional Japanese kilns at Bizen, Tamba, Shigaraki, and Iga. These powerful and rustic pots, made for centuries by anonymous potters in rural Japan, embodied the very essence of what the masters admired. Just as they had praised Korean rice bowls for possessing the aesthetic sensibility they sought, so they also took up these native wares with enthusiasm. In doing so, however, they transformed the nature of the ceramics. With the patronage of lords and tea masters, the potters at Bizen and Shigaraki especially began to make more sophisticated pieces.

Bizen ware is unique in depending entirely on the beauty of the shapes and the reddish brown of its stoneware body for its effect. Occasionally, a pinkish design results from covering part of the pot with rice straw soaked in salt during firing, but there are never glazes or painted decorations. Even cruder are the Iga flower vases that resemble moss-covered stones with their odd shapes and rough surfaces. Like the Jōmon pots of the prehistoric period, they have a striking sculptural presence. The pots were often fired for several days until cracks appeared in their surface. Shigaraki, like Iga, was made with a coarse clay containing sand, which creates an irregular surface. For this reason, it was not used for tea bowls, but rather flower vases and water containers (fig. 110).

In Africa, these centuries saw the development of the kingdoms of Ife and Benin in Nigeria. Ife potters from the Yoruba people, working mostly from the twelfth to the fifteenth century, made superbly naturalistic heads. The representations are very specific, with details of hair, features, and facial striations, perhaps scarification, forcefully suggesting an individual presence in terms of rank and societal role. The figures that have survived intact seem to represent the ruler or members of the court and perhaps were used for second, ceremonial burials of important people. All of the faces possess a distinctive poise and thoughtful dignity (fig. 111). Fascinatingly, these heads have been found on altars with figures so abstract as to have hardly any recognizable features at all.

The royal art of Benin is perhaps the most famous from pre-Colonial Africa. First visited by Westerners in the fifteenth century, the city of Benin was highly organized, with a population of some 50,000 living around the palace walls. Benin artists are most famous for their work in bronze and ivory, but they also made ceramics. Much of the ambitious work in clay resembles contemporary bronze sculptures in style, suggesting that clay was simply used as a cheaper medium.

Chapter 8

The Century of Porcelain, 1700–1800

While faience continued to be made throughout Europe during the eighteenth century, it was the invention of true porcelain that proved the most interesting aspect of European ceramics manufacture. Not only in the Western world, but in China and Japan, fine porcelain flourished as never before. Both the dominant European period style, known as Rococo, and the veritable craze for fine porcelains in the courts of Europe as well as those of the Manchu Ch'ing dynasty, furthered this development. In quality and sheer quantity, eighteenth-century ceramics production surpassed anything the world had seen.

The first Europeans to collect porcelains systematically were the French aristocrats at the court of Louis XIV, among them Dauphin Louis, son of the French king. The most famous collector of the day was August the Strong, Elector of Saxony and King of Poland, who assembled the greatest collection of Oriental as well as Meissen porcelains. This vast gathering included not only vases, jars, and services, but perfume bottles, jewelry boxes, barber dishes, and porcelain figurines. In 1717, he demonstrated his passion by trading an entire regiment of cavalry soldiers to the King of Prussia for some choice K'ang-hsi vases, and in 1732, he built a Japanese "Palais" at his palace in Dresden to accommodate his huge collection. It is reported that in 1733, the year of his death, no fewer than 36,000 pieces had been delivered to him.

To own fine porcelains and, later in the eighteenth century, to sponsor a porcelain factory, became a status symbol among European rulers. In France, the Prince de Condé brought together a superb collection of largely Japanese porcelains at his palace in Chantilly and became the patron of a famous porcelain factory. In Prussia, it was Queen Sophie Charlotte, the wife of King Frederick I, who had a large cabinet built in her palace at Charlottenburg near Berlin for her splendid collection of Chinese, Japanese, and also German porcelains. Many other palaces in Europe had special rooms in which lavish displays covered entire walls.

Although several European potters, notably in Italy, had experimented with making porcelain, it was not until 1708 that the German alchemist Johann Friederich Böttger produced true porcelain. His attempts to make gold attracted the attention of August the Strong, who forcibly brought Böttger to the castle of Albrechtsburg near Meissen in Saxony. There, after the quest for gold had failed repeatedly, Böttger turned his inventive skills to making porcelain instead. The Meissen factory was established in 1710, and it was here that Böttger produced pure white porcelain one thousand years after the Chinese had perfected the process. At once, it became the most highly admired ware in Europe, and between 1733 and 1763 Meissen was the most prosperous and influential ceramics factory in the West.

The earliest products from Meissen so closely resemble Chinese and Japanese models that it is sometimes difficult to tell them apart. Soon, however, specifically European designs appeared, often derived from shapes originally used by silver- and goldsmiths. Particularly popular decorations consisted of sprays of roses or acanthus leaves, and handles with sweeping curves fashioned in true Rococo style. The leading figures in Dresden after Böttger's death in 1720 were Johann Gregor Horoldt and the sculptor Johann Joachim Kändler, who came in 1731. Horoldt improved the enamel color used, and decorated the porcelains with genre scenes taken from contemporary Europe and imaginary life in China and Japan.

Kändler was outstanding for his porcelain figures, some of them intended for the King's Japanese "Palais," and his life-size highly detailed animals in the Baroque style (fig. 112). Most of his porcelain sculptures, however, were

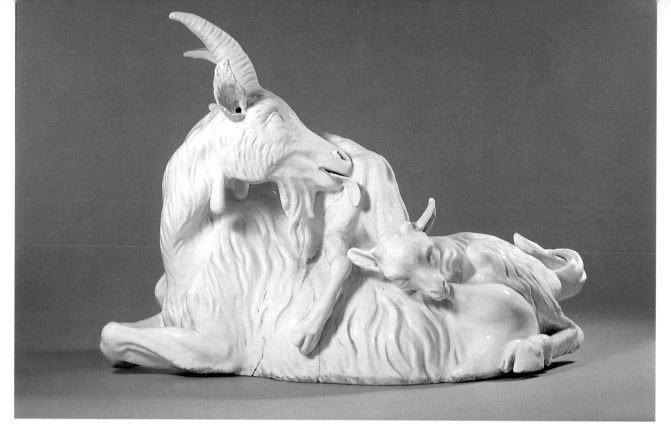

112. Mother goat and suckling kid, hard-paste porcelain, modeled by Johann Joachim Kändler (1706–1775). Germany, Meissen, c. 1732. (62.245) The Metropolitan Museum of Art, New York; Gift of Mrs. Jean Mauzé, 1962. Photograph © 1988 The Metropolitan Museum of Art.

small in scale and executed in a typically Rococo spirit. Kändler also designed beautiful cups, saucers, plates, and pots, which enjoyed a tremendous vogue. Frederick the Great of Prussia and Catherine the Great of Russia were among his patrons.

Perhaps the single most famous production of Meissen is the so-called Swan Service, which featured the graceful bird as a design motif on all 2,200 pieces. Commissioned by a prominent Dresden nobleman, Heinrich von Brühl, it occupied Kändler and his assistants between 1737 and 1741 (fig. 113). Equally impressive are the exquisitely modeled porcelain figurines, which represent some 1,100 different designs in all. Particularly popular were characters from the Italian comedy, such as Harlequin and Columbine, portraits of court aristocrats like Madame de Pompadour, and beings from Classical mythology. There also were sculptures of animals and birds as well as porcelain clocks. The Meissen factory has continued to be active into modern times, creating new designs as well as replicating older ones, and its largest export market today is Japan.

Meissen's monopoly on the production of ceramics was soon broken as factories sprang up all over the region. Karl Eugen, the Duke of Wurttemberg, founded the Ludwigsburg factory, while the Elector of Mainz established one in Höchst, the Elector of the Palatine one in

Frankenthal, and the King of Prussia the Berlin porcelain works. The most important factory after Meissen was that of Nymphenburg near Munich, established under the patronage of the Prince Max Joseph in 1761. Its great fame rests primarily on the creations of Franz Anton Bustelli (1723-1764), an Italian sculptor influenced by German contemporaries. His figures convey the feeling of grace and elegance, often shown to particular advantage with theatrical subjects (fig. 114). An impressive Rococo figural group, called *The Audience of the Chinese Emperor*, was modeled by Johann Peter Melchior (1747-1825) at Höchst (fig. 115).

After Germany, the most important country for the production of fine porcelains was France, where the Prince de Condé established a factory on his Chantilly estate in 1726. Given his magnificent collection of Far Eastern examples, it is not surprising that the early wares were in an Oriental style. From 1740 on, however, the Chantilly works exhibited a more individual character with a distinctly French Rococo sensibility. Favorite decorative motifs were flowers, especially roses and cornflowers, painted in a naturalistic manner or molded in relief. The shapes are graceful and there often are charming touches, such as fashioning a handle out of flowers (fig. 116).

The most famous French factory was established in 1753 in Sèvres outside of Paris. With the patronage

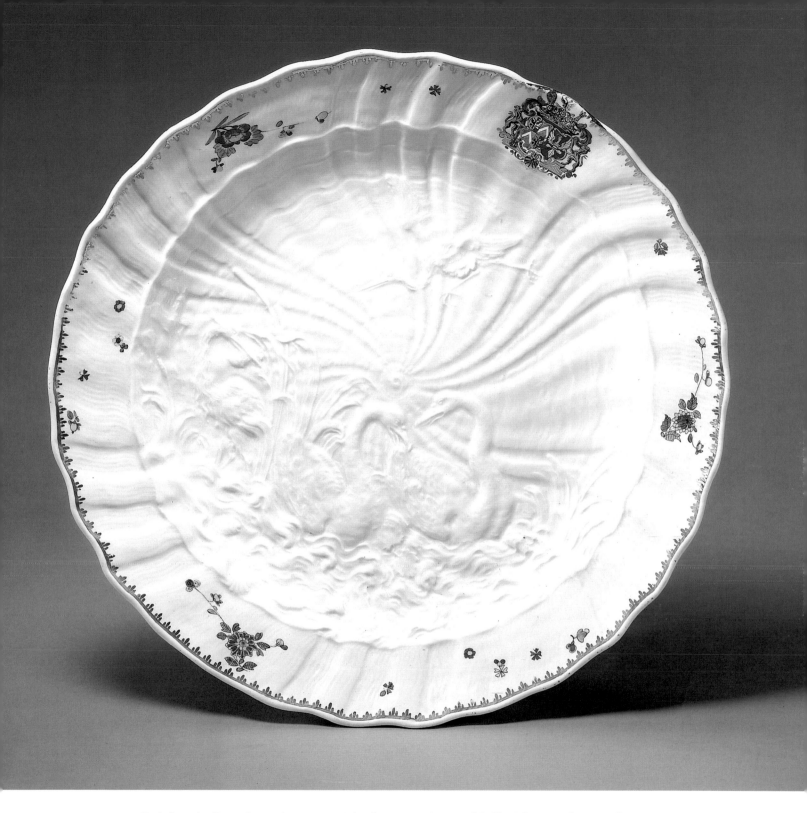

113. Dish from the Swan Service (2,200 pieces), hard-paste porcelain, modeled by Johann Joachim Kändler (1706–1775), and with the arms of Count Heinrich von Brühl of Dresden. Diam. 13¼". Germany, Meissen, c. 1737–1741. (48.165) The Metropolitan Museum of Art, New York; Gift of Rosenberg and Stiebel, Inc., 1948. Photograph © 1988 The Metropolitan Museum of Art.

of Louis XV and his favorite mistress, Madame de Pompadour, it became the Royal factory. Here, in 1768, hard-paste porcelain was made for the first time in France. Prior to this time, with the single exception of Strasbourg, all French work had been soft-body porcelains. The Sèvres style featured painted flowers and birds, and genre scenes taken from paintings by François Boucher and other contemporary artists (fig. 117). The most unusual pieces were porcelain flowers mounted on wire stems or applied to the surface or handles of vases. These flowers soon became a great fashion. It is reported that Madame de Pompadour received Louis XV on a winter day before a bank of porcelain flowers, each of which had been sprayed with the scent appropriate to the blossom represented.

In Italy, an attempt to produce porcelain-like Chinese blue-and-white ware was made as early as the late sixteenth century by Francesco de' Medici, Grand Duke of Tuscany. The enterprise failed, however, and only a few examples of this Medici proto-porcelain exist. It was not until the eighteenth century that porcelain was made with German and Austrian inspiration. The most important factory was at Capodimonte, above Naples. Established by the Bourbon King Charles IV in 1743, it produced soft-paste porcelains of a very fine quality. The most remarkable Italian achievement was a cabinet in the palace at Portici near Naples, where the entire room, including the walls, was made of porcelain.

Other nations on the Continent, as a matter of prestige and economic advantage, established their own porcelain factories, but none equaled Meissen or Sèvres in importance. Other types of pottery, however, continued to be made. In Holland, Delft maintained a high level of quality in its work. An unusual piece is a pot for chocolate that comes with its own tripod to hold a spirit lamp. Compared to the restraint of Delftware made in the previous century, this example seems positively riotous in its color and arabesques of shape and line. There is still Chinese influence, but the whole is indisputably European (fig. 118).

The English porcelain industry was very active. While traditional potters continued to make fine earthenware, slipware, and tin-glazed pottery, porcelain was made in several places. The oldest factory and the one that produced the finest wares opened in the Chelsea district of London in 1745. Its smooth white paste as well as the beauty of its painted decorations surpass all other English wares and it is the only English porcelain that enjoyed a great reputation on the Continent. Many of the early wares use Kakiemon designs, while the figurines resemble those made in Meissen. Particularly fine are the decorative objects such as snuff boxes, seals, and small sculptures in the form of birds and flowers. A pair of candelabra is a delightful tour-de-force (fig. 119). The factory closed for good in 1784.

Three more production centers existed in England. The other outstanding London factory was Bow, best known for its porcelain figurines from the mid-eighteenth century.

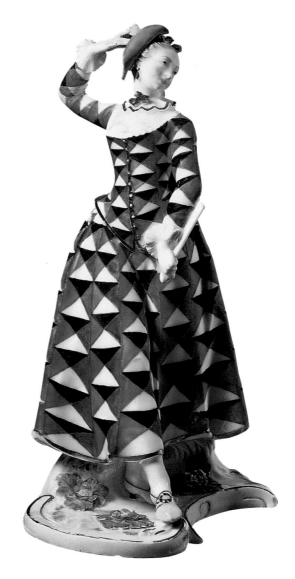

114. Figure of Columbine, hard-paste porcelain, modeled by Franz Anton Bustelli (1723–1763). H. 8⅝". Germany, Nymphenburg, c. 1757. (50.211.251) The Metropolitan Museum of Art, New York; Gift of R. Thornton Wilson in memory of Florence Ellsworth Wilson, 1950. Photograph © 1990 The Metropolitan Museum of Art.

115. *The Audience of the Chinese Emperor*, hard-paste porcelain, modeled by Johann Peter Melchior (1747–1825). H. 15⅞". Germany, Höchst, c. 1766. (50.211.217) The Metropolitan Museum of Art, New York; Gift of R. Thornton Wilson in memory of Florence Ellsworth Wilson, 1950. Photograph © 1990 The Metropolitan Museum of Art.

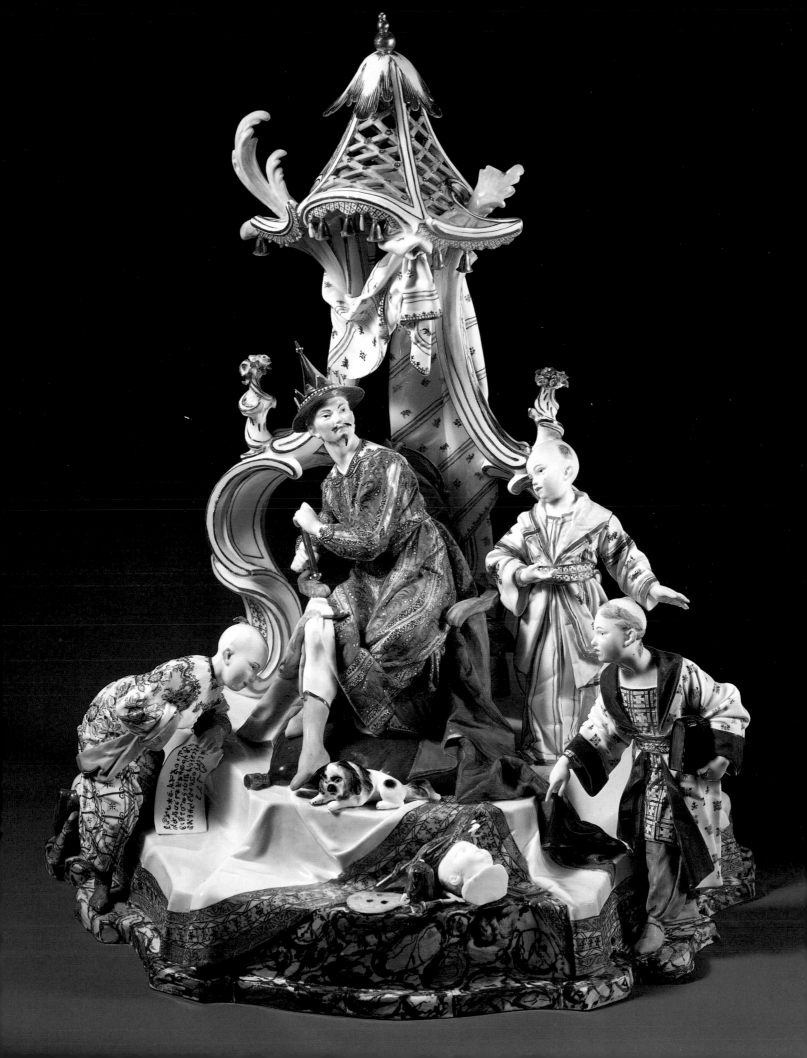

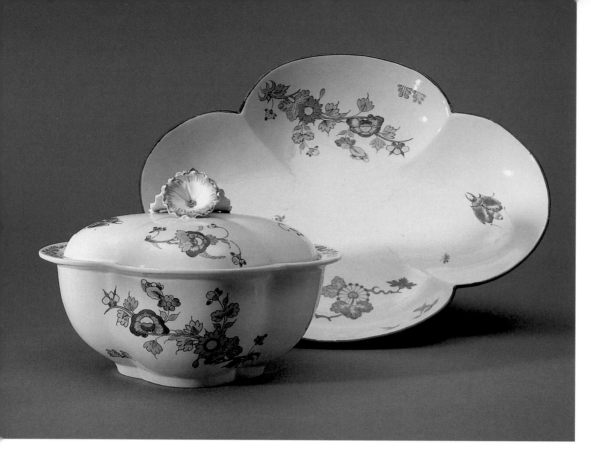

116. Covered sauce tureen with tray, porcelain with enameled decoration. H. 4⅜"; L. 9½". France, Chantilly, c. 1735. (1907-23-9abc) Photograph by Andrew Garn. Cooper-Hewitt, National Design Museum, Smithsonian Institution/Art Resource, New York.

Here too, Far Eastern inspiration was prominent, with designs modeled on Chinese blue-and-white and famille-rose porcelains, as well as Japanese Kakiemons. Bow also created its own version of the French conceit of porcelain flowers (fig. 120).

A factory in the cathedral city of Worcester, founded in 1751, produced porcelains distinctive because of the Cornish soapstone that was mixed into the clay. The shapes of the pots are also often different, reflecting the influence of silver molding. The most popular Worcester porcelains were those decorated in blue-and-white and the so-called Worcester Japans, English versions of Kakiemon works from seventeenth-century Japan. A garniture, or set of matched vases made for display on a mantelpiece, shows the subtle readjustments of decoration made to accommodate the three different shapes (fig. 121). Another work is a large face-jug, where brilliantly colored birds, butterflies, and decorative motifs celebrate eighteenth-century splendor (fig. 122). The company, still active today, is the oldest surviving porcelain factory in England.

The most influential British factory, however, was established by Josiah Wedgwood (1730-1795). Born into a family of potters, he began his career at fourteen as an apprentice to an older brother. He opened his own factory in 1759, but it was not until 1769 and the factory in Staffordshire named Etruria that Wedgwood perfected his creamwares into what he called pearlwares. Drawing inspiration from Classical vases, cameos, and sculptures especially, he created designs that fed and fueled the contemporary craze for Classical art. Wedgwood preferred hard stoneware to porcelain because it lent itself better to precise modeling in relief. The bodies of these pots, called Jasperware, usually were stained lavender blue, but pinkish lilac, sage-olive green, and yellow, decorated with white reliefs, were all used at the kilns (fig. 123). There can be no question that Wedgwood's industrialized production methods and his Neo-Classical taste changed the history of Western ceramics.

The eighteenth century was also a great age for the production of porcelain in the Far East. Critical opinion today favors Sung ceramics for their variety and subtle aesthetic sensibility, but the Chinese porcelains of the eighteenth century are technically the finest ever made. No rulers have emphasized the manufacture of fine porcelains more than the early Ch'ing, when the traditional center of pottery production, Ching te-Chen, had no less than one million inhabitants. Most of them were employed directly or indirectly by the ceramics industry. The three thousand kilns there had a huge output, both for the domestic market and for export. It is estimated that more than sixty million pieces of porcelain were shipped out of China before 1800. There also were special kilns, reserved for the Court

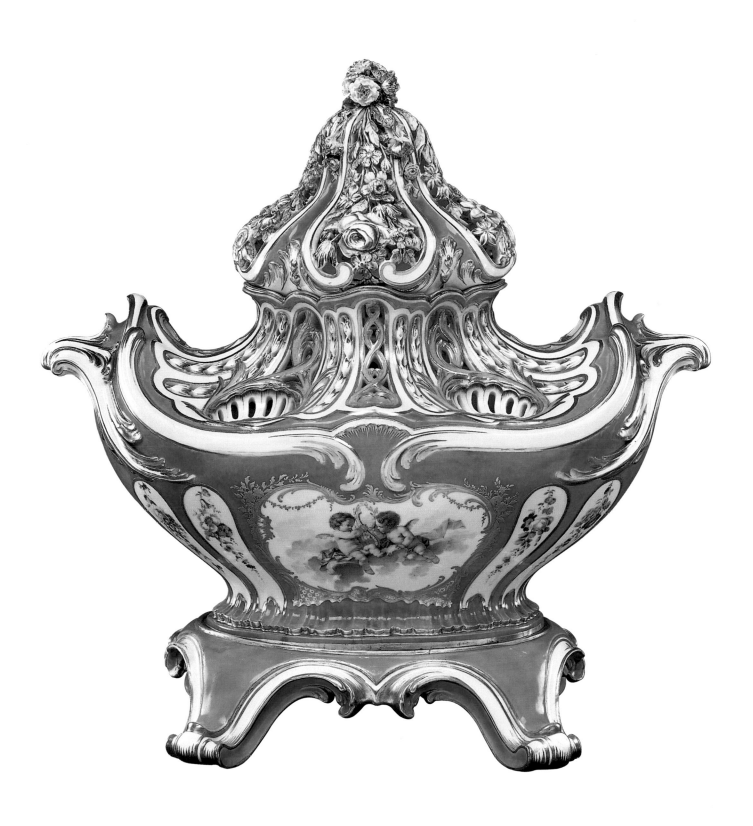

117. Pot-pourri vase, soft-paste porcelain. Model attributed to Jean-Claude Duplessis (active 1747–1774); figure decoration attributed to Charles-Nicolas Dodin (active 1754–1802). France, Sèvres, c. 1756. (58.75.88a-c) The Metropolitan Museum of Art, New York; Gift of the Samuel H. Kress Foundation, 1958. Photograph © 1981 The Metropolitan Museum of Art.

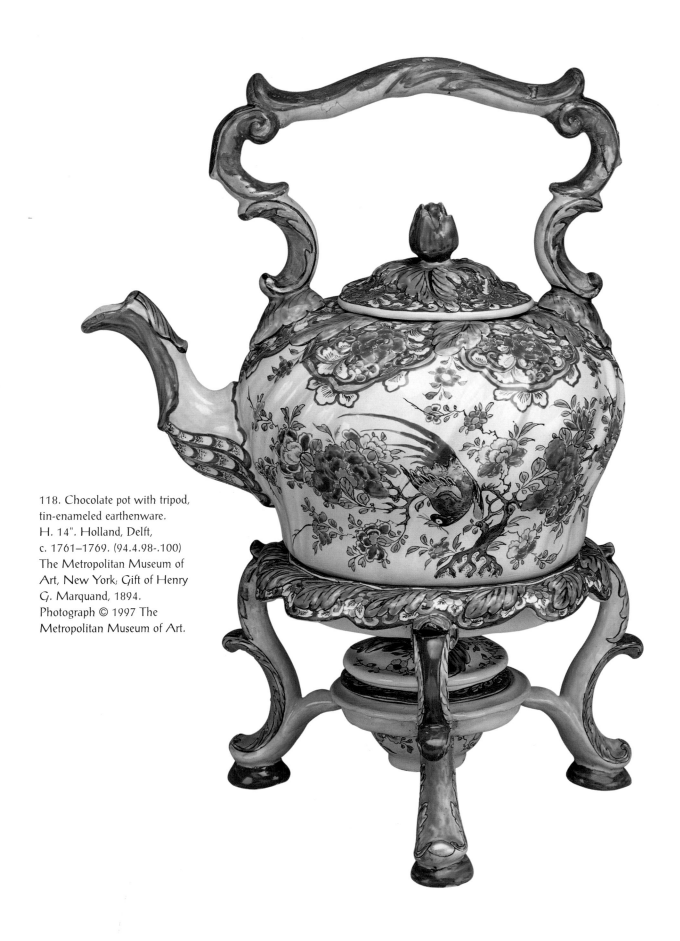

118. Chocolate pot with tripod,
tin-enameled earthenware.
H. 14". Holland, Delft,
c. 1761–1769. (94.4.98-.100)
The Metropolitan Museum of
Art, New York; Gift of Henry
G. Marquand, 1894.
Photograph © 1997 The
Metropolitan Museum of Art.

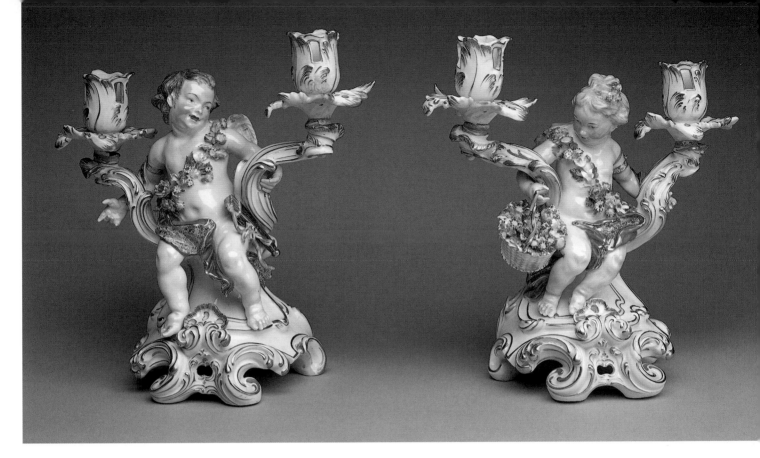

119. Pair of candelabra, soft-paste porcelain.
H. 10⁹/₁₆". England, Chelsea, c. 1765. (54.163.3-.4)
The Metropolitan Museum of Art, New York; Gift
of Mrs. Francis P. Garvan in memory of Francis P.
Garvan, 1954. Photograph © 1997 The
Metropolitan Museum of Art.

120. Pot of flowers, soft-paste porcelain. H. 7".
England, Bow, c. 1750. (70.205) Smithsonian
Institution, Washington, D.C.

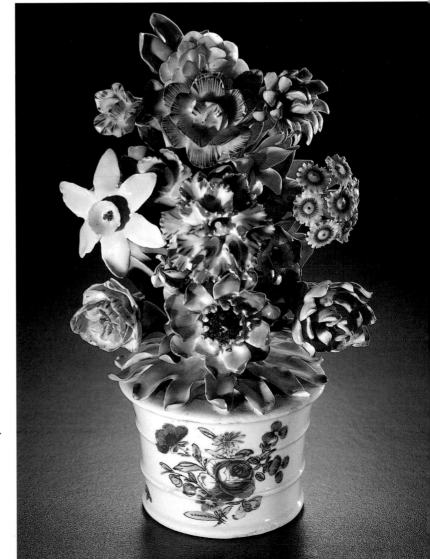

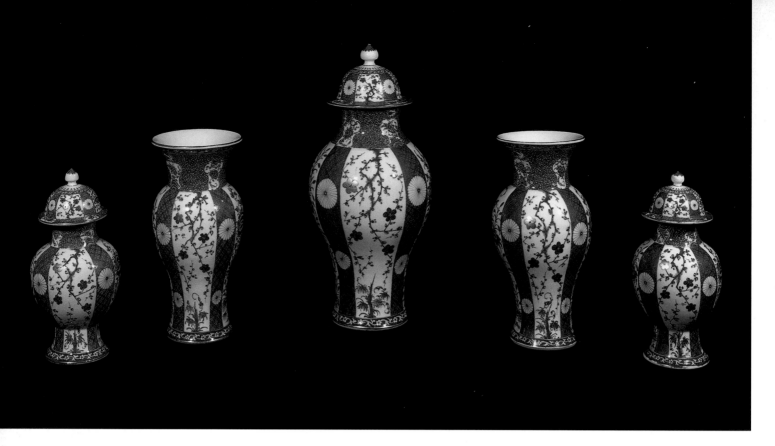

121. Mantel garniture, porcelain. H. 12¼", 8½", 7¼". England, First Period Worcester painted in Kakiemon style, c. 1770. Courtesy Leo Kaplan Ltd., New York.

and under the supervision of an agent of the Emperor, which made porcelains for the Imperial Palace.

The Emperor responsible for this state of affairs was K'ang-hsi (1662-1722) who, although Manchu, was a great patron of the arts and of Chinese cultural traditions. In contrast to the Sung period, when potters both made and decorated their wares in many local kilns, the Ch'ing completely centralized the manufacture of porcelain. With the active participation of the Emperor, an assembly line–like organization was established using as many as sixty different artisans. Each specialized in one aspect of the process.

The main types of ware produced during the reign of K'ang-hsi, his son Yung-cheng (1723-1735), and his grandson Ch'ien-lung (1736-1795), were overglazed enamels and monochromes. The most splendid of the richly decorated porcelains are the famille verte, so-called because their dominant color is green. Others use black, yellow, or rose. Popular motifs include flowers of the seasons, birds, landscapes with and without figures, scenes from history and legend, beautiful ladies, Buddhist and Taoist deities, symbols of good luck and long life, and all kinds of ornamental designs. Tall, magnificently decorated vases, called Imperial vases, were the most admired of Chinese ceramics during the early twentieth century. Western collectors paid huge prices for outstanding examples (fig. 124).

The other famous type of porcelain from the Ch'ing period is monochrome ware. Although one-colored pots were produced as early as the T'ang dynasty, it was not really until the Ming period that monochromes in yellow, red, blue, and white were made. During the Ch'ing period, potters used a wider range of colors. Shapes include all types of vases, dishes, bowls, cups, jars, seal boxes, and pots. The most unusual color used by the K'ang-hsi potters was a greenish pink called peachbloom in English and p'ing-kuo in Chinese. Decoration, if present at all, consists of incised or low-relief designs under the glaze (fig. 125).

A sizable proportion of Ch'ing porcelain was export ware, intended for the European market. At first, much of it reached the West through Amsterdam, since the main European traders of the Far East were Dutch, but soon the English, French, and Americans became active. The shapes of these export porcelains were largely conventional, although some were made expressly for Western tastes. At the time of George Washington's death in 1799, for example, a special set was made to honor him. Sometimes pieces combined Western and Chinese elements, as in a helmet-shaped enameled porcelain ewer based upon European designs for silver pitchers (fig. 126).

The eighteenth century was also the golden age of porcelains in Japan. The center of the industry was Arita in

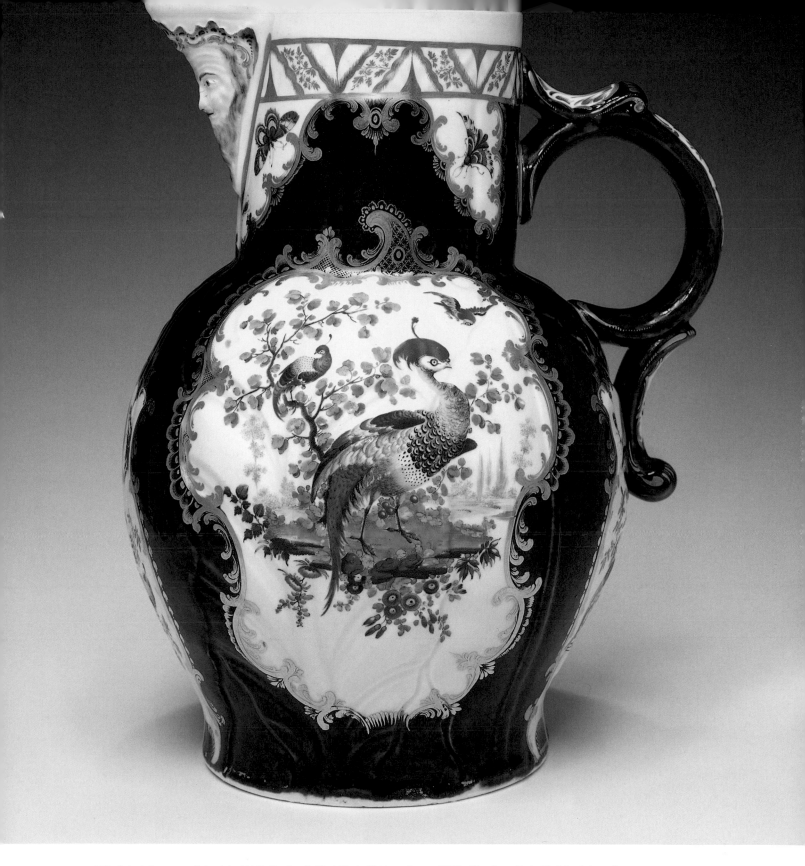

122. Mask jug, porcelain. H. 11¾". England, First Period Worcester, c. 1770. Courtesy Earle D. Vandekar of Knightsbridge Incorporated, New York.

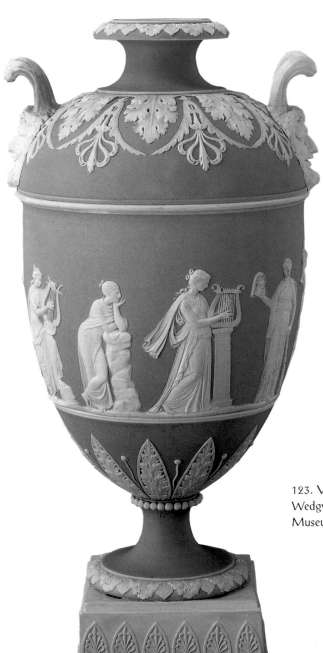

123. Vase, jasperware. H. 10¾". England, Wedgwood, c. 1780. Victoria and Albert Museum, London, and Art Resource, New York.

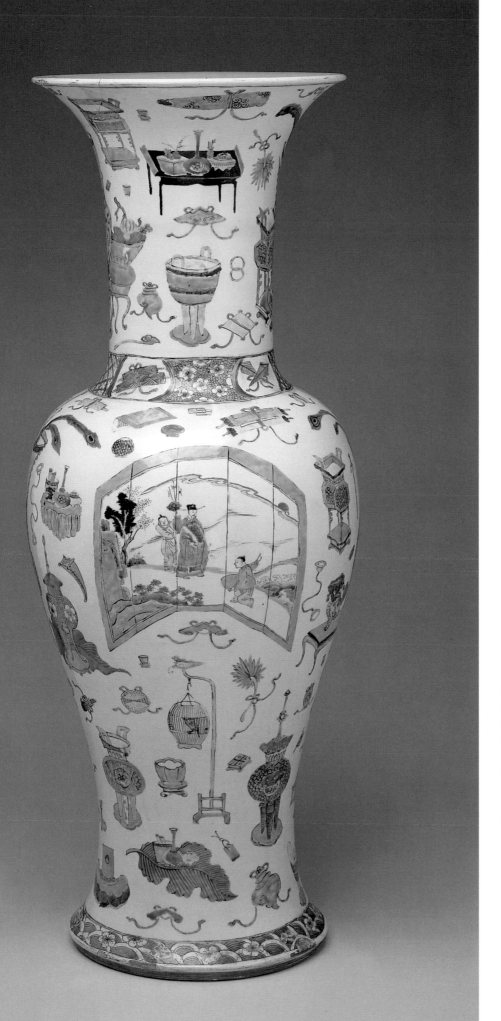

124. Imperial vase, porcelain in baluster shape with famille-verte decoration, showing "the hundred antiques" and "the four elegant accomplishments." H. 29". China, Ch'ing dynasty, K'ang-hsi period (1662–1722). (14.40.334) The Metropolitan Museum of Art, New York; Bequest of Benjamin Altman, 1913. Photograph © 1997 The Metropolitan Museum of Art.

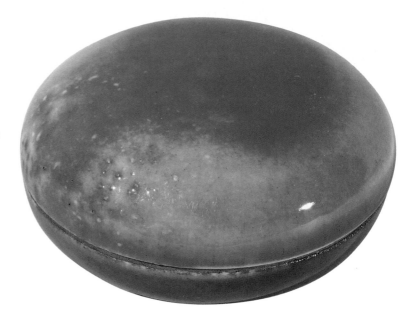

125. Round peach-bloom covered box
for a scholar's desk. Diam. 3". China,
Ch'ing dynasty, 18th century.
Collection Munsterberg, New York.

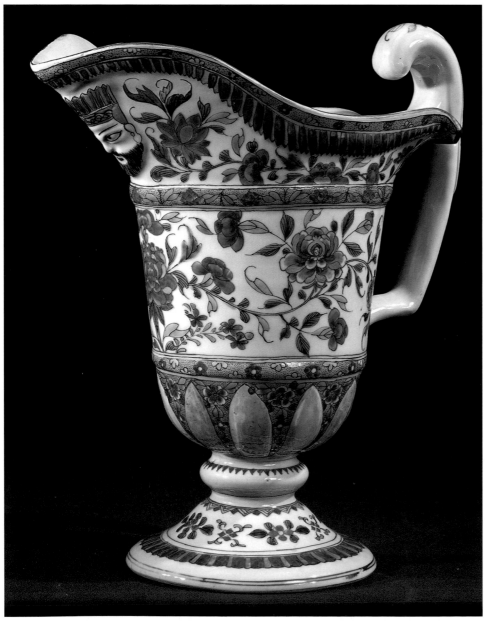

126. Ewer, famille-verte porcelain with
overglaze enameled floral designs.
H. 11⅛". China, Ch'ing dynasty,
K'ang-hsi period, late 17th century.
Courtesy Weisbrod Chinese Art Ltd.,
New York.

127. Covered bowl, porcelain
painted with underglaze blue
and overglaze enamels. H. 14⅜".
Japan, Saga prefecture, Arita
ware, Kakiemon style. Edo
period, c. 1670–1690.
(1979.234a,b) Photograph by
Lynton Gardiner. Asia Society,
New York; Mr. and Mrs. John
D. Rockefeller 3rd Collection.

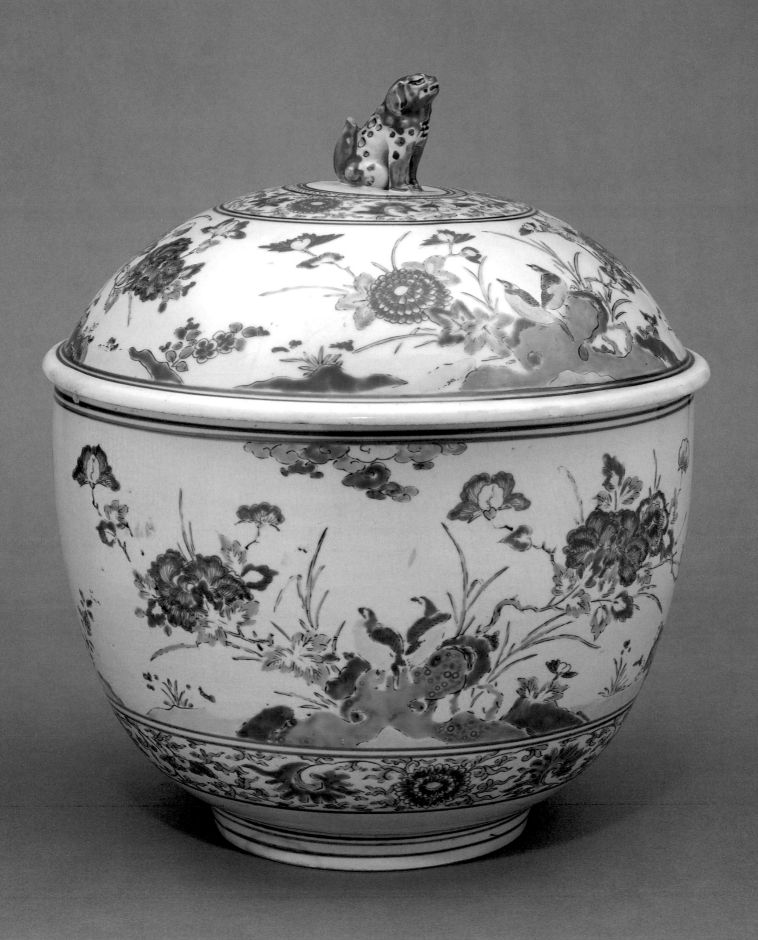

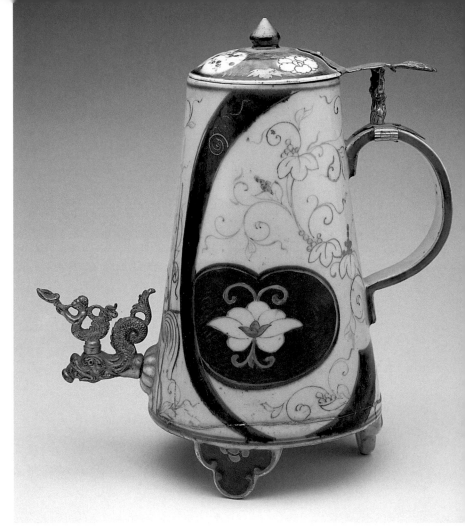

128. Coffee pot, porcelain, with Dutch brass mounting. H. 11⅜". Japan, Imari ware, 17th century. Collection Munsterberg, New York.

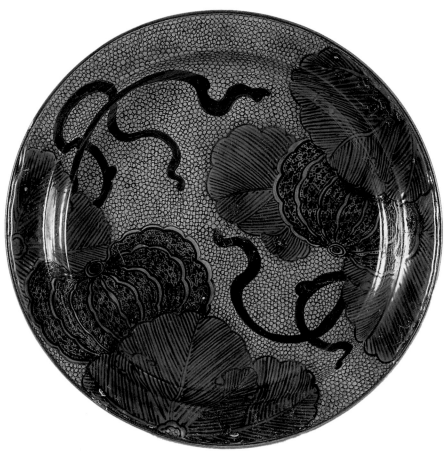

129. Large plate with design of pumpkins, Ko-Kutani porcelain with overglaze enamels. Diam. 14⅞". Japan, Arita ware, Edo period, c. 1650–1660. Photograph by Carl Nardiello. Mary and Jackson Burke Foundation, New York.

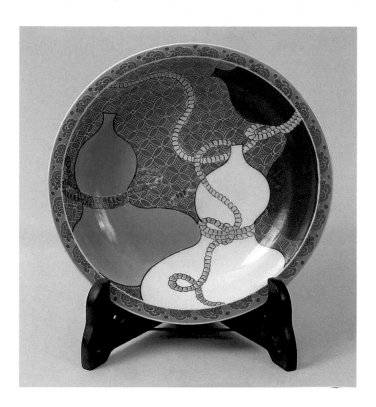

130. Plate with gourd design, porcelain. Diam. 8½". Japan, Nabeshima, 18th century. Collection Munsterberg, New York.

131. Square dish with design of plovers over waves, earthenware with iron-brown underglaze decoration. Dish by Ogata Kenzan (1663–1743); design by Ogata Korin (1658–1716). W. 8¼". Japan, Kyoto ware. (1966.365) © The Cleveland Museum of Art, Cleveland, Ohio; Purchase from the J. H. Wade Fund.

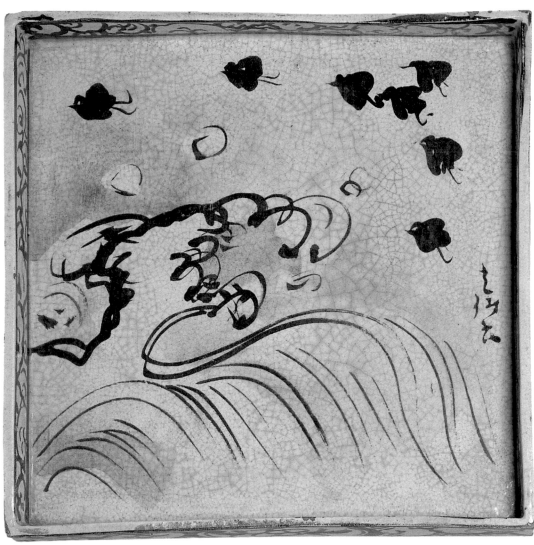

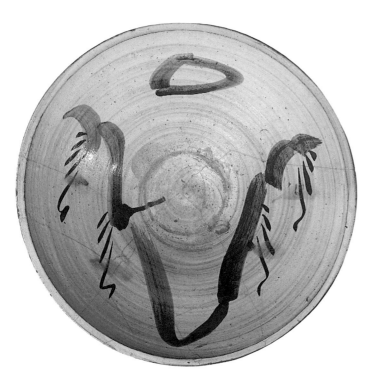

132. Kneading bowl, glazed stoneware with slip and painted decoration. Diam. 19⅞". Japan, Futugawa, 18th century. (75.124) The Brooklyn Museum of Art, Brooklyn, New York; Gift of the Tokyo Marine & Fire Insurance Co.

Saga prefecture on Kyushu, where porcelain clay had been discovered by Korean-born potters in the early seventeenth century. The earliest Japanese porcelains were blue-and-white wares in the Korean tradition, but by the middle of the seventeenth century enamel-decorated pieces based on Chinese wares of the late Ming and early Ch'ing periods became popular. The potter responsible for this development was Sakaida Kakiemon (d. 1666), who made the first enameled wares at mid-century. Using not only blue, but also red, yellow, green, and gold, he executed gracefully asymmetrical floral and bird designs on the milky-white body of his pots (fig. 127). These wares arrived in Europe about 1680, and at once enjoyed enormous popularity. Western versions were made by Meissen, Chantilly, Chelsea, and Worcester, among other factories.

A somewhat coarser and more common version of Arita porcelain was called Imari ware, because it was exported from the port city of Imari in Kyushu to other parts of Japan and to the West. It consists of both blue-and-white and enameled wares, often decorated in bright colors. All kinds of vessels, figures, and ornaments were made in this style. Some of these were designed for the West, such as a coffee pot mounted with Dutch brass fittings (fig. 128). The best period for both Imari and Kakiemon porcelains was between 1650 and 1750, but they continue to be made today, frequently by descendants of the original seventeenth-century families. Kakiemon

XIII, for example, was declared a Living National Treasure in 1971, even while he trained his son and grandson to succeed him.

Another highly esteemed Arita porcelain, Kutani ware, probably comes from the Kutani kilns, Kaga prefecture, although there is some uncertainty about this. The best work, today called old or Ko-Kutani ware, was made during the second half of the seventeenth century, after which time manufacture ceased for over a hundred years. Striking colors, with a dark green, deep yellow, and purple were particularly popular, and stylized designs typically decorate large plates (fig. 129).

Another Arita porcelain, Nabeshima ware, was made in small quantities for the local lords. The pots have pure white bodies and decorations in underglaze blue, as well as red, green, and yellow enamel. Floral forms and patterns derived from textiles and traditional painting ornament them. Repetition, abrupt cropping of the forms, and bold juxtaposition of the design elements seem particularly attractive features to the modern eye (fig. 130).

While the manufacture of fine porcelains was the most notable achievement of Japanese potters during the eighteenth century, many other kinds of work were also made. Unlike China, where the ceramics industry was concentrated in one place, Japan had kilns all over the country. Furthermore, the Japanese accorded their greatest potters a status equal to that of the best-known painters and far higher than any sculptor or architect. This never occurred in China.

Perhaps the greatest Japanese artist-potter was Ogata Kenzan (1664–1743), the younger brother of the famous Rimpa school painter, Ogata Korin. Active as a potter during the first half of the eighteenth century, Kenzan was also a painter, calligrapher, and designer of lacquers and textiles. Kenzan's pottery, mostly wares intended for use in the tea ceremony, is outstanding for the beauty and originality of its designs. In some pieces, inspired by the technique of his teacher Ninsei, who was the first to apply to earthenware the gorgeous colored enamels used for porcelains, Kenzan painted with enamel colors over the glaze. In other pieces, he painted designs often drawn from nature with bold, free strokes in iron oxide under the glaze (fig. 131).

Quite the opposite of Kenzan were the thousands of peasant potters who worked at small provincial kilns supplying the needs of local markets. Yet they too made important contributions to the Japanese ceramics tradition. Then as now, they produced some of the finest pottery made in Japan. A splendid example of local eighteenth-century ware is a bowl from the Futagawa kiln in Fukuoka prefecture. Noted for their large bowls used for kneading wax and their storage jars for water and food, these potters typically brushed bold decorations in green or brown on a white slip (fig. 132).

Chapter 9

Ceramics of the Nineteenth Century

Ceramics production increased enormously during the nineteenth century as new techniques became available to the industry. From an artistic point of view, however, the century is one of the least interesting in the history of the medium. This is true in the West as well as in the Islamic world and Asia. Various reasons have been suggested for this phenomenon. One of the most common explanations is that traditional styles and shapes were imitated rather than creatively interpreted. Another is that technical bravura became more important than artistic excellence. Whether or not these frequently cited reasons offer useful explanations, they do identify two indisputable characteristics of nineteenth-century ceramics. A deep interest in older artistic styles also inspired the establishment of museums for the decorative arts, such as London's Victoria and Albert Museum, which opened in 1852. At the same time, ceramics became a commercial industry, and production on a vast scale became possible.

It is fair to say that the bulk of pots made in the West between 1800 and 1900 were copies or adaptations of older works. The so-called Empire style, which developed in early nineteenth-century France during the Napoleonic Empire, was basically a Neo-Classical revival. Designs show figures from Classical mythology as well as contemporary life. The center of production was the French state factory at Sèvres, but similar wares were made in Vienna, Berlin, and St. Petersburg (fig. 133). Neo-Gothic jugs with elaborate relief decorations, such as Charles Meigh's apostle tankard of 1842, which shows the apostles standing in imitation cathedral niches, reflect mid-century interest in the Gothic style. English factories such as Wedgwood, Worcester, and Minton continued to produce works at a great rate, many of them following older models.

At their best, nineteenth-century Western potters used older styles in celebration of their confidence and skill.

The exuberance of a majolica centerpiece made by the Wedgwood factory, for example, evokes the superabundance of a Victorian table while demonstrating the ambition of its makers (fig. 134). A Century vase, commissioned from the sculptor Karl Mueller by the Union Porcelain Works, combines scenes from American history with profiles of George Washington and bison-head handles. Made for the Philadelphia Centennial Exposition of 1876, the vase confirms the importance of the past through the manipulation of traditional forms (fig. 135). The Rockingham wares from Vermont, on the other hand, so-called because they resemble the mottled brown, yellow, and white glazed pottery made at the Rockingham kilns in England, only offer molded imitations of the originals.

The vitality and sheer productiveness of ceramics factories throughout America and Europe should not be underestimated. Perhaps precisely because of this success, a reaction against machine-made, stylistically derivative wares grew in force. The most important figure in this rebellion was the English designer and craftsman William Morris (1834-1896), whose influence extended well into the twentieth century. Morris passionately advocated a return to craftsmanship and an understanding of materials as the only way to revive the spirit and quality of old craft traditions. For Morris, medieval craftsmen represented the ideal alliance of art and labor. His ideas found expression in the Arts and Crafts Movement. In 1888, with his help, the Arts and Crafts Exhibition Society was founded in England to support true artistic craftsmanship and cultivate public taste for the decorative arts.

The only potter of note among the founders of the Arts and Crafts Exhibition Society was William de Morgan (1839-1917). He made beautifully crafted imitations of Persian and Hispano-Moresque pots, famous for their brilliantly colored glazes (fig. 136). More like the studio pot-

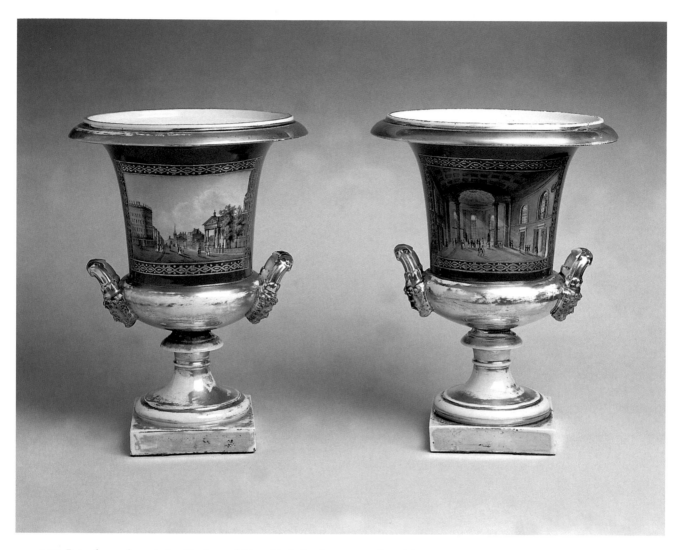

133. Pair of urns decorated with views of New York, hard-paste porcelain. H. 13". France, Sèvres, c. 1831–1835. (38.165.35, 38.165.36) The Metropolitan Museum of Art, New York; Harris Brisbane Dick Fund, 1938. Photograph © 1997 The Metropolitan Museum of Art.

134. Table centerpiece, 19th-century majolica modeled in the style of Hughes Protat. H. 13". England, Wedgwood, 1867. Reproduced from *Majolica* (1990) by Nicholas M. Dawes.

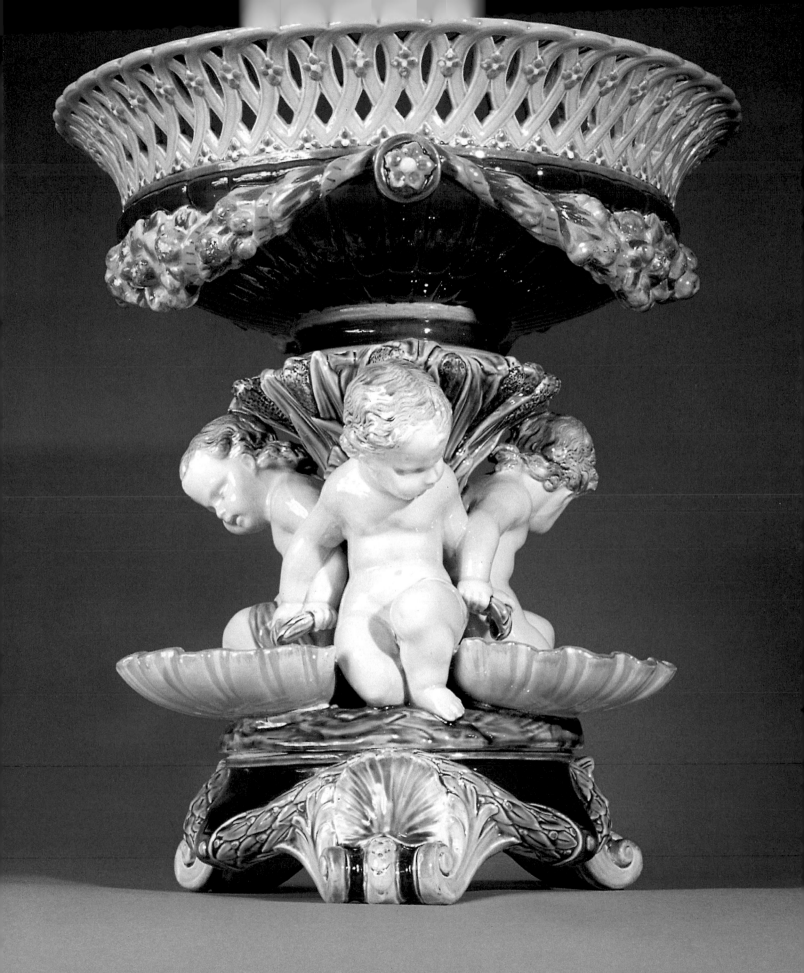

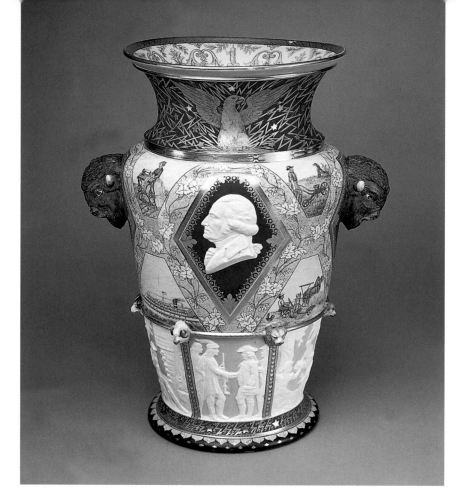

135. The *Century Vase*, hard-paste porcelain with a portrait of George Washington, bison heads, and historical reliefs. H. 24¼". United States, designed by Karl L. H. Mueller (1820–1887) for the Union Porcelain Works (1863–c. 1922), Greenpoint, New York, and exhibited in 1876 at the Centennial Exposition in Philadelphia, Pennsylvania. (43.26) The Brooklyn Museum of Art, Brooklyn, New York; Gift of Carll and Franklin Chace in memory of their mother, Pastora Forest Smith Chace, daughter of Thomas Carll Chace.

ters of today were the four Martin brothers, who set up shop in 1877. Working with the traditional English medium of stoneware, they made all kinds of vessels and decorative pieces, including face jugs and pots in animal form. Particularly characteristic are rather sinister, standing birds called Quizzical or Martin birds, that open up to reveal a hollow interior (fig. 137). In 1914, after the deaths of three of the four brothers, the last closed down the studio.

It is a measure of the rapid success of the movement that many of the large firms set up specialized departments to produce art pottery. Minton was one that established an Art Pottery Studio in London in 1872–1873. The location, it was announced, offered the advantage of study at the local botanical gardens as well as at the South Kensington (later renamed the Victoria and Albert) Museum. A pair of lovely Japanesque vases, which sit on elaborate bases specially crafted as part of the works, show every attribute of care and artistry. The sinuous curves of the designs suggest that inspiration may well have been taken from nearby gardens (fig. 138).

The ideas of William Morris and the Arts and Crafts Movement also exerted an important influence in the United States. The most famous and artistically most accomplished of the art potteries was the Rookwood pottery of Cincinnati, Ohio. Founded in 1880 by Maria Longworth Nichols, Rookwood was established largely by women who wished to use their artistic abilities to decorate ceramics. The strongest influence on them was Japanese pottery and, in 1887, a Japanese artist named Kataro Shirayamadani came to America and joined them.

The most characteristic feature of Rookwood wares is the use of underglaze colored-slip decoration on an earthenware body, a technique that was introduced in 1884 by a leading figure in the factory, Laura Fry. The pottery produced here during the 1880s and 1890s with elegant Oriental shapes and beautifully painted designs representing naturalistic animals, fish, and plants, enjoyed widespread popularity (fig. 139). Their pieces won Gold Medals at the Paris World's Fair of 1889 and the Buffalo Pan-American Exposition of 1901.

Another prominent American firm that reflected the ideals of the Arts and Crafts Movement was the Grueby Faience Company in Boston. Most famous for its glazes, the company used a technique William Grueby invented near the end of the century. The best-known color was "Grueby green," a smooth matte green applied over earthenware vases that had been thrown by hand. Decoration,

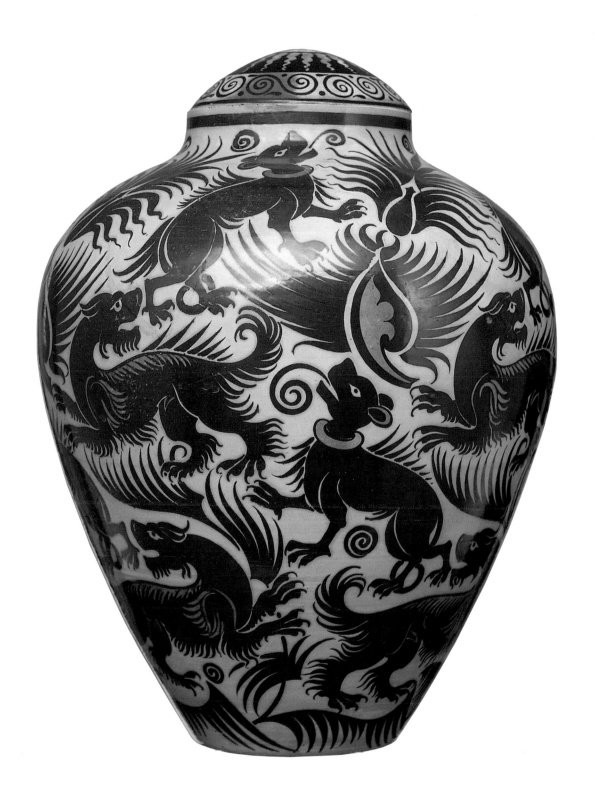

136. Covered vase, lustreware, made by William De Morgan (1839–1917). H. 13¾". England, c. 1890. (23.163.2ab) The Metropolitan Museum of Art, New York; Purchase, Edward C. Moore, Jr. Gift, 1923. Photograph © 1997 The Metropolitan Museum of Art.

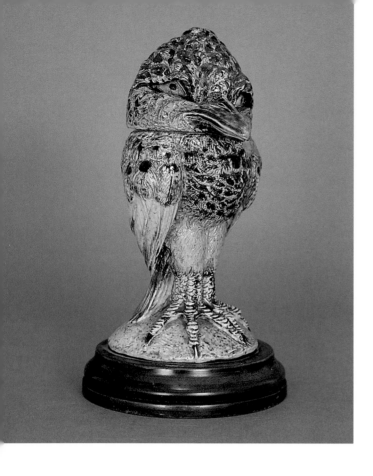

137. Tobacco jar in the shape of an owl, salt-glazed stoneware. H. 9½". England, Martin Brothers Pottery, c. 1890. Courtesy David Rago Auctions/Lambertville, New Jersey.

138. Pair of left and right vases, pottery. H. 4½". England, Minton, c. 1880. Private collection.

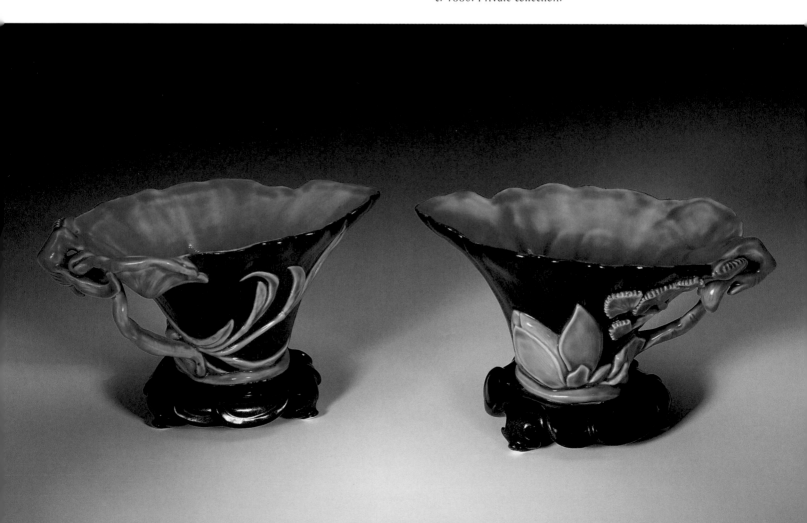

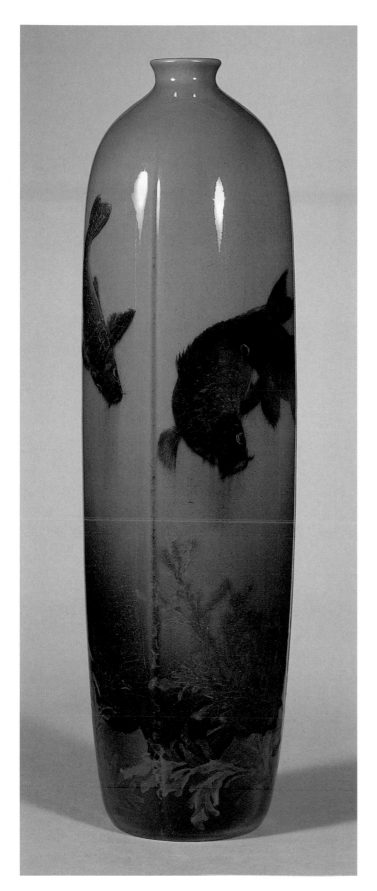

139. Vase, earthenware with slip-painted underglaze, decorated by Matthew Andrew Daly (1860–1937). decorated by Matt Daly. H. 14¼". United States, Cincinnati, Ohio, Rookwood Pottery, 1887. (09.888) The Brooklyn Museum of Art, Brooklyn, New York; Gift of Mrs. Carll H. DeSilver.

140. Vase, earthenware with mat glaze. H. 13". United States, Grueby Faience Company, Boston, Massachusetts. Courtesy David Rago Auctions/Lambertville, New Jersey.

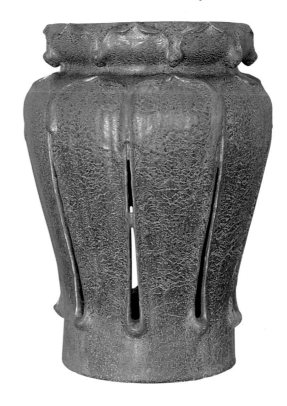

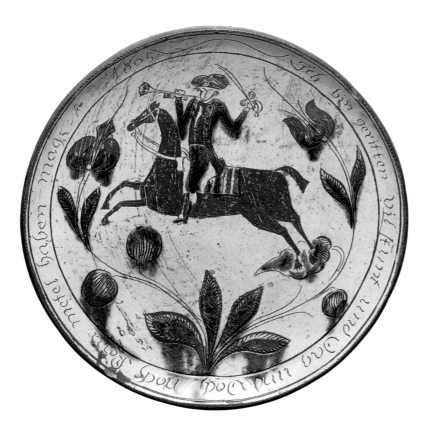

141. Sgrafitto plate. Diam. 12". Made by Johannes Neesz (1775–1867). The inscription on the rim reads: "I have ridden many hours and days and yet no girl am able to have." United States, Tylersport, Montgomery County, Pennsylvania, dated 1805. Museum of American Folk Art, New York; Promised anonymous gift.

142. Presentation punch bowl, salt-glazed stoneware. Diam. 15½". Inscribed "Elizabeth Crane" and "May 22, 1811, C. Crane." United States, attributed to John Crolius, Jr. (1755–1853), New York City. Courtesy David A. Schorsch Company and America Hurrah Antiques, New York. Museum of American Folk, New York; Promised anonymous gift.

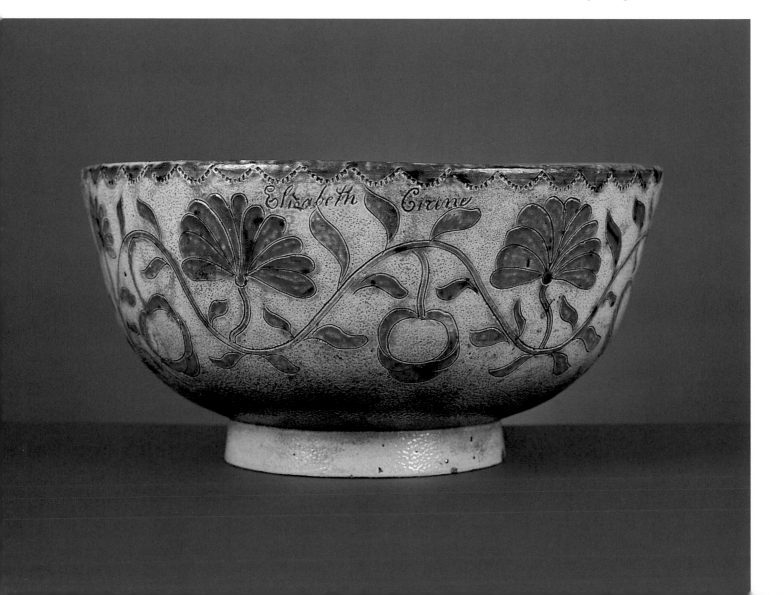

often of vegetal form, was usually carved into the body of the pot (fig. 140). Here too, women executed the decorations. Grueby made it a policy to hire and train women, believing that working on pots could provide respectable employment for the unskilled.

Side-by-side with these highly sophisticated productions were genuine folk traditions. A beautiful type that appeared in late eighteenth-century America became known as Pennsylvania German pottery. Its stylistic origin lay in the folk pottery of the German Rhineland, from which most of these settlers had come. The shapes are usually utilitarian ones, such as simple jugs, bowls, plates and, above all, pie dishes. The wares consist of lead-glazed red clay with yellow slip decorations to which copper green sometimes was added. Often a sgraffito design was incised on the surface of the vessels and inscriptions in the German dialect spoken by the people of the region are common. The slip drawings decorating these pots have a naïveté that is very appealing. The decorative motifs are largely traditional, such as tulips, roses, eagles, doves, and other animals, but there also are lovers, huntsmen, and soldiers, including George Washington and Andrew Jackson (fig. 141).

The stonewares made in local kilns of the eastern United States are also much admired today. The first American kiln to produce this kind of stoneware was probably that of William Crolius near Collect Point, New York, in 1730. But stoneware did not become common until after the Revolution and, by the nineteenth century, it was made all over the Northeast. The pots are undecorated or have simple designs of birds, flowers, or patriotic motifs painted in cobalt blue. Fired at a high temperature, these wares often were saltglazed and nonporous to make them suitable for holding liquids. Sturdy bottles, bowls, and containers of all kinds were popular, and inscriptions often noted the occasions for which they were made (fig. 142).

The South had its own traditions. One of the most remarkable consists of stoneware face jugs made primarily in the Carolinas and Georgia during the first half of the nineteenth century. Almost certainly created for their own use by black slaves at plantation potteries, these vessels may have played a role in religious ritual since not all of them are functional containers and some are as small as four inches high. In the example reproduced here, the features have been pushed and pinched into place, imposed on the surface of a conventionally shaped pot. Most surprising are the teeth, carefully described in almost menacingly good condition. The jug projects a kind of splendid, fierce energy that overwhelms the quite ordinary basic vessel (fig. 143).

The nineteenth century was not outstanding in the history of Chinese ceramics. Beginning with the Chia Ching period (1796–1820), a steady deterioration took place in both the quality and quantity of production. Furthermore,

as the Manchu dynasty declined and the country was torn by civil war and foreign invasions, the lavish patronage of the Imperial Court ceased. Finally, the overseas market, which had been responsible for most of the prosperity of the Chinese ceramics industry, diminished. Foreign ceramics factories, notably those of England and Japan, were able to capture much of the international market.

Although Ching-te Chen continued to be the greatest center of porcelain manufacture in the world, the works are little more than inferior imitations of older styles. The best ceramics tend to be replicas of Ming and early Ch'ing porcelains, made with great skill and often intended to fool the unwary. Nineteenth-century potters did not hesitate to supply their products with the reign marks of earlier periods, which sometimes makes it difficult to identify a piece as an original or a later reproduction.

The ceramics production of Japan was far more creative, although it too does not compare to earlier times, notably the Momoyama and early Edo periods. The first half of the nineteenth century, or the late Edo period, saw a continuation of many older types of pottery. Imari, Kakiemon, and Nabeshima porcelains continued to be manufactured in Arita, while the Kutani kilns in Ishikawa prefecture enjoyed a revival, as did those of Seto, which now made white porcelain. The styles remained much the same, but the execution deteriorated as the porcelains came to be made for a less discriminating public (fig. 144). The tea wares also do not equal earlier achievements. This is true even when the pieces were made by descendants of the very potters who had produced masterpieces only a few generations earlier.

Commodore Perry arrived in Japan in 1853, and the Meiji Emperor opened Japan to the West in 1868. Both events had far-reaching effects. A German named Gottfried Wagner was invited to Japan and introduced Western ceramics production methods. The result was an expansion of the industry and a huge increase in the export trade, but a decline in quality as the traditional family system was replaced by factories. This happened with porcelains as well as enameled earthenware of the Satsuma type, which now was made all over Japan. Huge quantities of these pots were exported to Europe and America, where they were much admired.

At the same time, traditional folk pottery continued to be made. Like the Pennsylvania German wares and the saltglaze stonewares of the Hudson Valley, these productions of rural people enjoy great favor today with collectors. Under the name of Mingei they are widely exhibited and much written about. Fine examples, such as an oil plate with a delightful rabbit in grass design from Seto (fig. 145), stoneware plates, bottles, jars, bowls, and dishes came from local kilns all over the country (fig. 146).

Traditional uses of clay also flourished in the American Southwest, the Pacific Islands, and, most important of all,

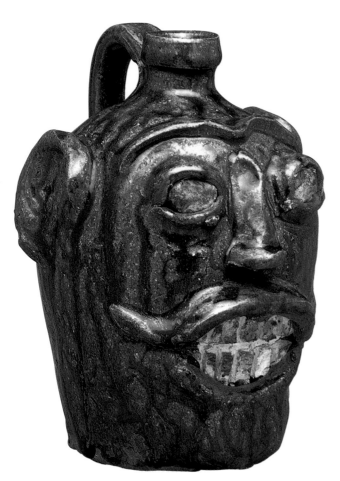

143. Face vessel, stoneware with brown-sand-and-ash glaze; eyes and teeth of unglazed porous white clay. H. 6¾". United States, Bath, South Carolina, made by Col. Thomas J. Davies, c. 1856. ('17-196). Philadelphia Museum of Art, Philadelphia, Pennsylvania; Given by Frank Samuel.

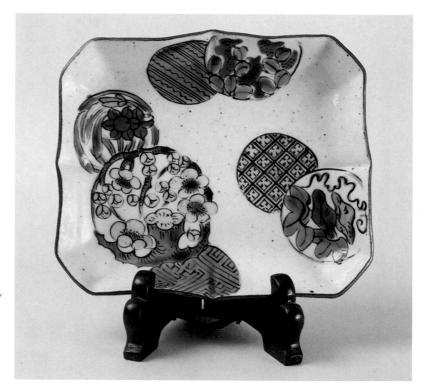

144. Rectangular dish with floral designs, porcelain. L. 6". Japan, Kutani, 19th century. Collection Munsterberg, New York.

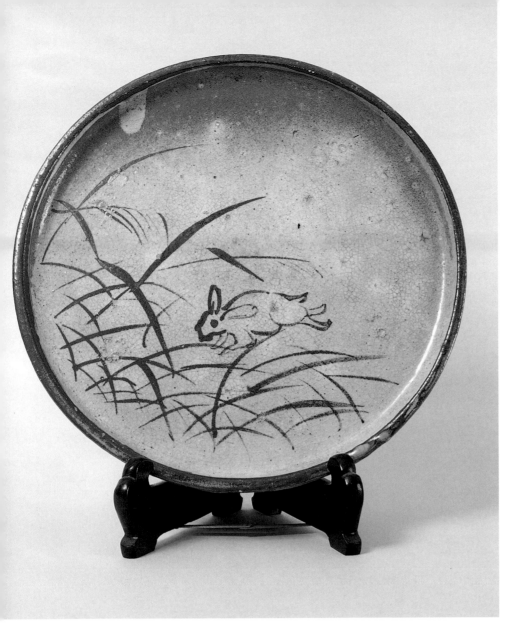

145. Plate with rabbit design, stoneware. Diam. 9¼". Japan, Seto, Edo period, early 19th century. Collection Munsterberg, New York.

146. Long-necked bottle with drip glaze. H 9⅝". Japan, Karatsu, Edo period, early 19th century. Collection Munsterberg, New York.

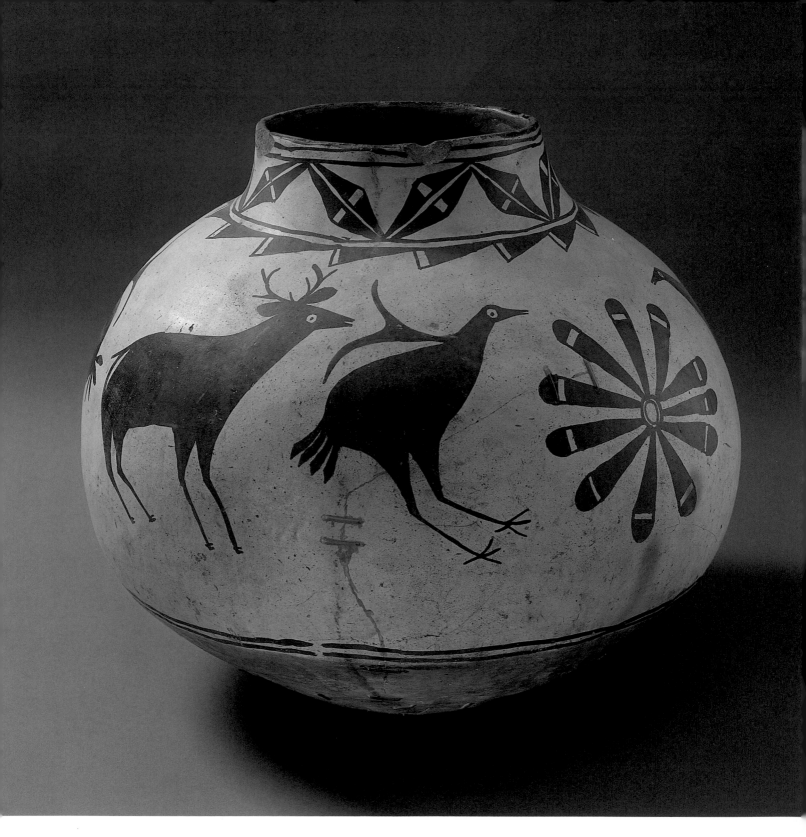

147. Globular pot with animal designs. Diam.19¹¹/₁₆". United States, Southwest, Zia Pueblo, 19th century. (40-39-10/19440). Photograph by Hillel Burger copyright © President and Fellows of Harvard College. All rights reserved. Peabody Museum, Harvard University, Cambridge, Massachusetts.

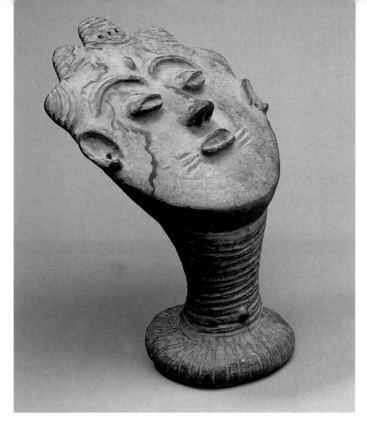

148. Funerary head (memorial head of a priestess), terracotta. H. 12½". Africa, Ghana, Akan culture, early to mid-19th century. (66.68) Seattle Art Museum, Seattle, Washington; Eugene Fuller Memorial Collection.

poses. Most impressive is the degree to which even simple containers were conceived as worthy objects, shaped and decorated with care. Much of the formalism familiar from the sculpture, the abstractions and stylizations and symmetries, appears in these pots and clay figures as well. In some cases, the clay objects clearly have been modeled on more expensive metal and wood precedents. Mostly, however, the pieces represent a use of clay quite distinct from other media. As in so many parts of the world, this creativity is largely the result of female efforts. With a few exceptions, both the making and the use of pottery fall into the female sphere.

Most familiar are the clay sculptures used in religious ceremonies or rituals of various kinds. In Ghana, the Akan commemorated important dead with clay heads as early as the beginning of the eighteenth century. These were used away from the actual place of burial and made the center of various funerary ceremonies. Appearing like abstract designs to us, the patterns of scarification as well as aspects of the features and the hair described very specific people to the original audience. They were portraits and they functioned as such (fig. 148).

A sculpture of a mother with children made by the Fante, also from Ghana, beautifully illustrates the abstraction and symmetry of form we associate with African art (fig. 149). It also evokes a tradition of clay sculpture that goes back 2,500 years, at least, to the masterpieces of the Nok. It is with the Nok, in fact, that the first known representations of a mother and child appeared in sub-Saharan art. This piece by the Fante, unlike the earlier one from Djenne in Mali, is more usual in describing the relationship between the figures as one of public presentation instead of human intimacy. Mother and child are ceremonially rather than biologically connected.

African village culture gave constant attention to the ordinary objects of everyday life. A symmetrically rounded Bamana pot from Mali arranges motifs familiar from everyday life such as lizards and turtles within the field of the curving sides of the vessel (fig. 150). A water jar from Zaire, long-necked to prevent water from splashing out, rises gracefully from a rounded middle. Black marks from firing contribute to the decoration of the painted surface (fig. 151). An anthropomorphic pot made by the Mangbetu in Zaire transforms the vessel into an elaborately detailed image of ideal female beauty. Given the subject, it is interesting that these are among the few ceramics from Africa documented to have been made by men. Made around the turn of the century, they were prestige objects intended for local leaders as well as colonial administrators and missionaries. Some of the pots are not even functional (fig. 152).

In the Pacific Islands, traditional culture continued untouched well into the twentieth century. A ceramic head vessel, or face pot, was made by the Kwoma people, north

throughout the vast expanses of sub-Saharan Africa. The dating of most of these works is only approximate, since the objects belong to rich cultural traditions with great continuities in style and iconography. Like Japanese tea wares or Meissen porcelain, they are best understood in terms of the world from which they came and its rituals.

Employing the production methods of the Neolithic age, without use of a potter's wheel or specially built kilns, the Indians of the Southwest continued to create simple, coil-built pots with painted decorations. The center of this industry lay with the Pueblos of the Southwest, especially the Acoma, Santo Domingo, Hopi, and Zuni. Designs on the surfaces of jars and bowls often refer to Indian mythology and symbolism. Even motifs that appear to be entirely formal, such as volutes, circles, triangles, stars, feathers, and clouds, usually preserve symbolism that goes back hundreds, even thousands, of years. Of particular interest are the bird and flower designs resembling those found in ancient India and the animals with arrows piercing their bodies, a motif that occurs in Paleolithic art as well as contemporary Eskimo and Australian aboriginal art (fig. 147).

Although less well known in the West than wooden sculptures, works in clay actually account for a large part of what survives from nineteenth-century Africa. The pieces exhibit a variety of styles and were meant for many pur-

149. Mother with twin children, terra-cotta. H. 18¼". Africa, Ghana, Akan/Fante culture, probably 19th century. (81.17.442) Seattle Art Museum, Seattle, Washington; Gift of Katherine White and the Boeing Company.

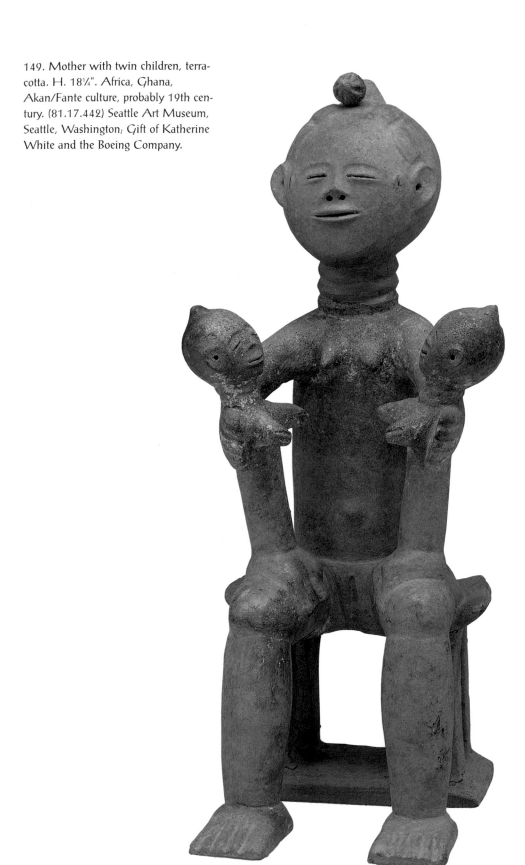

150. Ceremonial vase with relief modeling, terracotta. H. 15". Africa, Mali, Bambara culture, 19th century. (72.246) The Detroit Institute of Arts, Detroit, Michigan; Founders Society Purchase, Joseph H. Boyer Memorial Fund.

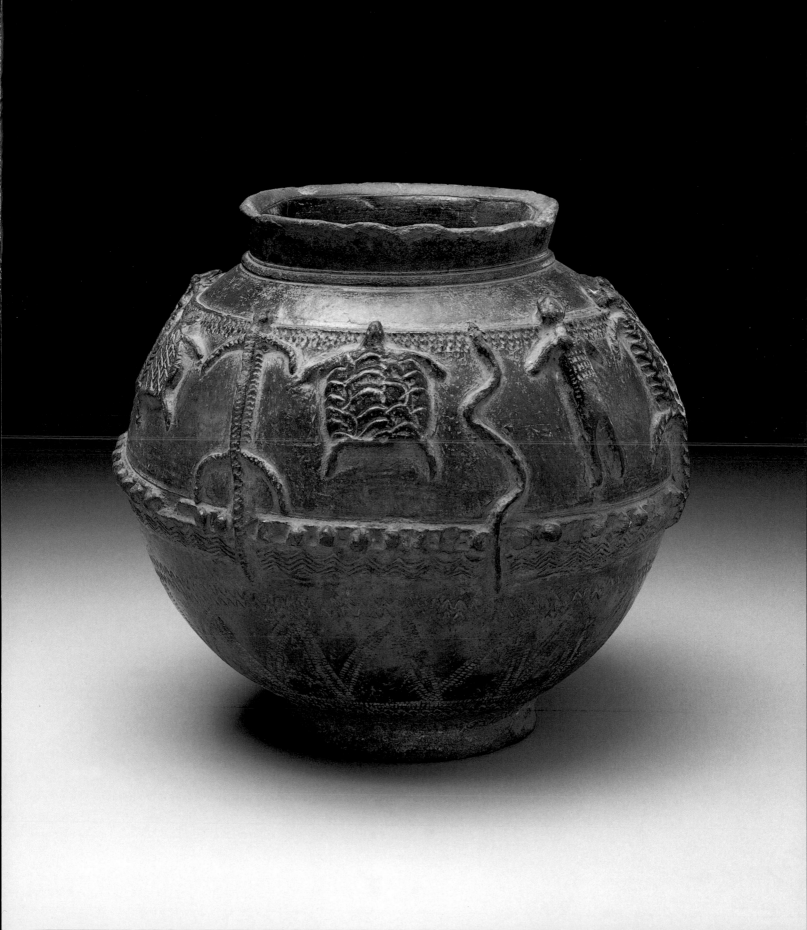

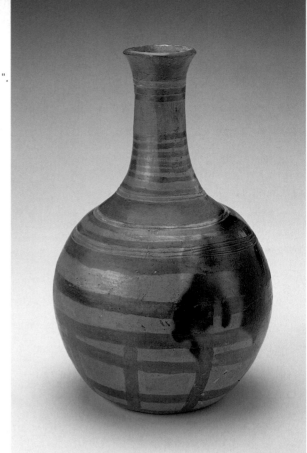

151. Long-necked water bottle with reddish bands and firing marks. H. 11". Africa, Congo or Zaire, Teke culture, before 1930. (89-13-62) National Museum of African Art, Smithsonian Institution; Purchased with funds provided by the Smithsonian Collections Acquisition Program.

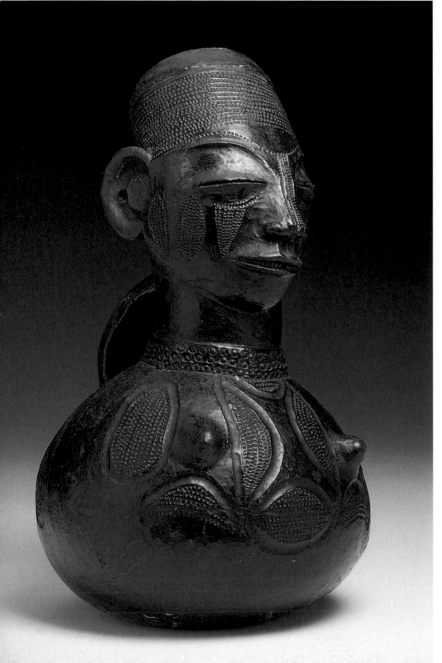

152. Anthropomorphic pot in the shape of idealized female head and bust. H. 10⅝". Africa, Equatorial forest, Zaire, Mangbetu culture, c. 1900. (X1986.555) The University of Iowa Museum of Art, Iowa City, Iowa; The Stanley Collection.

153. Painted head vessel. H. 15½". Papua New Guinea, Kwoma, 19th–20th century. (1978.412.859) The Metropolitan Museum of Art, New York; The Michael C. Rockefeller Memorial Collection; Gift of Nelson A. Rockefeller, 1969. Photograph © 1997 The Metropolitan Museum of Art.

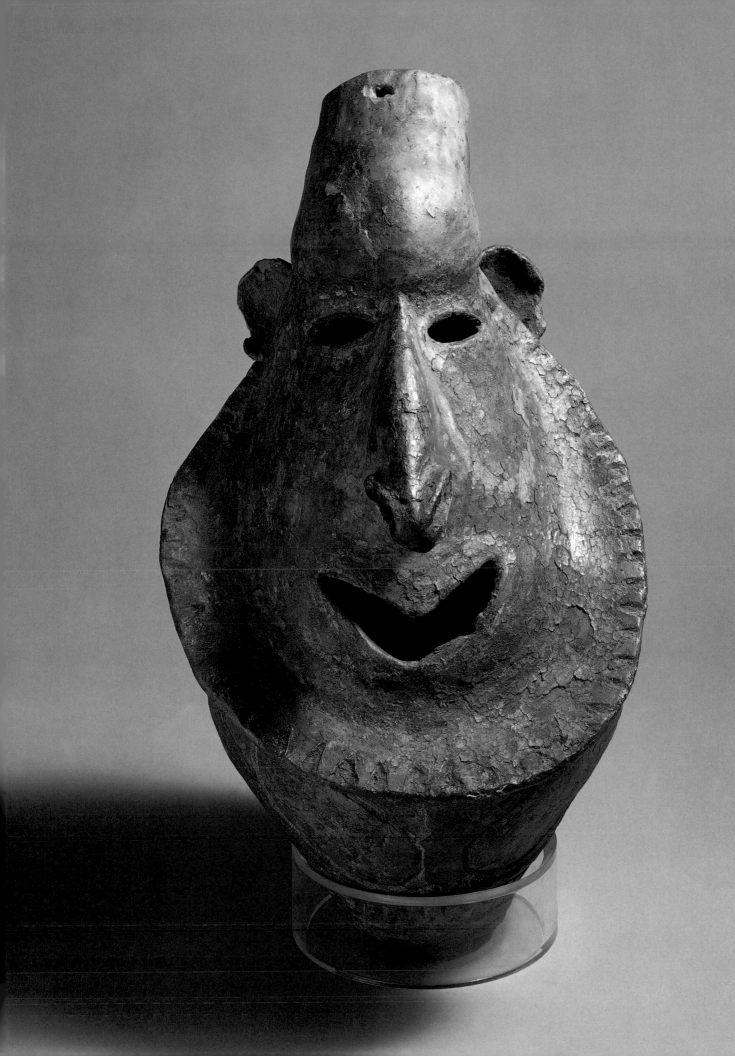

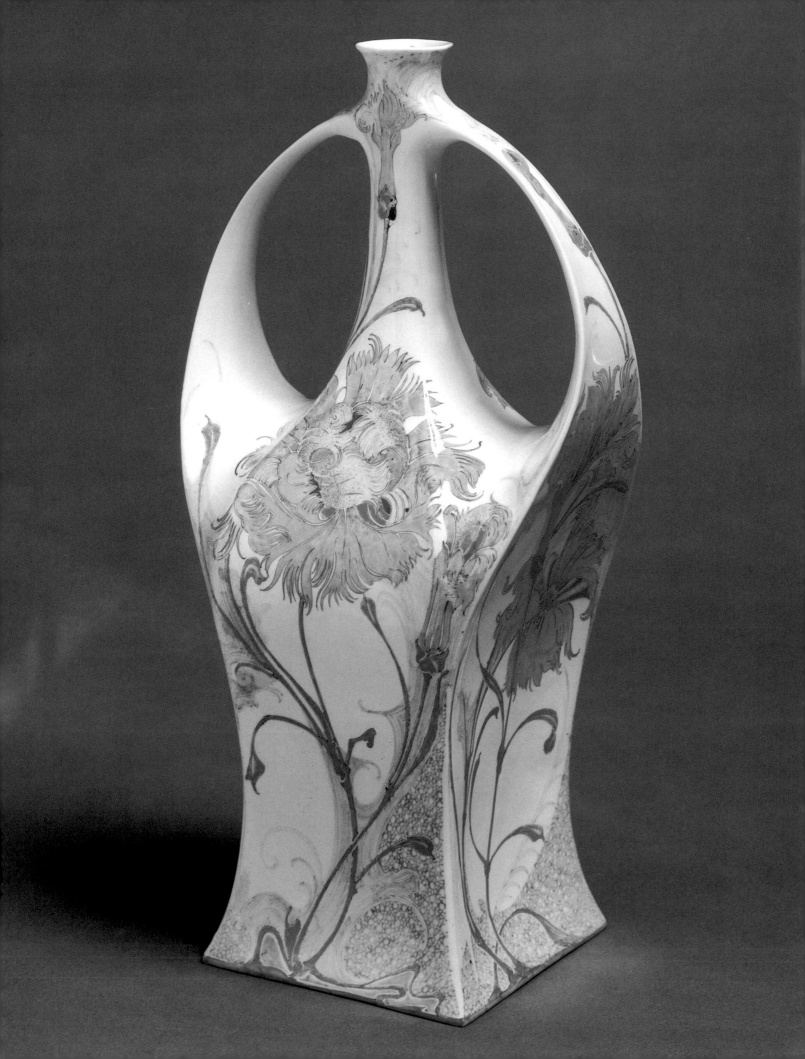

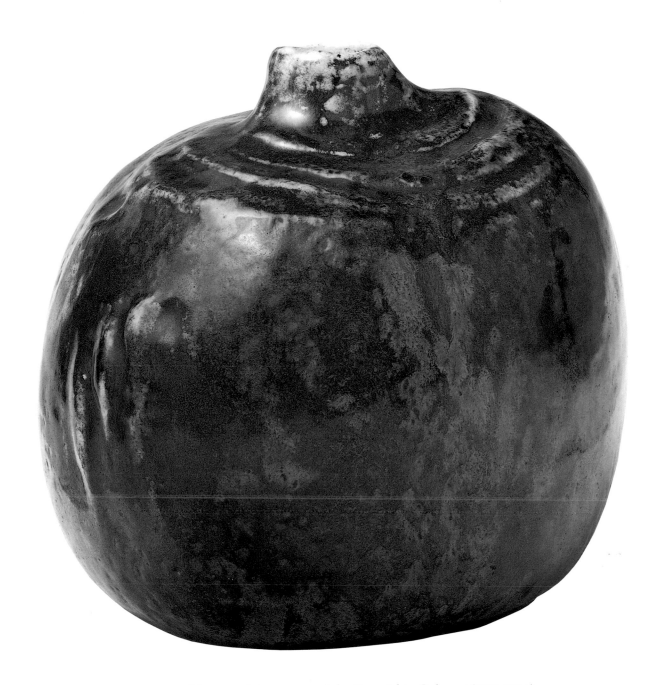

155. Vase, glazed stoneware, made by Pierre-Adrien Dalpayrat (1844–1910).
H. 8½". France, c. 1905. (26.228.16) The Metropolitan Museum of Art, New
York; Purchase, Edward C. Moore, Jr. Gift, 1926. Photograph © 1997 The
Metropolitan Museum of Art.

154. Vase, porcelain, decorated by Sam
Schellink (1876–1958). H. 15".
Holland, Rozenburg Pottery and
Porcelain Factory, The Hague, 1903.
(1994-117-2) Cooper-Hewitt, National
Design Museum, Smithsonian
Institution/Art Resource, New York.

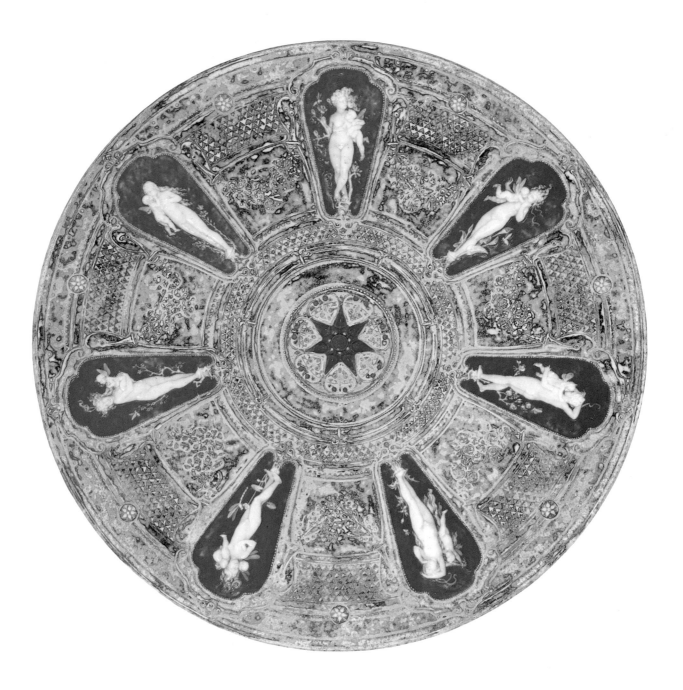

156. Plate, hard-paste porcelain with panels of pâte-sur-pâte, made by Taxile-Maximin Doat (1851–1938). Diam. 17". France, Sèvres, 1900. (1989.9) The Metropolitan Museum of Art, New York; Purchase, Robert L. Isaacson Gift, 1989. Photograph © 1997 The Metropolitan Museum of Art.

157. *Scarab Vase*, excised and carved porcelain, made by Adelaide Alsop Robineau (1865–1929). H. 16⅝". United States, People's University, Saint Louis, Missouri, 1910. (30.4.78) Photograph © Courtney Frisse. Everson Museum of Art, Syracuse, New York.

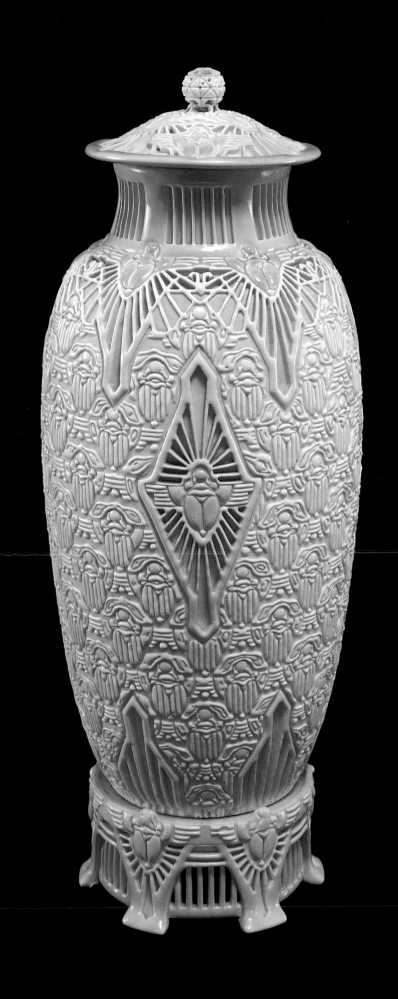

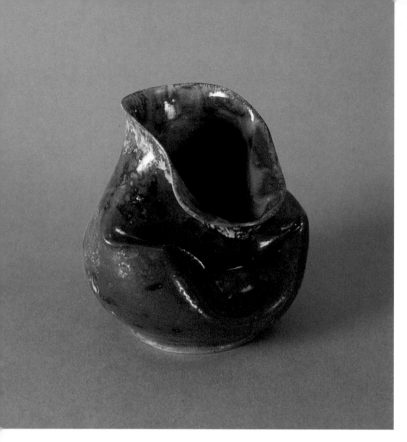

158. Vase, glazed earthenware, made by George E. Ohr (1857–1918). H. 5½". United States, Biloxi, Mississippi, c.1900. Courtesy David Rago Auctions/Lambertville, New Jersey.

of the Sepik River in Papua New Guinea, in traditional style and for the traditional purpose in this century. Displayed during feasts to celebrate the yam harvest, the faces are those of powerful spirits. Leaves and human hair decorate the pots on these special occasions, and they are placed on altars or on top of posts (fig. 153).

The very end of the century saw the birth of Art Nouveau or Jugendstil in Europe. As the names suggest, this artistic movement deliberately aligned itself with the new. Thus it also is known as the Modern style. The exhibition in 1900 of Art Nouveau and Jugendstil objects at the International Exposition in Paris marked the high point of the style, which lasted little more than a decade as an independent art movement. As with the Arts and Crafts Movement, all kinds of visual things, from architecture to the smallest details of jewelry, reflected its style. Potters working in this manner favored tall, slender forms, often derived more from Japanese art and William Morris's floral and leaf designs than actual plants. It was the sensuous, undulating lines of natural growth that appealed to the aesthetic sensibilities of these artists rather than details of naturalistic representation.

The most artistically significant Art Nouveau ceramics were made at the Hague in Holland by the Rozenburg factory. Under the leadership of J. Jurriaan Kok, a technique for soft-paste or eggshell porcelain was invented that expressed the ideals of the movement to perfection. The pieces are thinly potted in elegant curves and striking silhouettes. Art Nouveau designs, often colorful flowers and insects, were painted on the surface by Sam Schellink, among others (fig. 154). These splendid creations had particular success at the Paris exhibition in 1900. After that showing, many others attempted to work in the same style.

In France, a number of potters worked in the tradition of the artist-potter, sometimes collaborating with painters and sculptors, as with the highly productive pair of Paul Gauguin and Ernest Chaplet (1835–1902). Pierre Adrien Dalpayrat (1844–1910), who was a member of the group around Chaplet, was an important figure in the development of nineteenth-century French ceramics. His hand-thrown and modeled pots were decorated with richly colored glazes that sometimes show the influence of Japanese techniques (fig. 155). The Englishman Taxile-Maximin Doat (1851–1939) worked at Sèvres, where he became a specialist in porcelain techniques. Gold medals won for his own works, such as a handsome plate intended as wall decoration (fig. 156), led to an independent studio and a series of articles on high-fire ceramics. Between 1909 and 1915, Doat was the Director of the University City Pottery in St. Louis, where he established an impressive program.

One of the foremost American potters to combine the ideals of Arts and Crafts hand labor with the forms of Art Nouveau was Adelaide Alsop Robineau (1865–1929). She began her career in ceramics as a painter of china, but she set up her own kiln in Syracuse, New York, after contact with Doat. From 1905 on, she worked with the technique that made her famous, the carving of dry unfired porcelain. The labor involved is staggering. Robineau's *Scarab Vase*, one of the most famous pieces of American pottery, also appropriately titled *Apotheosis of the Toiler*, took 1,000 hours to carve. Although it owes a debt to Chinese carved porcelains as well as Art Nouveau forms, the vase has an artistic presence all its own (fig. 157).

Another American potter whose work reflects the influence of Art Nouveau forms is "Mad" George Ohr (1857–1918) from Biloxi, Mississippi. Ohr was as determined and as eccentric in his own way as Robineau was in hers. After holding a variety of jobs, he learned the basic skills of potting and then took a two-year tour of pottery establishments in America. From about 1890 to 1909, Ohr potted individual—even astonishing—glazed earthenware works. They can be funny, vulgar, startling, and even alarming. A relatively simple pot has a mouth that suggests a Venus flytrap, and there is something unsettling about the reach of the opening toward the viewer. At the same time, it reflects the movements of Art Nouveau line (fig. 158). In 1909, in yet another surprising twist, Ohr gave up pottery to become a Cadillac dealer.

Chapter *10*

Ceramics of the Modern Period

The twentieth century has been a very creative period in the history of ceramics. Two different approaches to pottery, both with roots in the writings of William Morris, appeared in Europe and the United States as well as in Japan. On the one hand, the legacy of the Arts and Crafts Movement was to value the handiwork of artists over the machine productions of industry. This attitude, with its Romantic bias toward the signature of the individual, became accepted by many potters as essential to the definition of fine art. Critics such as Herbert Read and the designers of the Bauhaus, on the other hand, agreed with Morris in the categorical separation of the hand- from the machine made, but they extolled multiple, machine-produced ceramics as representing the very essence of our modern industrial age. To explore design with the techniques of industry seemed the fundamental task for contemporary artists.

The most important theorist of the artist-potter is Bernard Leach (1887–1979), whose *Potter's Book* (London, 1940) sold over 100,000 copies and became a kind of Bible for an entire generation. In it, Leach argues that the ceramicist should assume full responsibility for the process of pottery making, should be true to the material, and should use strong, simple shapes like those employed by the great masters of Sung China, Yi Dynasty Korea, and Japanese tea ware. A colorful and forceful personality who traveled widely and lectured in both the East and the West, Leach exerted a strong influence on many younger potters and, more than any other single person, shaped the ceramics taste of our age.

The decisive event in Leach's artistic career was a long stay in Japan, where he went in 1909. He took up pottery and became a convert to the Japanese approach under the tutelage of the sixth Kenzan, who worked in the tradition of the eighteenth-century potter of that name. He also met Hamada Shoji, one of the great modern Japanese potters, who accompanied Leach to England in 1920. It was with the assistance of Hamada that Leach set up his kiln in St. Ives, Cornwall, and began to produce Japanese-style stoneware decorated with freely brushed designs as well as English slipware pottery (fig. 159). It is estimated that Leach himself made over 100,000 pots there and that others at the St. Ives pottery produced more than a million pieces.

The most accomplished of Leach's many pupils, followers, and co-workers—a group that included his wife Janet, his son David, and his grandson—was Michael Cardew (1901–1983). Unlike Leach, who derived his style from Japanese sources, Cardew was inspired primarily by English slipware. After working at St. Ives, Cardew took over an old pottery at Winchcombe, Gloucestershire, in 1926, and hired local potters to help him revive slipware and lead-glazed ceramics. In 1939, he moved to Cornwall and established the Bridge Pottery. His jugs, jars, mugs, bowls, and bottles are strong in shape and decorated with simple incised or brushed designs. Cardew worked largely in earthenware during his early years, but later he preferred to use stoneware, which resulted in some of his finest pieces (fig. 160). A lengthy stay in Africa gave him a chance to study traditional pottery from another culture and this experience also influenced his work. *Pioneer Pottery* (1969) collects his thoughts about ceramics, especially those from Africa.

Leach and his circle were not the only influential artist-potters working in England. Three European refugees who moved to London also became important figures. The first to establish herself was the Viennese-born Lucie Rie (1902–1995), who studied with Michael Powolny (1871–1954) in Vienna during the mid-twenties and then won exhibition medals and critical acclaim throughout

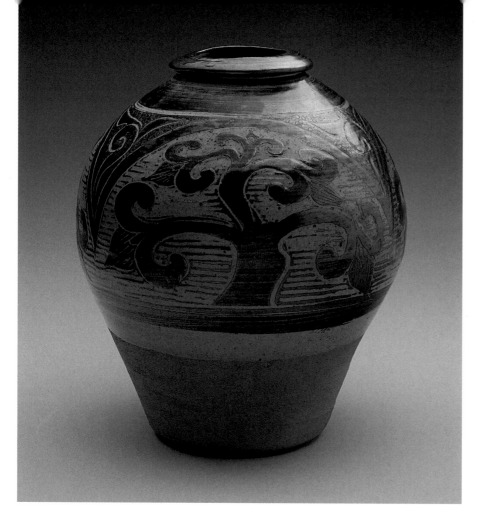

159. *Tree of Life* vase, stoneware, made by Bernard Leach (1887–1979). H. 13½". England, St. Ives, Cornwall, 1957. Cooper-Hewitt, National Design Museum, Smithsonian Institution/Art Resource, New York.

160. Jug, earthenware, made by Michael Cardew (1901–1983). H. 11". England, Winchcombe, Gloucestershire, 1938. Victoria and Albert Museum, London, England/Art Resource, New York.

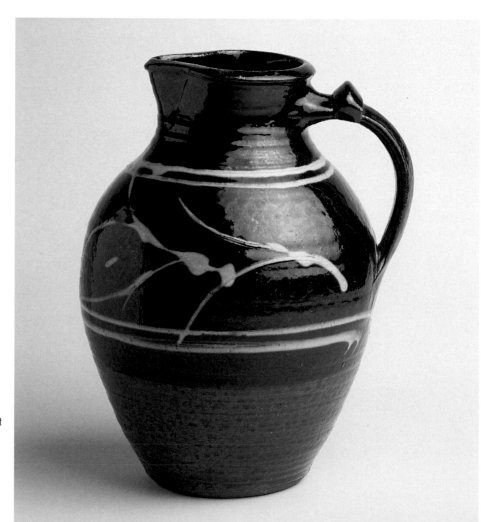

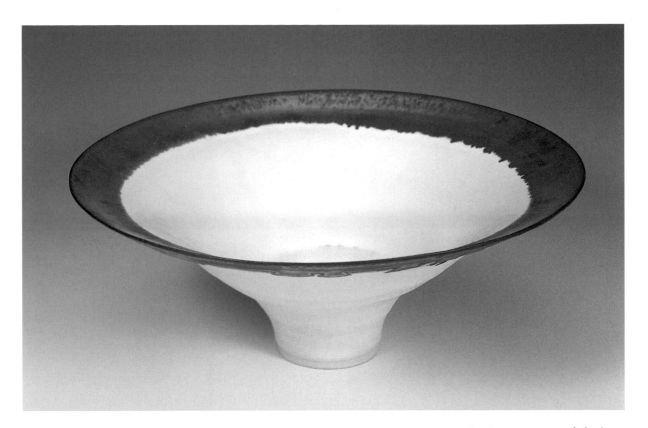

161. Bowl, stoneware, made by Lucie Rie (1920–1995). Diam. 5⅛". England, London, mid-20th century. (77.72) Everson Museum of Art, Syracuse, New York; Gift of Mrs. Theodore Hancock.

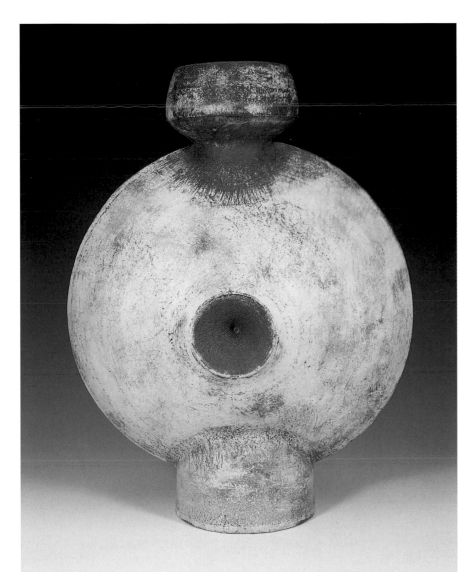

162. Vessel, stoneware, made by Hans Coper (1929–1981). H. 20". England, London, 1958. (60.29) Everson Museum of Art, Syracuse, New York; Museum Purchase from the 20th Ceramic International.

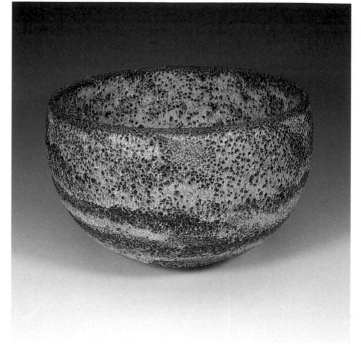

164. Bowl with pitted surface, made by Otto (b. 1908) and Gertrude (1908–1971) Natzler. Diam. 11½". United States, Los Angeles, California, 1960. (P. C. 66.21) Everson Museum of Art, Syracuse, New York; Museum Purchase from the 21st Ceramic International.

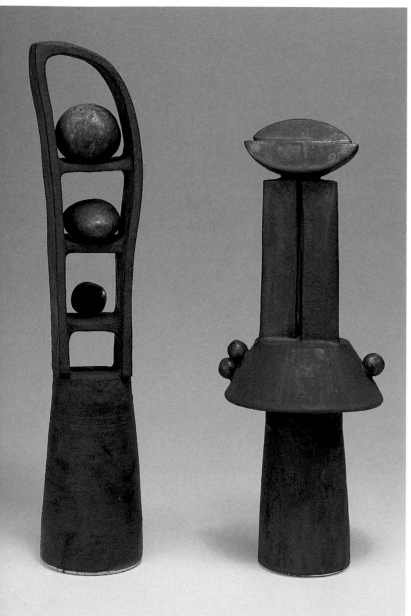

163. *(Left)* Untitled, stoneware, H. 18"; *(Right)* Untitled, stoneware, H. 15½"; made by Ruth Duckworth (b. 1919). United States, Chicago, Illinois, both 1993. Courtesy Garth Clark Gallery, New York.

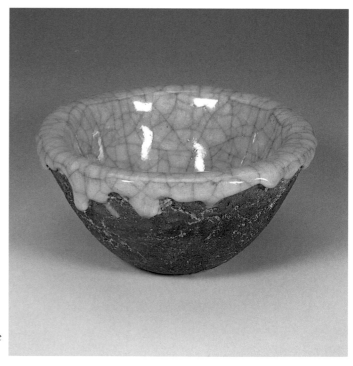

165. Bowl with turquoise glaze, made by Glen Lukens (1887–1967). Diam. 6⅛". United States, Los Angeles, 1940. (P. C. 40.331.2) Everson Museum of Art, Syracuse, New York; Gift of the artist.

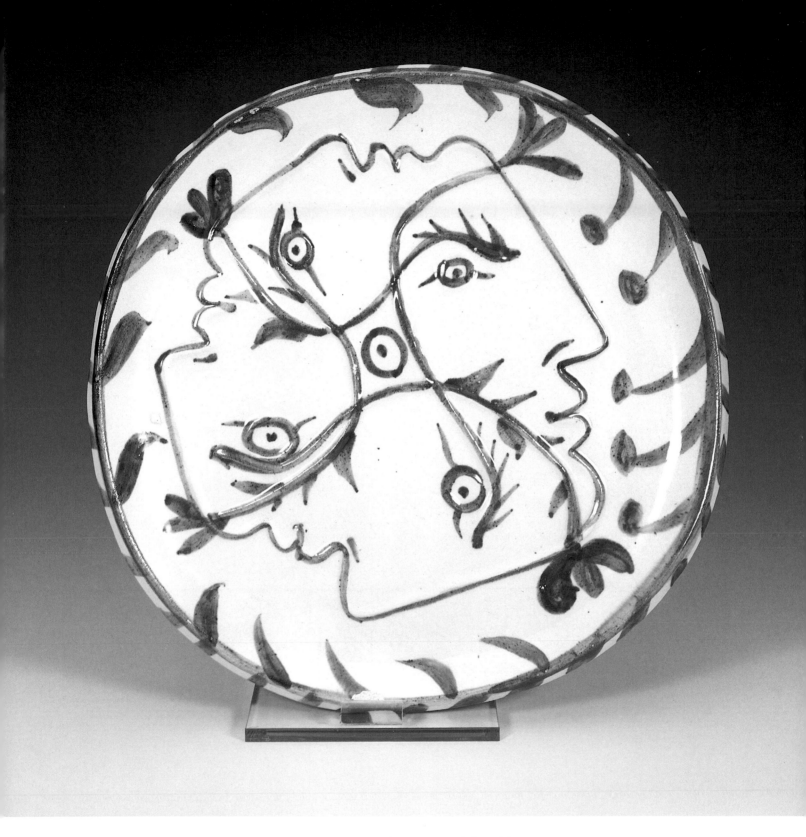

166. White plate with four profiles drawn in blue glaze, made by Pablo Picasso (1881–1973). Diam. 10½". France, Vallauris, c. 1950. (P. C. 83.31) Everson Museum of Art, Syracuse, New York; Gift of Mr. and Mrs. Herbert Slotnick.

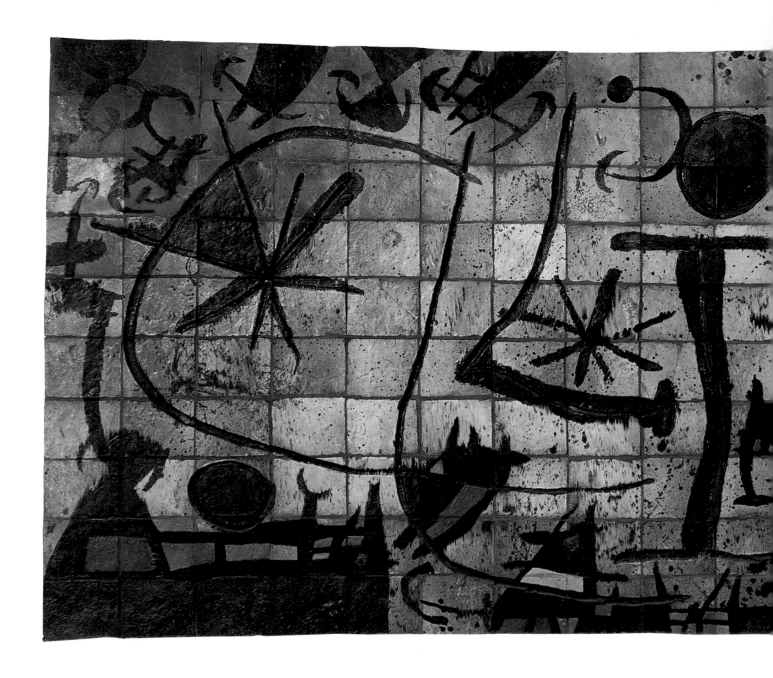

167. *Alicia, 1965,* ceramic tile wall, made by Joan Miró (1893–1983) with J. L. Artigas (1892–1980). H. 97", L. 228⅞". Spain, 1965. (FN 67.1844) Solomon R. Guggenheim Museum, New York; Gift, Harry F. Guggenheim in memory of his wife, Alicia Patterson. Photograph by David Heald © The Solomon R. Guggenheim Foundation, New York.

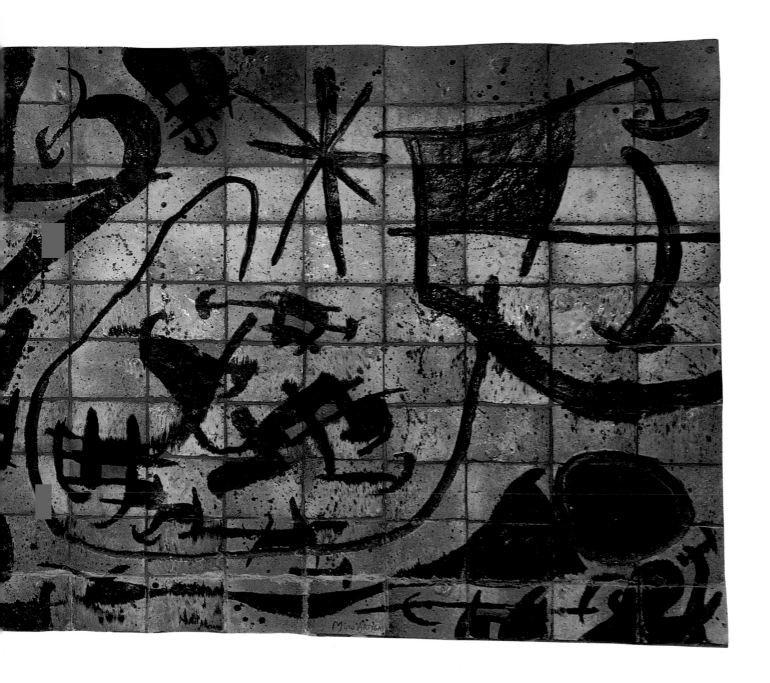

Europe. After settling in London in 1939, Rie changed from working with earthenware to stoneware and porcelain, partly under the influence of Leach. Her pots, bowls, and plates are simply shaped vessels of elegant, spare outline. Decoration most often consists of bubbling surface textures or thin lines scratched through the glaze. Within the context of such self-imposed restraint, the wavering line of glaze as it bleeds onto a slip surface may become a compelling visual focus (fig. 161). The originality of Rie's work as well as her importance as a teacher made her an international reputation.

The greatest potter to be associated with Rie, and one of the great names in twentieth-century ceramics, is the German-born Hans Coper (1920–1981). Coper studied textile design in Dresden, but in 1939 he moved to England, where he received his formal artistic training. The most decisive point in his development occurred when he met Rie. In 1947, he began working for her and he stayed in her studio until 1958. In that year, his first solo exhibition took place to great acclaim in London. A major show in 1967 at London's Victoria and Albert Museum assured his position in the history of modern ceramics.

Coper always worked with vessel shapes, but he treated them like abstract sculptural pieces. Using matte glazes and textured surfaces, he explored the possibilities of a limited number of forms. Cycladic figures and the work of modern artists such as Constantin Brancusi were of greater influence on him than ceramics traditions. This approach gives his work a grandeur and a creative presence that has few equals (fig. 162).

Ruth Duckworth (b. 1919) came from Hamburg, Germany, in 1936 and began to study art in England. Until 1956, she was a sculptor, working with stone among other media. In that year, she began to work with clay and, at the suggestion of Rie, returned to school to learn about glazing. By 1960, she was teaching in London and working on a small scale with porcelain forms as well as with large-scale stoneware murals and sculptures. In 1964, she moved to Chicago to teach. Her influence both in Britain and in the United States has been considerable. Duckworth has continued to work in a variety of styles, including white porcelain so thin that the light shining through becomes part of the piece, and ceramic sculptural ensembles with all the presence of publicly scaled works even when they are actually very small (fig. 163).

Other European refugees were Gertrude (1908–1971) and Otto (b. 1908) Natzler, who were born in Vienna and began to work together while still there. From the beginning, she made the pots while he created the glazes. After winning a silver medal in the Paris exhibition of 1937, the couple left for America, ending up in Los Angeles. During the next three decades, they produced deservedly well-known ceramics, which often combine simple shapes with striking glazes (fig. 164). The surfaces of these pots range from pitted to lustre finishes. After his wife's death, Otto Natzler continued alone, creating both the shapes and the glazes.

Another important figure in California was Glen Lukens (1887–1967), who settled in Los Angeles around 1924. He had studied ceramics at the Art Institute of Chicago, and began his career by teaching crafts in secondary schools. In 1936, he became Professor of Ceramics at the University of Southern California's School of Architecture. Inspired by the example of ancient Indian pottery from the neighboring Southwest, Lukens advocated respect for materials and tradition, and creativity as a private, inward process. He also studied the glazing techniques of Egyptian faience potters. His own work typically combines simple regular shapes with thick glazes in strong colors (fig. 165).

Many potters on the Continent produced excellent work using traditional techniques and forms. More important for the history of ceramics, however, was the work of the Spanish painters Pablo Picasso and Joan Miró. Picasso took up ceramics in 1947 at age sixty-six, as part of a burst of creativity and experimentation that followed the end of the war. He worked at the Madoura pottery in Vallauris on the French Riviera, making hundreds of brightly colored clay vessels in the shape of female figures and owls as well as more conventional dishes (fig. 166). His interest continued for some twenty-five years.

Miró began to work with ceramics after his return to Spain during the Nazi occupation of France. In collaboration with the potter José Artigas, he produced vessels as well as tiles and sculptures decorated in his distinctive mix of brightly colored flat forms and black lines. Miró found the challenge of relating large-scale tile murals to the architecture around them especially absorbing. Sometimes his designs replicated those of earlier paintings, as in the wall at Harvard University. A particularly fine mural, commissioned as a memorial to the wife of Harry F. Guggenheim, Alicia Patterson, is in the Guggenheim Museum in New York (fig. 167).

Very different is the work of those potters who explored the new machine aesthetic. The most influential theorist of this position has been the architect Walter Gropius, who founded the Bauhaus to expound his ideas. A school of art and architecture, it was established first in Weimar, Germany, in 1919, then moved to Dessau in 1925, and, finally, to Berlin, where the Nazis closed the institution in 1933. Teachers included major figures of twentieth-century art, notably Gropius himself, Wassily Kandinsky, Lazslo Moholy-Nagy, Paul Klee, and Mies van der Rohe. Among the leading designers for ceramics at the Bauhaus was Otto Lindig, whose earthenware coffee set from 1930 became a famous example of modern style.

A machine-based aesthetic found ready acceptance in the porcelain factories. The earliest of such works made by

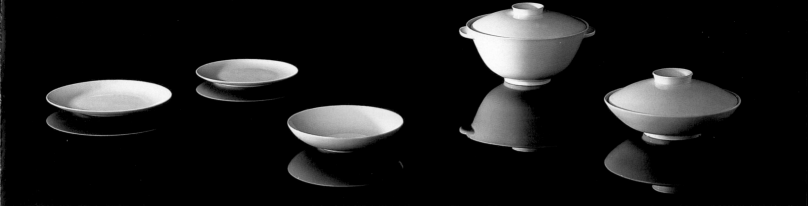

168. Urbino service, porcelain, designed by Trude
Petri (1906–1968). Diam. of tureen 11½". Germany,
Staatliche Porzellan-Manufaktur, Berlin, c. 1930–1934.
(1989.203.1ab-.5) The Metropolitan Museum of Art,
New York; The Cynthia Hazen Polsky Fund, 1989.
Photograph by Mark Darley © 1989 The Metropolitan
Museum of Art.

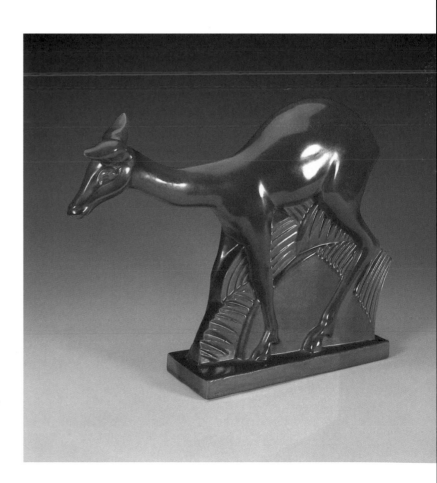

169. Deer. H. 8½". France, Art Deco,
c. 1927. Private collection.

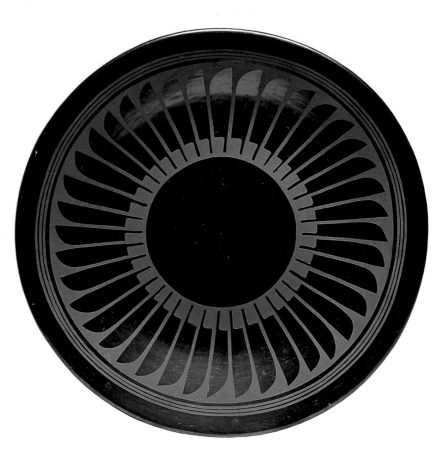

170. Plate, feather design, painted and burnished earthenware, made by Maria (1884–1980) and Santana Martinez. Diam. 15⅛". United States, Native American, New Mexico, San Ildefonso Pueblo, 1943–1951. (1951.363). © The Cleveland Museum of Art, Cleveland, Ohio; The Harold T. Clark Educational Extension Fund.

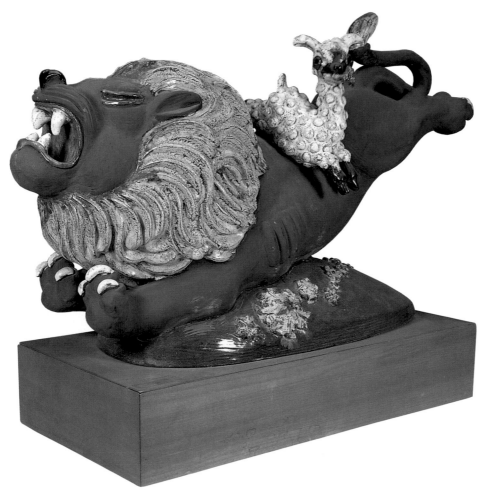

171. *Spring*, terracotta, made by Viktor Schreckengost (b. 1906). L. 30". United States, Cleveland, Ohio, 1941. (63.44) Everson Museum of Art, Syracuse, New York; Gift of International Business Machines Corporation.

172. Cup in style of Ogata Kenzan, made by Rosanjin Kitaoji (1881–1959). H. 3¾". Japan, 20th century. (76.68) The Brooklyn Museum of Art, Brooklyn, New York.

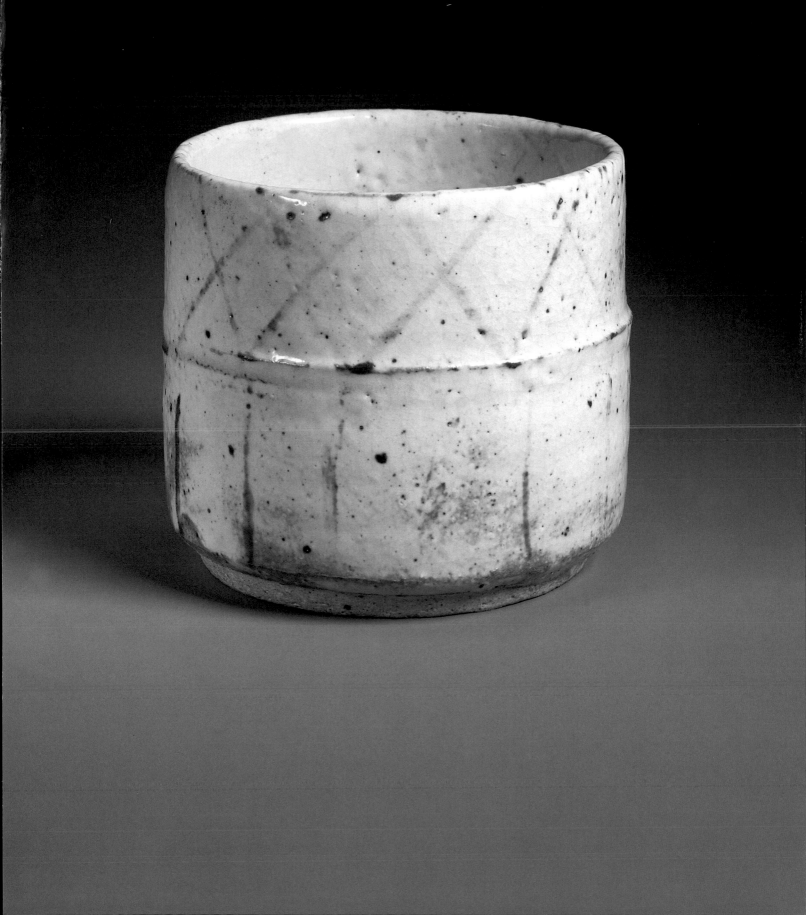

modern industrial designers came from Meissen, which had been the first place in Europe to manufacture porcelains during the eighteenth century. The other pioneering porcelain factory during the early twentieth century was Rosenthal at Selb in Bavaria. Here Philipp Rosenthal designed the Darmstadt set in 1905 and the Donatello service in 1907. While the designs from Meissen owe a good deal to the fundamentally nineteenth-century characteristics of Art Nouveau, using a molded-relief border, underglaze-blue designs, and overglaze gilding, the Darmstadt and Donatello sets already exhibit the simple lines and absence of decoration that became characteristic of modern porcelains. It is not surprising that the factory adopted Bauhaus ideas during the 1920s.

One lovely example of such factory-made porcelain is the Urbino service, which was designed by Trude Petri and produced in Berlin at the State Porcelain Works during the early 1930s (fig. 168). The service, consisting of many individual pieces, won first prize at the Paris World's Fair of 1937. The elegance of the vessel shapes as well as the luminosity of the white surfaces show a debt to Chinese porcelains, excellent examples of which could be found in Prussian museums and private collections. In spirit, however, the ceramics owe most to the ideas of modern design and particularly to the Bauhaus.

Institutionalized cooperation between the artist-potter and the industrial designer has been long established in Finland, where the Arabia factory has employed creative artists for many years. Before the twentieth century, Finnish potters produced saltglaze red pottery of no particular distinction. It was graduates of the craft school in Helsinki who introduced the idea that the artist could be employed profitably by industrial factories. Numerous outstanding Finnish designers taught at this school and spread their ideas, which resembled those advanced at the Bauhaus. Notable among them was Kaj Frank, who became art director of the Arabia factory during the 1950s.

Arabia, which today is the largest ceramics factory in Europe, originally was founded by the Swedish Rorstrand company in 1874, but passed into purely Finnish control in 1916. It is unique in providing studios and stipends for individual artist-potters who work on their own. If deemed suitable, the results are put into industrial production. Resident potters are also permitted to work on wall pieces and sculptures, which then may be marketed through trade outlets and crafts fairs sponsored by Arabia. Underlying this approach to functional design is a political commitment to improving the quality of life in contemporary society.

One more event of the 1920s had a profound impact on the history of mass-produced, designer-created ceramics. In 1925, the French government organized yet another international exposition, this one specifically devoted to the relationship between art and industry. The style that the show made popular, Art Deco, swept the world of design, influencing everything from jewelry to skyscrapers. A small brilliantly colored red-orange sculpture of a deer, its streamlined form emphasized by the highly reflective surface, typifies the Art Deco *objet d'art* (fig. 169).

Art Deco was enormously successful in America. One interesting appearance of the style is in the pottery of Maria Martinez (1884–1980) from San Ildefonso Pueblo in New Mexico. Like other modern Indian women, including Lucy Lewis, Martinez continued the ancient ceramics traditions of her tribe. Often working with other members of her family, notably her husband Julian, she recreated an old burnished pottery with a silver-black sheen, which she decorated with interpretations of Pueblo motifs. The stylishness, the streamlining, and the colors of Art Deco appear, for example, in a blackware plate ornamented with a pattern of synchronized, abstracted feathers (fig. 170).

Another American potter influenced by Art Deco was Viktor Schreckengost (b. 1906), who was the fifth generation in a family of ceramicists. He studied ceramics in Cleveland, Ohio, and then in Vienna under Michael Powolny. After his return to the United States, he divided his time between teaching, potting independently, and working as a designer for various ceramics firms. In the latter capacity, Schreckengost created a set of punch bowls for Eleanor Roosevelt that became the most popular product of the Cowan Pottery Studio. These are very much in the jazzy Moderne spirit of Art Deco. At the same time, he made ceramic sculptures that are funny and expressive in the way of caricature. Often they visualize verbal phrases, as in *Spring*, where a lion literally brings in a lamb on its back (fig. 171). Schreckengost also made important contributions to architectural ceramics. He has been honored repeatedly for his achievements.

The country with the richest and most varied output in the twentieth century, which has achieved greatness both with artist-potters and industrial designers, is Japan. Traditional as well as avant-garde styles exist side-by-side, from folk pottery to sophisticated tea wares and modern sculpture. Unlike China or Korea, Japan has continued to have a vital ceramics production. Outstanding potters have enjoyed a position comparable to that of artists in other media and, in the postwar period, a few have been designated Living National Treasures and given lifelong stipends.

Outstanding among many fine potters is Rosanjin Kitaoji (1881–1959), whom many consider the greatest artist-potter of the modern age. Starting as a calligrapher and seal cutter, Rosanjin only turned to pottery in middle age. According to legend, he wanted to supply his favorite Tokyo restaurant with more suitable serving dishes for their gourmet food. Once he took up ceramics, he developed a passion for this form of artistic expression. Rosanjin specialized in tea wares in the style of the Momoyama period, such as Shino, Oribe, Bizen, and Shigaraki, but he also made Kenzan-type pottery, Chinese-style blue-and-

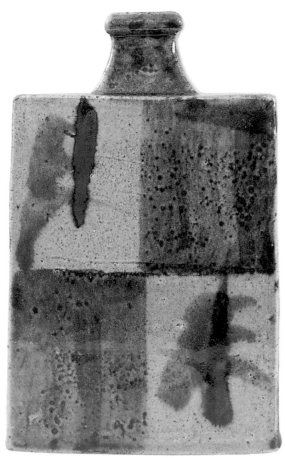

173. Square bottle in Korean style, stoneware, made by Hamada Shoji (1894–1978). H. 8". Japan, 20th century. Collection Munsterberg, New York.

174. Square box with lid, made in the studio of Kawai Kanjiro (1890–1966). H. 3½". Japan, 20th century. Collection Munsterberg, New York.

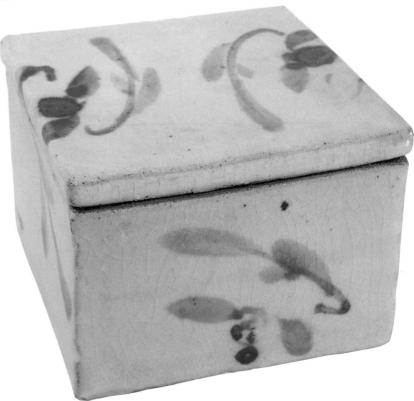

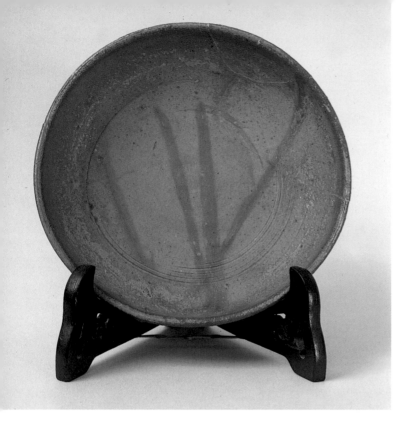

175. Plate with straw marks in Bizen style, made by Kaneshige Toyo (1896–1967). Diam. 7½". Japan, 20th century. Collection Munsterberg, New York.

white porcelains, and Korean Yi dynasty ware, as well as highly original contemporary pottery. At his best, particularly with the Bizen and Shino wares, Rosanjin equals the quality of the ancient wares and surpasses anything of this kind made by his contemporaries (fig. 172).

Rosanjin's great rival was Hamada Shoji (1894–1978). In contrast to Rosanjin, who admired the tea wares above all, Hamada was interested primarily in Japanese folk pottery and the pots of rural Korea. Settling down in the village of Mashiko north of Tokyo, Hamada became the great spokesman for Mingei pottery in contemporary Japan. A friend of Bernard Leach, with whom he had worked at St. Ives in Cornwall, and co-founder of the Mingei movement with Yanagi Soetsu, Hamada's life and work reflect his commitment to his ideals. For Hamada, the best ceramics were simple utilitarian wares made by potters who took pride in their craft but did not regard themselves as artists. In keeping with this philosophy, he never signed his work, predicting that as time went by, his own minor pieces would be attributed to his pupils and their best work might be attributed to him. His output was large, with thousands of pieces coming from his kiln every year. He tended toward simply shaped vessels of all kinds colored in browns, grays, greens, and blacks and decorated with a few well-chosen brushstrokes (fig. 173).

Kawai Kanjiro (1890–1966) was a close associate of

Hamada's and a fellow member of the folk-art movement. His early work reflects the influence of the Korean wares of the Yi dynasty both in shape and in decoration, but by the 1930s, he had developed a highly original style of his own. Most outstanding are his painted designs, usually stylized floral forms rendered in beautiful but subdued colors. Others in his studio, notably his nephew, followed this style (fig. 174). During his later years, Kawai himself turned to more sculptural forms and abstract designs that represented a dramatic departure from the ideals of Mingei.

Another great potter was Tomimoto Kenkichi (1886–1963). Trained as an architect, he turned to ceramics under the influence of Bernard Leach. His early work, with its simple shapes and free brushwork, reflects the influence of Korean folk pottery, but he soon broke with Mingei traditions and began to work in porcelain. Using pure white bodies and colorful painted designs that include gold and silver, Tomimoto created a style of refinement and sophistication. Like Hamada and Kawai, he was designated a Living National Treasure.

The descendants of the great pottery families of Arita, Kyoto, and the Mino district carry on a ceramics tradition that goes back to the sixteenth century, often in the same family. While their work does not equal the best of earlier periods, modern Kakiemon and Nabeshima porcelains, enameled wares of the Kyoto potters, tea wares by Shino masters such as Arakawa Toyozo, and Bizen pots such as those by Kaneshige Toyo are of a very high artistic quality (fig. 175).

In contrast to these urban ceramicists, many of whom have had sophisticated visual educations, are the genuine folk potters. They continue to produce, as they have for centuries, utensils for the use of themselves and their neighbors in the rural villages. This type of ware has survived best in the isolated areas of Japan, notably in the extreme north of Honshu, in the mountainous areas of Kyushu, and around the southern city of Kagoshima. Even these productions of farmer-potters, however, are sold in the Mingei shops of the big urban centers.

All of these Japanese potters belong to an older generation, mostly no longer alive today, and younger potters have looked in new directions. These contemporary artist-potters consider ceramics to be a medium of self-expression, and the greatest influences come from Western artists such as Picasso and Miró. At the same time, as in the Western world, the bulk of the ceramics output comes from immensely active factories, especially those of Nagoya. These wares often combine expert craftsmanship with highly accomplished decoration by industrial designers. The shapes chosen are usually European, but the pictorial motifs are from either the West or East. The ceramics are intended for both the domestic and the overseas market.

Epilogue

Postwar American Ceramics

Extraordinary vitality characterizes postwar American ceramics. Working in every possible style and technique, thousands of potters have committed themselves to the highest levels of creativity and the most exacting technical standards. Perhaps even more than during the nineteenth century, there is a sense of contemporary potters discovering past achievement, but in a spirit of confident appropriation rather than respectful admiration. Of course, this attitude characterizes modern art in general, but it also shows a new maturity in American ceramics. The past and other traditions serve as inspiration and a goad to invention, thus serving as a challenge rather than a burden. An especially important influence has come from Japan, but works from Ancient America, Africa, and Europe also have played their part.

This breadth of taste and influence is all the more remarkable because of the de facto exclusion of ceramics from the history of modern art as presented by the major American museums. Most striking is its near total omission from the collections of The Museum of Modern Art in New York. Through exhibitions, publications, and its own collections, MOMA has created an establishment taste in modern art for the second half of the twentieth century. Yet the museum still adheres to the basic division between art and craft formulated by Alfred Barr at the time of its founding. Except in a few cases where ceramics fit into the department of design (e.g., Bauhaus pieces) or sculpture (e.g., Peter Voulkos), the entire contribution of potters is considered craft and thus not to be found in the museum.

It was left to other institutions—notably the Everson Museum of Art in Syracuse, New York, and the American Craft Museum in New York City—to stage the exhibitions that have shaped our sense of the period. Certain landmark shows, like "Abstract Expressionist Ceramics," organized by John Coplans in 1966, were held in university

museums. Superb historical collections in nearly every major museum also have been available to nurture and inspire contemporary potters.

Training in ceramics has mostly taken place in specialized colleges and art schools. Alfred University in Alfred, New York, and the California College of Arts and Crafts in Oakland have been two of the most important, but many other places have established departments with a cumulative total of thousands of students. By and large, there is little contact with industry. The potters see themselves as artists, and do not concern themselves with the problems of mass production and machine-made ceramics. The industry, in turn, prefers specialized designers. The result is a division into two unrelated worlds of ceramics production.

All of this activity came together during the 1950s, when American potters became creative leaders. The result transformed not only American art but that of Europe and Japan as well. The central figure as both an artist and a teacher was Peter Voulkos (b. 1924), whose work moves between beautifully crafted traditional pottery and large abstract clay sculptures. After beginning his education at Montana State University in Bozeman as a painter, Voulkos discovered clay. He went on to the California College of Arts and Crafts in Oakland, receiving an M.F.A. in ceramics in 1952. Two years later, at the age of thirty, he was invited to Los Angeles to establish a ceramics department at the Otis Art Institute. It was here that Voulkos abandoned functional pottery for the expressive works in clay that have made him famous.

In 1958, Voulkos moved to the University of California at Berkeley, where he continued to be highly visible until his retirement in 1985. In 1962, he gave up ceramics for metal, not returning to clay again until 1973. Then, in a series of several hundred plates, he made vigorous com-

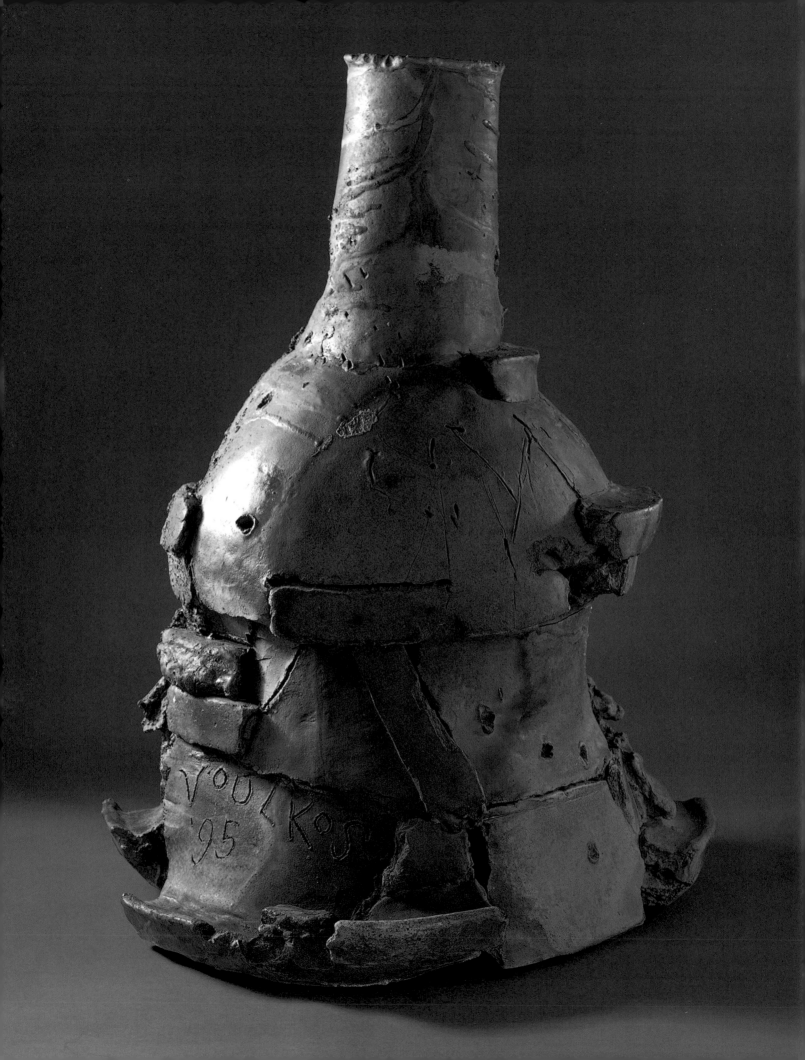

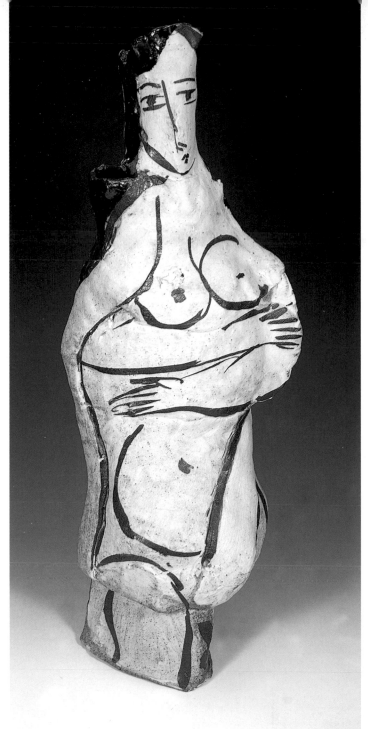

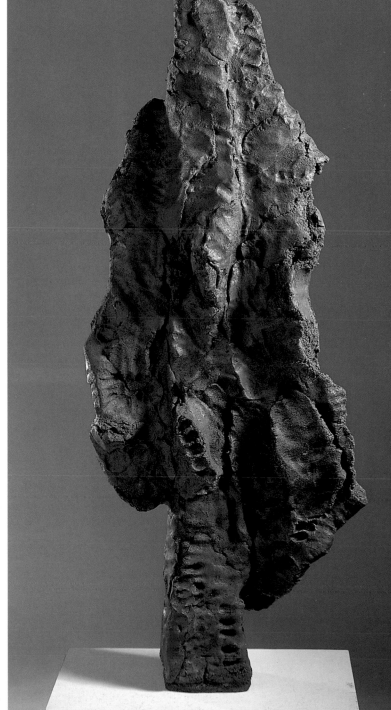

177. *Double Lady*, stoneware, made by Rudy Autio (b. 1926). H. 28¼". United States, 1964. (68.63). Everson Museum of Art, Syracuse, New York; Museum Purchase from the 25th National Ceramics Exhibition.

178. Untitled (from the *Spears* series), stoneware, made by John Mason (b. 1927). H. 59½". United States, 1963. (AC1997.38.1) Los Angeles County Museum of Art, Los Angeles, California; Smits Ceramics Purchase Fund. Copyright © Museum Associates, Los Angeles County Museum of Art. All rights reserved.

176. *Big Missoula*, wood-fired stoneware, made by Peter Voulkos (b. 1924). H. 41". United States, California, 1995. (AC1996.61.1) Los Angeles County Museum of Art, Los Angeles, California; Smits Ceramics Purchase Fund. Copyright © 1997 Museum Associates, Los Angeles County Museum of Art. All rights reserved.

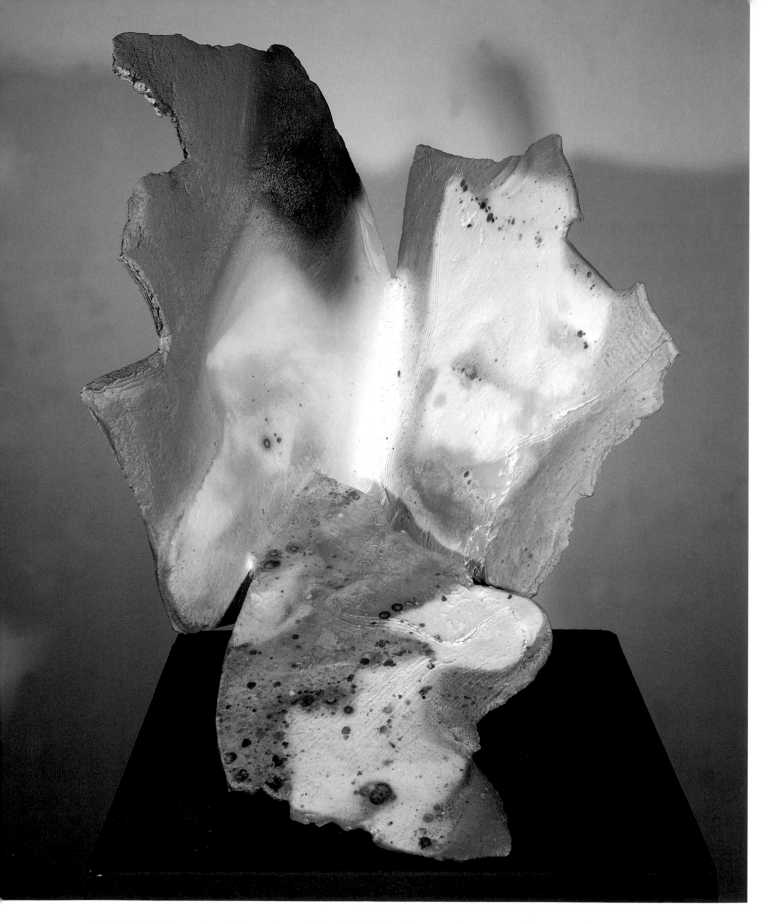

179. Untitled three-wing sculpture, raku, made by Paul Soldner (b. 1921). H. 29". United States, California, 1994. Everson Museum of Art, Syracuse, New York; Gift of the artist in honor of the retirement of museum director Ronald A. Kuchta.

ment on the artistic process itself as well as the vocabulary of modern ceramics. During the 1980s, Voulkos moved in new directions again, creating what he calls "stack" sculptures out of hundreds of pounds of clay fired in Japanese-style wood-burning kilns. He even has worked in Japan itself using kilns at sites that go back to the seventeenth century. These huge pieces still occupy his attention (fig. 176).

The work of Voulkos and his followers sometimes has been called the ceramics equivalent of Abstract Expressionism. Although the example of gestural painting and its monumental scale surely influenced Voulkos, and he himself experimented with the style in paintings, other sources seem at least as important for these developments. Zen Buddhism, with its emphasis on spontaneous creation and a delving into the depths of being for the sources of art, provided inspiration to many potters, especially in California. Japanese pottery generally, experienced first-hand when Hamada and then Rosanjin and Kaneshige toured America, permanently changed the history of American ceramics. Voulkos was one of the first Americans to use a Japanese-style wood-fired kiln, for he was eager to discover the surprises created by the extraordinary heat. Finally, ceramics by Picasso and, to a lesser degree, Miró, influenced many Americans of this time in the way they explored the relation between the drawn line on the surface and the shape of the pot.

Rudy Autio (b. 1926) also came from Montana and he too went to Montana State University at Bozeman. After earning an M.F.A. from Washington State University in 1952, he became a founding resident artist at the Archie Bray Foundation in Helena, Montana. Established by a commercial clay company to support artistic endeavors, the foundation became a center of activity. In 1953, for example, while Voulkos was working there with Autio, Hamada stopped on his grand tour of the United States. Autio created a distinctive type of sculpture, where lines drawn on the lumpy surface of the clay suggest interpretations that do not quite coincide with the form beneath (fig. 177). Both the sense of tactile mass of these pieces and the expressiveness of the forms influenced Voulkos.

A dynamic personality and an extremely productive potter, Voulkos attracted many gifted students to Los Angeles. Several of them became famous in their own right. John Mason (b. 1927) studied with Susan Peterson at the Chouinard Art Institute in Los Angeles and then with Voulkos at the Otis Art Institute. He taught at a variety of places in California before coming to Hunter College in New York City, from which he is now retired. Mason made his first dramatic appearance in the history of ceramics with monumental wall pieces. Beginning in the late 1950s, he made pieces that evoked the methods and spirit of Abstract Expressionist painting more than the works of any potter. From these wall pieces, he moved to free-standing

sculptures and retained the scale and the free handling of the clay. The best of these are extremely impressive works of art (fig. 178). He then experimented with brightly colored monolithic form, slab-built forms, and the fire bricks themselves as elements of construction. These works, however, increasingly seem to be part of the history of Conceptual Art.

Paul Soldner (b. 1921) decided to become a potter while a graduate student at the University of Colorado in Boulder. In 1954, he entered the Otis Art Institute as one of the students working under Voulkos. He later became an important teacher at Scripps College in Claremont, California. In 1960, after potting in a monumental style as well as a functional one, he decided to experiment with the firing technique of Japanese raku ware. He has developed this into very much his own expression, and many of his pieces in this style have been widely influential. Some of what he values in the Japanese masters, especially the ability to follow the inevitable surprise of the artistic process and with it capture more spiritual qualities, can be seen in recent large-scale works (fig. 179).

Kenneth Price (b. 1935), who received his B.F.A. from the University of Southern California in 1956, studied with Voulkos at Otis between 1957 and 1958. But Price decided to leave California for Alfred University, where he completed an M.F.A. in 1959. Returning to Los Angeles in 1960, he began to produce brightly colored rounded forms resembling those of biomorphic Surrealist sculpture. He then turned to more traditional shapes of pottery, especially the cup, exploring the relation of shape to surface with flat, vivid decorations (fig. 180). Price also has created total environments, including a walk in store filled with decorated ceramics. Most recently, he has made both the shapes and the coloring more complicated in works that he calls "colored objects" rather than pots or sculpture.

Jerry Rothman (b. 1933) also studied at the Otis Art Institute. Holding an M.F.A. in both sculpture and ceramics, he has worked for the most part with sculptural forms, sometimes combining ceramics with metal and sometimes reaching heights of twenty feet. In addition, Rothman has explored traditional ceramic shapes, playing with historical style and the sensuous surface of glazed clay. A series of vessels in a style now called "Bauhaus Baroque," in recognition of the contradictory aspects of the pieces, combines beauty with ugliness and wit with intentional misunderstanding (fig. 181).

The other major movement in Californian ceramics of the 1960s is commonly called Funk Art. Robert Arneson (1930-1992), who was a published cartoonist during his school years, received his B.A. from the California College of Arts and Crafts in 1954 and an M.F.A. from Mills College, also in Oakland, in 1958. By 1962, he had become the head of the ceramics department at the University of California at Davis. He began his career making conven-

tional pots but, under the influence of Voulkos's work, he tried other styles before settling on a kind of neo-Dada art. The shock value of the pieces sometimes surpasses their artistic merit, although they are always filled with clever historical references and puns. Other works of his, such as his typewriter and his toaster, recall the humor of contemporary Pop artists such as Claes Oldenburg. More recent pieces tend toward sculpture that just happens to use clay instead of stone, wood, or bronze. Some of them are architectural in ambition, while others are portraits of friends and social comments on American society (fig. 182).

Other potters have worked close to the idioms of contemporary art. Viola Frey (b. 1933) received a B.F.A. from the California College of Arts and Crafts in 1956 and an M.F.A. from Tulane University two years later. In 1970, she joined the faculty of her Oakland alma mater. Frey's most famous pieces reshape cheap plastic throwaway figures into brilliantly colored, monumental ceramic sculptures. The effect is strange, a ubiquitous imagery suddenly encountered on a monumental scale (fig. 183). The ceramics have a dreamlike quality to them, a startling difference of scale or design or color from the expected.

Mary Frank (b. 1933) also works with monumental ceramic figures. Born in England, she came to this country in 1940 and studied sculpture, dance with Martha Graham, and drawing with Max Beckmann and Hans Hofmann. She also was married to the photographer Robert Frank. Her earliest works were small wooden figures, but she quickly became interested in the possibilities of wet clay. Frank produced her first larger-than-life clay sculptures in the early 1970s and, since then, has explored all kinds of poetic, romantic fantasies. The *Swimmer* can be seen as a complicated composite of her various interests. The limbs are stretched in the movements of dance, while the broken forms can be seen as a clay embodiment of sculptural drawing. Finally, the shaping and marking of the actual material becomes part of the visual experience of the body parts (fig. 184).

Trompe l'oeil ceramics are also part of the larger scene of contemporary art, although at the same time they belong to the long tradition of clay being made to imitate other materials. Some potters have sought the limits of technique. The Canadian-born Marilyn Levine (b. 1935) holds a variety of degrees, including an M.F.A. from the University of California at Berkeley in sculpture. She has copied various materials—especially leather—into stoneware, producing stunningly convincing replications. By including all the details of aging and wear, Levine wants to convey what she calls the "trace" left by people. Leather is a favored material precisely because it is so quickly marked by use. In their deceit of the eye, these satchels and briefcases force the viewer to experience and then re-experience the act of vision and the comprehension of visual tactility (fig. 185).

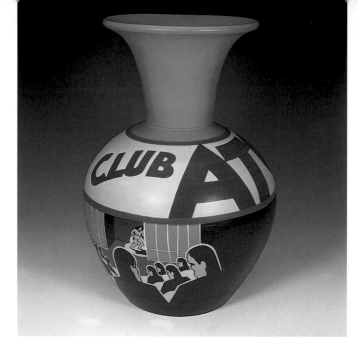

180. *Club Atomica*, made by Kenneth Price (b. 1935). H. 15". United States, Los Angeles, California, 1986. (86.72) Everson Museum of Art, Syracuse, New York; Museum Purchase.

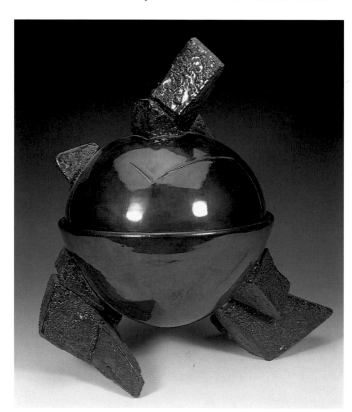

181. *Black Tureen*, porcelain, made by Jerry Rothman (b. 1933). H. 15½". United States, California, 1979. (79.13.2a-b) Everson Museum of Art, Syracuse, New York; Gift of Garth Clark.

182. *Myth of Western Man*, portrait of artist Jackson Pollock (1912–1956), ceramic, redwood, and painted wood, made by Robert Arneson (1930–1992). H. 87¼". United States, California, 1986. (1987.55) © The Cleveland Museum of Art, Cleveland, Ohio; Leonard C. Hanna, Jr. Fund.

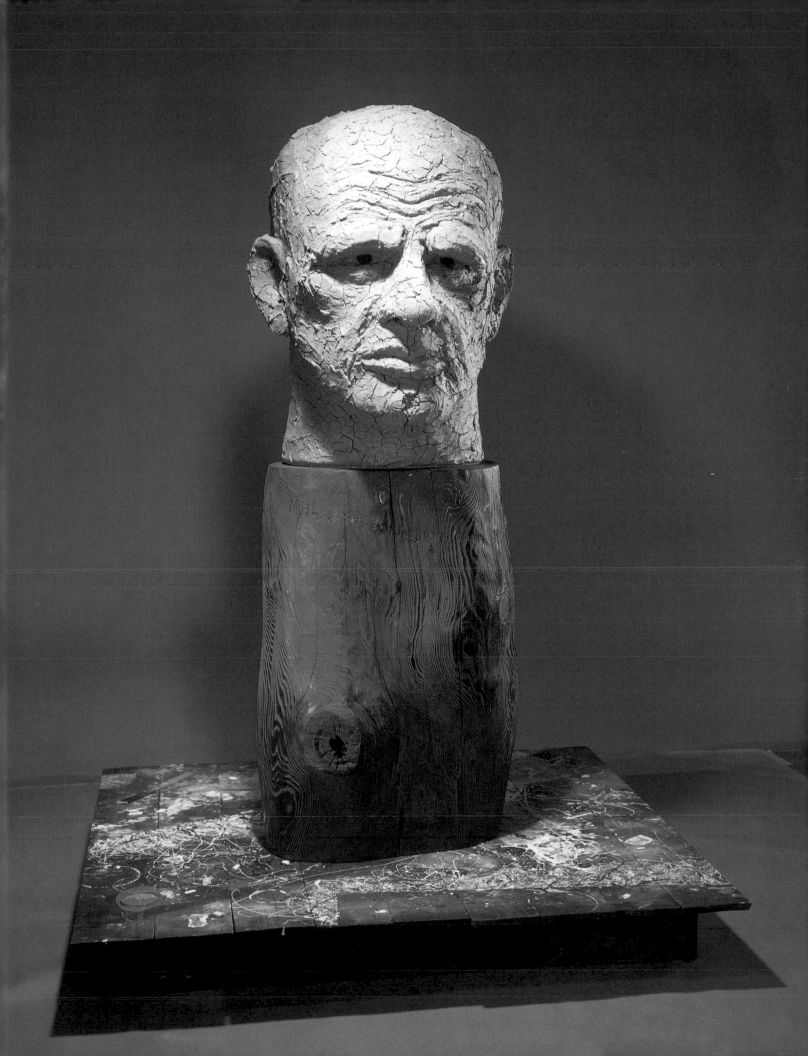

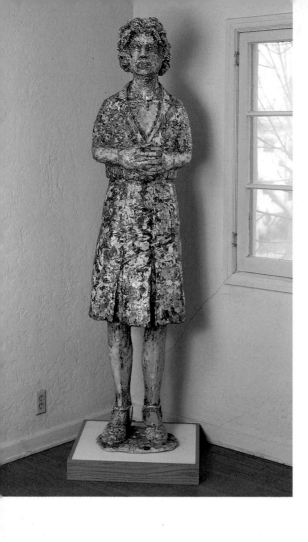

183. Untitled, glazed earthenware, made by Viola Frey (b. 1933). H. 98". United States, California, 1983. Courtesy Garth Clark Gallery, New York.

184. *Swimmer,* made by Mary Frank (b. 1933). L. 94". United States, New York, 1978. (79.31) Whitney Museum of American Art, New York; Purchase, with funds from Mrs. Robert M. Benjamin, Mrs. Oscar Kolin, and Mrs. Nicholas Millhouse. Photograph by Ralph Gabriner copyright © 1996 Whitney Museum of American Art.

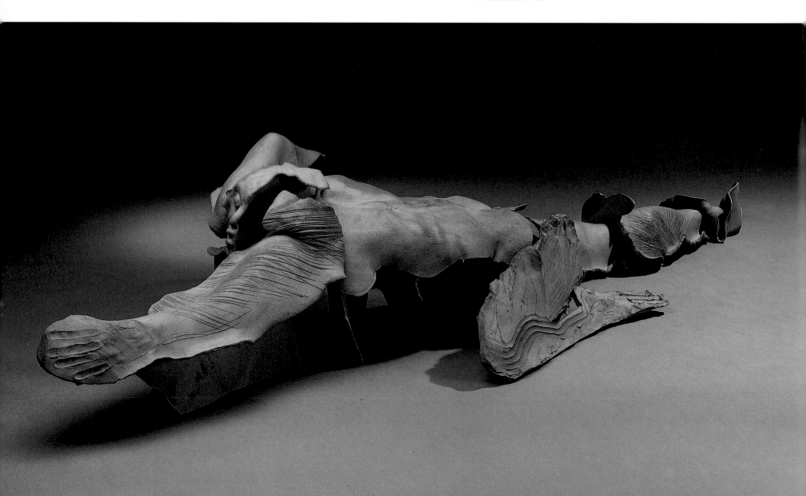

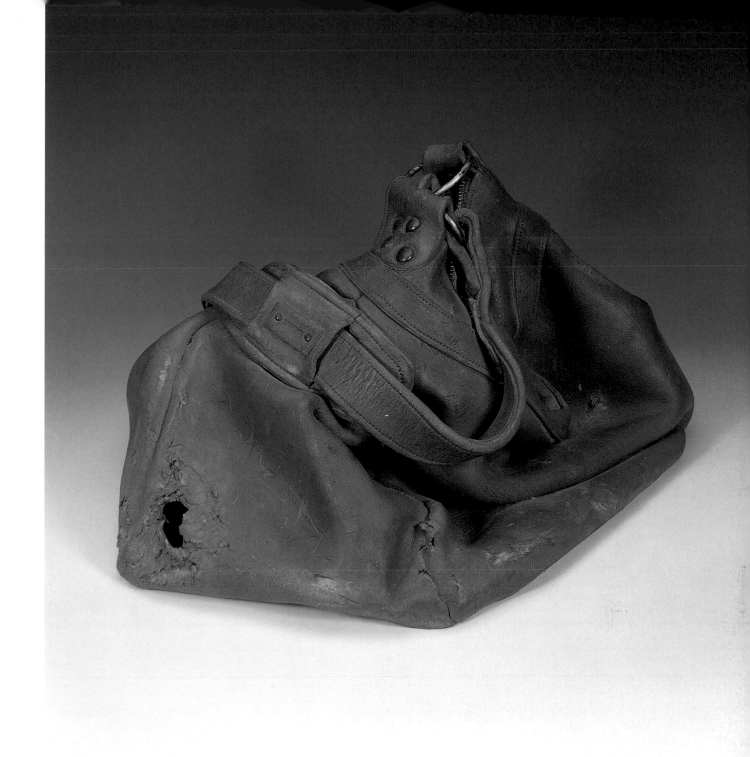

185. *Maki's Shoulder Bag*, stoneware with metal details, made by
Marilyn Levine (b. 1935). L. 14". United States, California, 1975.
(80.10) Everson Museum of Art, Syracuse, New York; Museum
Purchase.

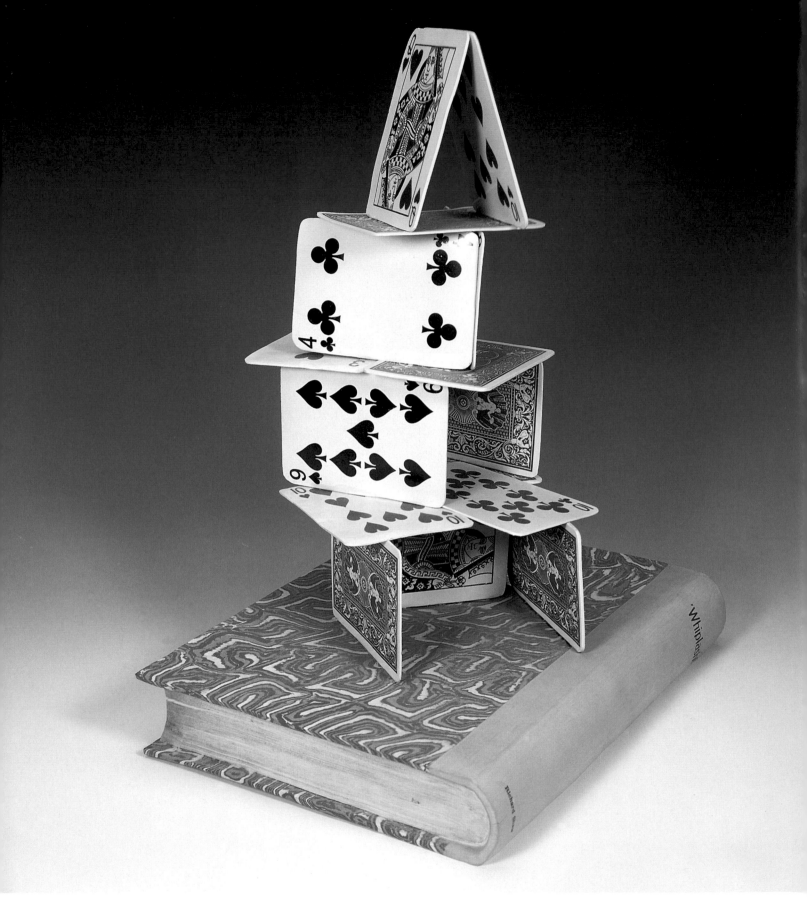

186. *Whiplash,* porcelain, made by Richard Shaw (b. 1941). H. 12¾". United States, California, 1978. (80.22) Everson Museum of Art, Syracuse, New York; Museum Purchase.

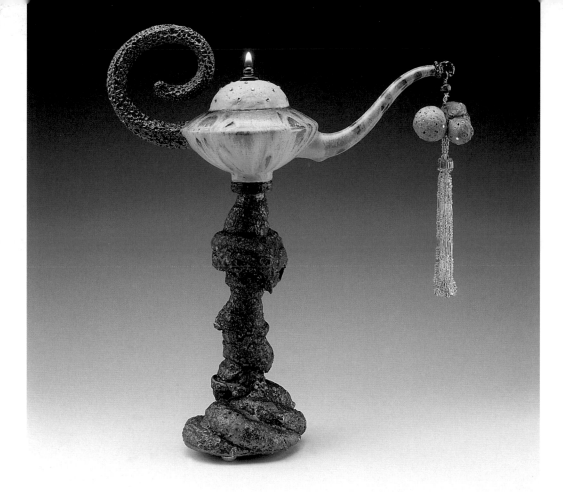

187. *Hi-Fibre Truffle-Sniffing Magic Lamp*, earthenware, stoneware, mixed media, made by Adrian Saxe (b. 1943). H. 11¾". United States, California, 1997. Photograph by Anthony Cunha. Courtesy Garth Clark Gallery, New York.

Richard Shaw (b. 1941) received his B.F.A. from the San Francisco Art Institute in 1965, studied at Alfred University, and then got an M.F.A. from the University of California at Davis in 1968. Although some of his work relates to Surrealist art, the tour-de-force of a porcelain piece like *Whiplash* seems closer to the triumphs of eighteenth-century European potters. Even the theme of a house of cards, vividly suggestive of the fragility and unpredictability of life, was popular during the eighteenth century (fig. 186).

Adrian Saxe (b. 1943) received a B.F.A. from the California Institute of the Arts in Valencia, California, in 1974. From the early 1970s, he has taught at California State University at Long Beach and, more recently, at the University of Los Angeles. Saxe works with porcelain, creating beautiful, elegant objects that take as their subject the history of decorative arts. He adopts motifs from older works and styles and combines them at will, making his own extraordinary craftsmanship as much a part of the works as shapes and glazes. Often Saxe's pieces put together striking silhouettes, textures, and colors (fig. 187). In their intellectualism, sophistication, and worldly wisdom, the ceramics might be called Post-Modernist.

Gifted Americans of the postwar period also include highly skilled potters who have chosen to work within the parameters of more traditional ceramics activity. The most astonishing career is that of Beatrice Wood (1894–1998). After a trip to Paris to study art, she returned to New York, where she became a friend of Marcel Duchamp. Wood belonged to his circle and made contributions to his magazines. In 1938, she became interested in ceramics and studied with both Glen Lukens and the Natzlers. From their rigorous and innovative teaching, especially in regard to glazing, Wood created a distinctive lustreware pottery, which she has made ever since. She has experimented with all kinds of shapes, including ones so traditional as to suggest the solemnity of ceremony (fig. 188). Her colors range from the simply beautiful to extraordinarily rich. Wood also makes small funny clay figures, but these have not been part of her public reputation.

An influential place for the study of pottery on the east coast was Alfred University (incorporating the New York State College of Ceramics). Perhaps no name is more closely associated with the revitalization of Alfred than Robert Turner. Turner (b. 1913) studied painting for years in Philadelphia and Europe before turning to pottery.

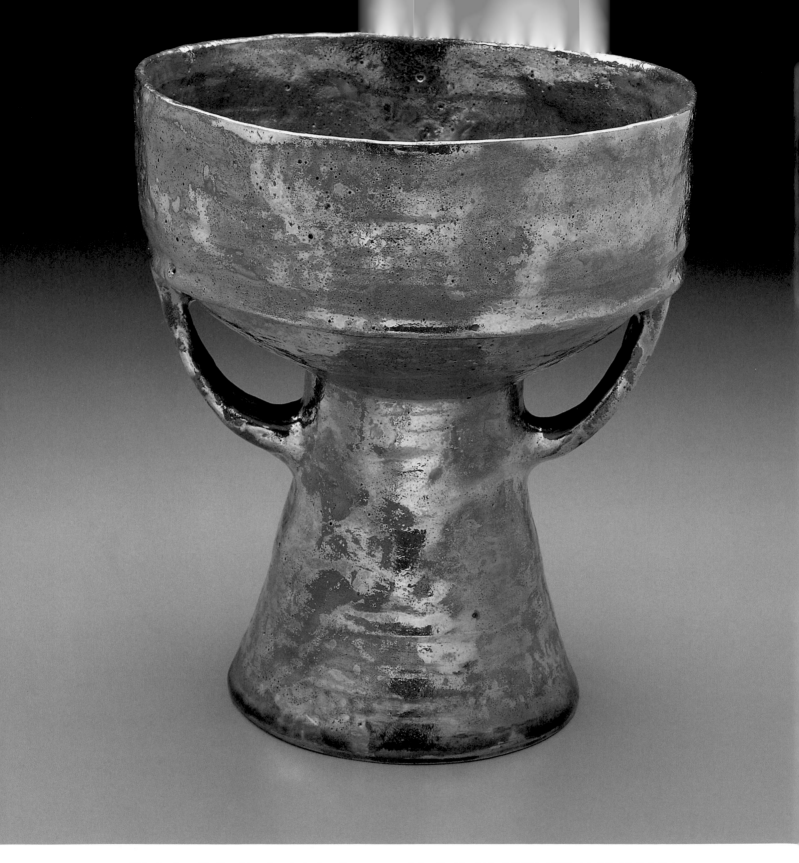

188. *Krater with Two Handles,* lustred earthenware, made by Beatrice Wood (1894–1998). H. 14". United States, California, 1987. Courtesy Garth Clark Gallery, New York. Collection of Lennie and Jerry Berkowitz, Kansas City, Missouri.

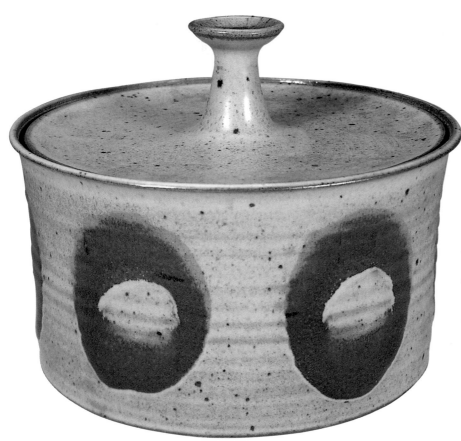

189. Casserole with lid, stoneware, made by Robert Turner (b. 1913). H. 7⅛". United States, Alfred, New York, 1953–1954. (55.692) Everson Museum of Art, Syracuse, New York; Museum Purchase.

190. *Tower Mesa*, raku-fired earthenware, made by Wayne Higby (b. 1943). Diam. 12". United States, Alfred, New York, 1981. (81.25) Everson Museum of Art, Syracuse, New York; Gift of the Social Art Club Memorial Fund and Museum Purchase.

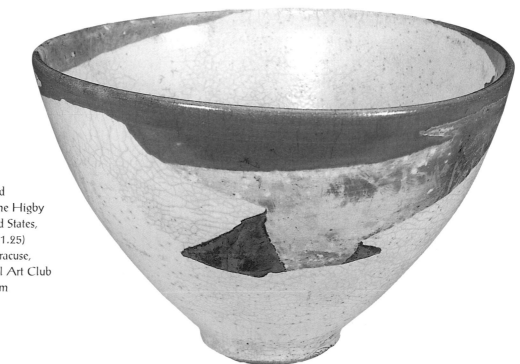

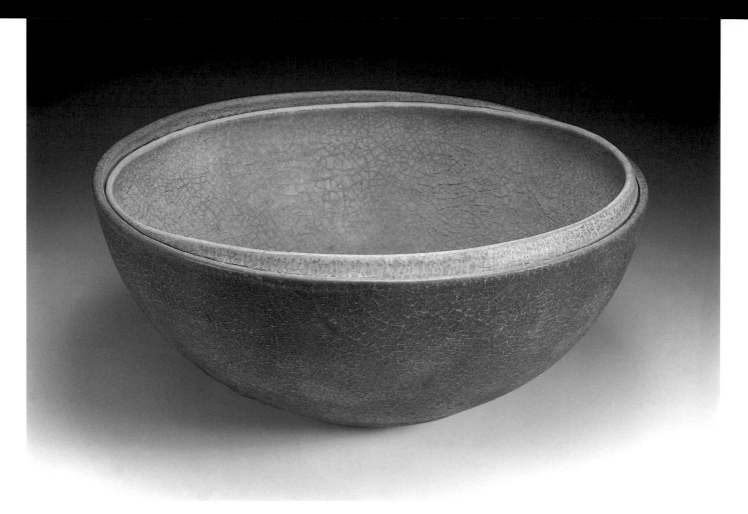

191. *Double Vessel,* wheel-thrown and altered stoneware, made by Richard E. DeVore (b. 1933). Diams. 10¼" and 10½". United States, Bloomfield Hills, Michigan, 1977. (1995.265) The University of Iowa Museum of Art, Iowa City, Iowa; Gift of Joan Mannheimer, 1995.

After three years of study at Alfred, he was invited in 1949 to establish a pottery studio at Black Mountain College in North Carolina. In 1951, he moved back to Alfred, where he remained until his retirement in 1979. More than anything else, Turner has devoted himself to the creation of stoneware vessels, in which he has developed a distinctive style of form and decoration (fig. 189). During the 1970s, he studied traditional Nigerian pottery, and, in 1972, he exhibited his first abstract ceramics.

Turner was succeeded at Black Mountain College by two more potters from Alfred, Karen Karnes (b. 1920) and her husband David Weinrib (b. 1924). Together they organized two symposia that proved immensely important for the direction of American pottery. The first, in 1953, brought to the United States Yanagi Soetsu, who had fostered the revival of folk art in Japan, and the master potters Hamada Shoji and Bernard Leach. The three men traveled through the United States giving lectures and demonstrations. The result was electrifying. They were followed by Rosanjin Kitaoji and Kaneshige Toyo, among others, whose demonstrations of their art inspired many imitations.

Another potter inspired by Japan is Wayne Higby (b. 1943). After receiving his M.F.A. from the University of Michigan in 1968, he held a variety of teaching positions. In 1973, he moved to Alfred, where he has remained an individual presence. Inspired by the Japanese technique of raku, Higby has combined it with painted landscape imagery that suggests the evocative views of Far Eastern painting. Each piece encourages the viewer to experience the work as landscape and form, as spatial illusion and surface (fig. 190).

Richard DeVore (b. 1933) is perhaps the purest and most passionate of contemporary potters. Born in Ohio, he got his M.F.A. from Cranbrook Academy of Art in Bloomfield Hills, Michigan, in 1957. There he worked under the Finnish potter Maija Grotell, who brought him back to Cranbrook as her successor in 1966. During the 1960s, he explored all styles and formats of ceramics, but from 1970 on, he concentrated specifically on the clay vessel. Taking up the cause of traditional pottery, DeVore rejected ceramic sculpture and the expressive adventures of the previous two decades. His work became serene and self-sufficient in its beauty. Simple shapes, matte glazes, and thoughtful arrangements combine to make some of the most profoundly modern pots of our period (fig. 191).

Suggestions for Further Reading

GENERAL

Camusso, Lorenzo and Sandra Bortone, eds. *Ceramics of the World, From 4000 B.C. to the Present.* New York: Harry N. Abrams, 1992.

Clark, Garth. *The Book of Cups.* New York: Abbeville Publishing Group, 1990. *The Eccentric Teapot. Four Hundred Years of Invention.* New York: Abbeville Publishing Group, 1989. *The Potter's Art. A Complete History of Pottery in Britain.* San Francisco: Chronicle Books, 1995.

Cooper, Emmanuel. *A History of World Pottery.* 2nd rev. ed., New York: Larousse and Co., 1981.

Freestone, Ian and David Gainster, eds. *Pottery in the Making: Ceramics Traditions.* Washington, D.C.: Smithsonian Institution Press, 1997.

Levin, Elaine. *The History of American Ceramics: 1607 to the Present, from Pipkins and Bear Pots to Contemporary Forms.* New York: Harry N. Abrams, 1998.

Nelson, Glenn C. *Ceramics: A Potter's Handbook.* 5th ed., San Diego, Calif.: Harcourt Brace Publishers, 1990.

Peterson, Susan. *Craft and Art of Clay.* 2nd ed. New York: Prentice-Hall, 1995.

Savage, George and Harold Newman. *An Illustrated Dictionary of Ceramics.* New York: Van Nostrand Reinhold Co., 1974.

THE EARLIEST CERAMICS

Barnett, William K. and John W. Hoopes. *The Emergence of Pottery, Technology and Innovation in Ancient Societies.* Washington, D.C.: Smithsonian Institution Press, 1995.

Kawami, Trudy S. *Ancient Iranian Ceramics from the Arthur M. Sackler Collection.* New York: Harry N. Abrams, 1992.

CLASSICAL CERAMICS

Boardman, John. *Athenian Black-Figure Vases.* London: Thames and Hudson, 1989.

——. *Athenian Red-Figure Vases. The Archaic Period.* London: Thames and Hudson, 1989.

——. *Athenian Red-Figure Vases. The Classical Period.* London: Thames and Hudson, 1990.

——. *Early Greek Vase Painting: 11th to 6th*

Centuries B.C. London: Thames and Hudson, 1998.

Greene, Kevin. *Roman Pottery*. Berkeley and Los Angeles, Calif.: University of California Press, 1992.

ISLAMIC CERAMICS

Attasoy, Nurhan, Julian Raby and Lulian Raby. *Iznik: the Pottery of Ottoman Turkey*. London: Thames and Hudson, 1994.

Fehervari, Geza. *Pottery of the Islamic World*. New York: St. Martin's Press, 1998.

Wilkinson, Charles Kyrle. *Nishapur: Pottery of the Early Ceramic Period*. New York: The Metropolitan Museum of Art, 1973.

WESTERN CERAMICS UNTIL 1800

Amico, Leonard. *Bernard Palissy: In Pursuit of Earthly Paradise*. Paris and New York: Flammarion, 1996.

Gleeson, Janet. *The Arcanum: The Extraordinary Story of the Invention of European Porcelain*. London: Bantam Press, Transworld Publishers, 1998.

Karmason, Marilyn G. and Joan B. Stache. *Majolica: A Complete History and Illustrated Survey*. New York: Harry N. Abrams, 1989.

ANCIENT AMERICAN CERAMICS

Brody, J.J., Stephen A. LeBlanc, and Catherine J. Scott. *Mimbres Pottery: Ancient Art of the American Southwest*. New York: Hudson Hills Press, 1991.

Crown, Patricia L. *Ceramics and Ideology: Salado Polychrome Pottery*. Albuquerque, N.M.: University of New Mexico Press, 1994.

Peckham, Stewart, Mary Peck and J.J. Brody. *From This Earth: the Ancient Art of Pueblo Pottery*. Sante Fe, N.M.: Museum of New

Mexico Press, 1992.

Peterson, Susan. *The Living Tradition of Maria Martinez*. Tokyo: Kodansha International, 1977.

———. *Lucy M. Lewis, American Indian Potter*. Tokyo: Kodansha International, 1984.

———. *Pottery by American Indian Women, The Legacy of Generations*. New York: Abbeville Publishing Group, 1997.

AFRICAN CERAMICS

Barley, Nigel. *Smashing Pots. Works of Clay from Africa*. Washington, D.C.: Smithsonian Institution Press, 1994.

Frank, Barbara E. *Mande Pots and Leatherworks: Art and Heritage in West Africa*. Washington, D.C.: Smithsonian Institution Press, 1998.

ASIAN CERAMICS

Adams, Edward B. *Korea's Co., Pottery Heritage*. Rutland, Vt., and Tokyo: Charles E. Tuttle Co., 1991.

Beittel, Kenneth R. *Zen and the Art of Pottery*. Tokyo and New York: John Weatherhill, 1990.

Honda, Hiromu and Noriki Shimazu. *Vietnamese and Chinese Ceramics Used in the Japanese Tea Ceremony*. London: Oxford University Press, 1993.

Honda, Hiromu, Dawn F. Rooney, and Noriki Shimazu. *Beauty of Fired Clay: Ceramics from Burma, Cambodia, Laos, and Thailand*. London: Oxford University Press, 1997.

Kenrick, Douglas Moore. *Jomon of Japan: The World's Oldest Pottery*. London: Kegan Paul International, 1995.

Leach, Bernard and Shoji Hamada. *Hamada, Potter*. New York: Kodansha America, 1997.

Li, He. *Chinese Ceramics. A New Comprehensive Survey*. New York: Rizzoli, 1996.

Moeran, Brian. *Folk Art Potters and Japan: Beyond an Anthropology of Aesthetics*. University of Hawaii Press, 1997.

Munsterberg, Hugo. *The Art of Modern Japan, from the Meiji Restoration to the Meiji Centennial, 1868–1968*. New York: Hacker Art Books, 1978.

——. *The Ceramic Art of Japan*. Rutland, Vt., and Tokyo: Charles E. Tuttle Co., 1964.

——. *The Folk Arts of Japan*. Rutland, Vt., and Tokyo: Charles E. Tuttle Co., 1958.

Peterson, Susan and Shoji Hamada. *Shoji Hamada: A Potter's Way and Work*. Tokyo and New York: John Weatherhill, 1995.

Valenstein, Suzanne G. *A Handbook of Chinese Ceramics*. 2nd ed. New York: The Metropolitan Museum of Art, 1979.

Wilson, Richard. *The Art of Ogata Kenzan:Persona and Production in Japanese Ceramics*. Tokyo and New York: John Weatherhill, 1991.

WESTERN CERAMICS FROM 1800 TO THE PRESENT

American Craft Museum. *Gertrud and Otto Natzler, Collaboration/Solitude*. (exh. cat.) New York: The Museum, 1993.

Arts Council of Great Britain. *Bernard Leach: 50 Years a Potter*. (exh. cat.) London: The Council, 1961.

Baldwin, Cinda K. *Great and Noble Jar: Traditional Stoneware of South Carolina*. Athens, Ga.: University of Georgia Press, 1993.

Bernstein, Melvin Herbert. *Art and Design at Alfred: A Chronicle of a Ceramics College*. New York: Art Alliance Press, 1986.

Burrison, John A. *Brothers in Clay: The Story of Georgia Folk Pottery*. Athens, Ga.: University of Georgia Press, 1994.

Clark, Garth. *A Century of Ceramics in the United States, 1878–1978*. New York: E.P. Dutton in association with the Everson Museum of Art, 1979.

——. *Michael Cardew*. Tokyo: Kodansha International, 1976.

——. and Eugene Hecht, Robert A. Ellison. *The Mad Potter of Biloxi: The Art and Life of George Ohr*. New York: Abbeville Publishing Group, 1990.

Clark, Garth, ed. *Ceramic Art. Comment and Review, 1882–1977*. New York: E.P. Dutton, 1978.

Drexler, Lynn Martha. *Clay Today; Contemporary Ceramicists and Their Work*. (exh. cat.) Los Angeles County Museum of Art. Los Angeles: The Museum, 1990.

Dormer, Peter. *The New Ceramics, Trends + Traditions*. Rev. ed. London: Thames and Hudson, 1994.

Levin, Elaine. *Paul Soldner, A Retrospective*. Seattle, Wash: University of Washington Press, 1992.

Los Angeles County Museum of Art. *Peter Voulkos*. (exh. cat.) Los Angeles: The Museum, 1965.

——. *John Mason*. (exh. cat.) Los Angeles: The Museum, 1966.

McCready, Karen. *Art Deco and Modernist Ceramics*. London: Thames and Hudson, 1995.

Naumann, Francis M., ed. *Beatrice Wood, A Centennial Tribute*. New York: American Craft Museum, 1997.

Perry, Barbara A. *American Ceramics: The Collection of the Everson Museum of Art*. New York: Harry N. Abrams, 1991.

——. *American Art Pottery from the Collection of the Everson Museum of Art*.

New York: Harry N. Abrams, 1997.

Poesch, Jessie J. and Sally Main Spanola. *Newcomb Pottery: An Enterprise for Southern Women, 1895–1904.* Atglen, Pa.: Schiffer Publishers, 1991.

Slivka, Rose and Karen Tsujimoto. *The Art of Peter Voulkos.* New York: Kodansha America, 1995.

Weiss, Peg, ed. *Adelaide Alsop Robineau: Glory in Porcelain.* Syracuse University Press, 1990.

IN THEIR OWN WORDS

Cardew, Michael, *Pioneer Pottery.* London: Longman, 1969.

Leach, Bernard. *A Potter's Book.* 1940; rev. ed., London: Faber and Faber, 1978.

Wood, Beatrice, *I Shock Myself: The Autobiography of Beatrice Wood.* San Francisco: Chronicle Books, 1990.

Index